TABLE OF CONTENTS

SUMMER 2021
VOLUME 1, NUMBER 4

EDITOR
LEON WIESELTIER

MANAGING EDITOR
CELESTE MARCUS

———

PUBLISHER
BILL REICHBLUM

———

JOURNAL DESIGN
WILLIAM VAN RODEN

WEB DESIGN
HOT BRAIN

Liberties is a publication of the Liberties Journal Foundation, a nonpartisan 501(c)(3) organization based in Washington, D.C. devoted to educating the general public about the history, current trends, and possibilities of culture and politics. The Foundation seeks to inform today's cultural and political leaders, deepen the understanding of citizens, and inspire the next generation to participate in the democratic process and public service.

Engage
To learn more please go to libertiesjournal.com

Subscribe
To subscribe or with any questions about your subscription, please go to libertiesjournal.com

ISBN 978-1-7357187-3-6
ISSN 2692-3904

———

EDITORIAL OFFICES
1604 New Hampshire Avenue NW
Washington, DC 20009

———

DIGITAL
@READLIBERTIES
LIBERTIESJOURNAL.COM

Liberties

ELLIOT ACKERMAN

Turning In My Card

"How many Vietnam vets does it take to screw in a light bulb?"
"I don't know. How many?"
"You wouldn't know. You weren't there."

In the American military, identity is an enduring obses-
sion. Long before debates swirled through cultural institu-
tions about the value of hyphenated American identities or
the relative fixity of gender-based pronouns, the American
military had already determined that identity supersedes
individuality. Within the ranks, the individual means little,
he or she exists as a mere accumulation of various organiza-
tional identities — your rank, your unit, your specialty — all
of which stand in service to the collective. This obliteration of
the individual begins in training, on day one, when every new
recruit is taught a first lesson: to refer to themselves in the third

person. You cease to exist, you have become "this recruit." And you are taught, among the many profanities you might hear in recruit training, that there is one set of slurs that is most unforgivable of all: I, me, my.

This doesn't last forever. I served in the Marines and one of the first privileges the Corps granted me on the completion of training was the privilege to again refer to myself in the first person. Except that I was no longer the same person. I was now 2nd Lieutenant Ackerman, my military identity had eclipsed my civilian one. This new identity placed me firmly within the military hierarchy as a junior officer, and from this position I would over years further build out my identity — and thus my authority — within the organization. I would pass through training courses that would give me expertise. I would go on deployments that would give me experience. And I would gain in seniority, which would give me rank. When in uniform, I would literally wear my identity. Badges of identity, indeed: eventually it became the captain's bars on my collar, the gold parachute wings and combat diver badges that showed I had passed through those rigorous training courses, as well as the parade of multicolored ribbons that at a glance established where I had served, if I had seen combat, and whether I had acquitted myself with distinction.

All these colorful pieces of metal on my uniform served the purpose of immediately establishing my place within a hierarchy. Which is to say, the military obsession with identity is not really an obsession with identity at all; it is an obsession with status and rank. And so it has become in the cultural hierarchy of America, where identitarians invoke an elaborate taxonomy of hyphenations and pronouns with the zealotry of drill instructors. Ostensibly, this new language is designed to celebrate individual difference. In practice it annihilates the

individual, fixing each of us firmly within an identity-based hierarchy that serves collective power structures.

As a combat veteran, I have been the beneficiary of identity-based hierarchies for years. But this was not always the case. In April 2004, I took over my first unit, a forty-man Marine rifle platoon. We were based in Camp Lejeune waiting to deploy to Iraq that June. On a rainy day, when I asked some of my Marines to patrol around the base practicing formations we would soon have to employ in combat, Sergeant Adam Banotai, a super-competent (and at times super-arrogant) twenty-one-year-old squad leader in the platoon told me that he thought my plan was a waste of time. He had been to combat, and I had not. Even though I outranked him, he sat above me in an invisible moral hierarchy in which combat sits as the *ne plus ultra* of status.

I decided to respond to this minor act of insubordination. I brought Sergeant Banotai into my office and had him sign a counseling sheet in which I marked him deficient in "leadership." I explained that leadership required loyalty both up and down the chain of command. By flagrantly refusing to follow orders he had been disloyal to me and, thus, a bad leader. When I explained that I would place this counseling sheet in his service record, Sergeant Banotai didn't like it one bit. As he signed, he said, "What the fuck do you know about leading Marines, sir. I was leading Marines while you were still in college."

Fair enough; but we still had to go to war together. Only a few weeks after the counseling sheet incident, out on patrol near Fallujah, my Humvee hit an IED. We were driving parallel to a long canal and I was first in the column of vehicles with Sergeant Banotai sitting a few Humvees back. He later told me

that from his perspective I simply vanished in a cloud of dust and smoke. As hunks of shrapnel and earth plunked down into the canal, he was certain that pieces of my body were among the debris, and, in a macabre admission, later told me that he imagined having to fish my joints out of the putrid water. What had happened was that two artillery rounds had gone off right next to my door. Fortunately, the rounds had been dug in too deep, so that their blast fountained upward, over my head, leaving me with dust in my throat and ears ringing but little else. I then jumped out of my Humvee. Whoever had detonated the IED fired a few shots at us as I jogged back to Sergeant Banotai. He and I worked together to co-ordinate our platoon's response, in which we searched the area and eventually carried on with our patrol.

After that day, everything changed. Our operations ran more smoothly, with no complaints. During off hours, Sergeant Banotai and the other NCOs came by my "hooch" to joke with me. We all got along. Several months — and firefights — later, I asked Sergeant Banotai about that sudden shift in attitude. At first he laughed off my question. When I pressed, he became a bit sheepish, even apologetic. "Well, you got blown up," he said. "After that we decided that you were okay, that you were one of us."

To this day his words bring to mind a moment in Oliver Stone's *Platoon*, in which Charlie Sheen's character, the doe-eyed new soldier Chris Taylor, after being wounded in his first firefight, returns to his platoon after a brief stay in a field hospital. An experienced soldier named King takes him to an underground bunker. Here the old hands are having a little party. When one of them asks, "What you doin' in the underworld, Taylor?" King replies on his behalf, "This here ain't Taylor. Taylor been shot, this man here is Chris, he been

9

resurrected." At which point, Chris joins their party, smoking dope and singing along to Smokey Robinson's "Tracks of My Tears" along with the rest of the platoon. It is an incredibly human scene and — call me sentimental — I am moved every time I watch it, as it traces my own experience of rejection followed by acceptance born out of combat. Chris's experience in the firefight has resurrected him. In the eyes of the group — the platoon — he isn't the abstraction "Taylor" anymore; his spilt blood has made him "Chris," an individual.

For a while, I resented Sergeant Banotai's response. I was the same person before the IED attack as I was after it, no more or less competent. This need to classify me as "other" because I was not yet a "combat vet" felt capricious, indulgent, condescending, and so against the best interests of the platoon, which needed coherent leadership up and down the chain of command to run smoothly in combat. But of course the metrics of identity are typically arbitrary, and also typically they rarely serve the best interests of the group. Tribal by nature, identity fixates on difference, too often seeking to narrow, as opposed to enlarge, who merits membership in the tribe. Identity is as much, or more, a method of exclusion as of inclusion; it fortifies itself by casting others out.

There is a famous Bedouin adage, which I first came across in Iraq: "I am against my brother, my brother and I are against my cousin, my cousin and I are against the stranger." In this remorselessly reductive manner, through the accentuation of differences (as opposed to the assertion of commonalities), one group is pitted against another in perpetuity. In my case, I had power over Sergeant Banotai because I was an officer. In his case, he exercised power over me for a time because he was already a combat veteran. Again, identity is hierarchy, a wolf in sheep's clothing.

Eventually we returned from Iraq. Sergeant Banotai left the Marine Corps, shedding that identity, and we shed the attendant hierarchy, the system of rank that had once existed between us. A few years later, when he invited me to serve as a groomsman in his wedding, I was still on active duty. He invited me to wear my uniform to the wedding, if I wanted. I wore a suit instead. We were now simply friends, resurrected (to use King's word) outside of identity and into individuality, where we remain to this day.

When he returned from Vietnam, the writer Karl Marlantes went to work at the Pentagon in an anonymous desk job. He had seen the worst of war as a Marine, earning two Purple Hearts in the process. Then, slowly, his actions in Vietnam caught up with him and he received several further commendations, to include the Navy Cross, our nation's second highest award for valor. In his memoir, *What It Is Like To Go To War*, Marlantes writes about the experience of earning these medals: "With every ribbon that I added to my chest I could be more special than someone who didn't have it. Even better, I quickly learned that most people who outranked me, who couldn't top my rows of ribbons, didn't feel right chewing me out for minor infractions. I pushed this to the limit." Marlantes stopped cutting his hair. He grew a mustache that he describes as a "scraggly little thing that made me look like a cornfed Ho Chi Minh." Eventually, a more senior officer who had also been to Vietnam but "had nowhere near my rows of medals" called Marlantes into his office. "I don't give a fuck how many medals you've got on your chest," he said. "You look like shit. You're a fucking disgrace to your uniform and it's a

11

uniform I'm proud of. Now get out of here and clean up your goddamn act."

Reflecting on the incident in his memoir, Marlantes writes, "I can't remember the man's name. If I could, I'd thank him personally. He called my shit." It takes courage to call someone else's "shit," particularly when their externally verifiable identity trumps one's own. We all know when someone is tossing about identitarian arguments in order to evade the substance of a matter, confidently issuing assertions that cannot stand on their own logic and so instead they hoist themselves up on who, in some framework, they are. Typically, these special pleadings are spoken with that tired preamble, "Speaking as a..." in which the speaker telegraphs their intention to silence dissent through an appeal to identity-based deference, as surely as if they are standing on a golf course shouting "Fore!" down the fairway. As on the golf course, the objective of the intervention is for everyone to get out of the way.

Rhetorically and psychologically, identity is often wielded as a weapon. Some identities cut sharper than others. I am descended from Ukrainian Jews on one side of my family and Scotch-Irish Texan wildcatters on the other. The world perceives me as a straight white man — a dull blade if I'm hoping to cut with identity. Except that there is one thing that corrects for my disadvantage in the identity sweepstakes and compensates for my dull archaic status: I am a combat veteran. Suddenly my blade is sharp! I am owed deference, and have the standing in the great American identity calculus to shut people up. Late in my military service, I came to understand how my identity accorded me such deference in certain situations, the ability to silence the dissent of those who might disagree with me when discussing, say, our wars in Iraq and Afghanistan.

Some might argue that this is appropriate, that I have earned it. I don't think so. The authority of experience certainly counts for something, but should it count for everything? Should only those who have the authority of "lived experience" be entitled to raising their voice on certain issues — on race, on gender, or, as in my case, on the critical issues of war and peace? Is Oliver Stone's *Platoon* acceptable because he is a Vietnam veteran, while Francis Ford Coppola's *Apocalypse Now* is a work of "cultural appropriation" because he is not? Must one have been to war for one's opinions about war to matter?

Consider an obvious example of the interplay between identity and art. *The Catcher in the Rye* is commonly regarded as a work of adolescent alienation, but I would argue that it is more properly understood as a war novel. J.D. Salinger was a veteran of the Second World War who landed at Utah Beach on D-Day and fought in the Battle of the Bulge and in the Hürtgen forest, and was among the troops that liberated the concentration camps — but generally he did not take on the war in his work, as if he knew that a limit existed as to what he could directly convey. Yet the voice of Holden Caulfield, for which the novel is renowned, is one whose provenance I recognized after returning from my own wars: it is the voice of the cynical veteran to whom everyone is "a phony," the vet who wants to visit the ducks in Central Park, to recover to an innocence that will never return and perhaps never was. Take the novel's last line: "Don't ever tell anybody anything. If you do, you start missing everybody." Those are quintessentially the words of a veteran. And yet Salinger scrupulously, as a matter of authorial intention, chose to omit his experience from his work, engaging with it obliquely. Do the new protocols of identity require that we put it back in?

There is a philosophical problem here: how can you truly know what someone else's experience is, or what access points he or she — or they, speaking of ever more recent complex identities — brings to a subject? I am not suggesting that identities are necessarily false, but they are certainly subjective, and we need to think more critically about the authority of subjectivity in our society. A good place to begin such critical self-examination would be to propose that there are no classes of people whom we should believe as such. We must show empathy, and make every effort never to begrudge it or hold it back, but after empathy we must inquire after truth, and evaluate the claims that are made on our conscience. Injury does not confer infallibility. Military veterans have sometimes misremembered the experience of battle, and sometimes even lied about it, and they are not immune, nobody is immune, from correction, from being called on "their shit."

The appeal to identity as the dispositive consideration in any debate is anathema to an open liberal society. Yet here we are. I recall reading a column by David Brooks in 2015, when the tide was beginning to rise on identity. His column was framed as a personal letter of appeal to Ta-Nehisi Coates on the occasion of the publication of Coates's *Between the World and Me*, a book that not only touches on the black experience in America but also on the American experience itself and the validity of our shared experiment in creating a multicultural democracy. It is a book about its author, but also about all of us. Brooks did not agree with some of Coates' conclusions, and his disagreement rattled him. "Am I displaying my privilege if I disagree?" he plaintively wrote. "Is my job just to respect your experience and accept your conclusions? Does a white person have standing to respond?" Those timid sentences are a kind of

epitaph for free and candid — and respectful and constructive — discussion.

Marlantes, when reflecting on his own standing as a decorated combat veteran, writes that "In the military I could exercise the power of being automatically respected because of the medals on my chest, not because I had done anything right at the moment to earn that respect. This is pretty nice. It's also a psychological trap that can stop one's growth and allow one to get away with just plain bad behavior." This "psychological trap" is now the trap of our culture, in which identity confers authority; a culture that not only stifles the interest in the individual by reducing him and her to a representative and a spokesperson, but also further isolates those groups whose interests it purports to advance.

This has certainly been the case among veterans. Few groups in American life are more fetishized. We are elaborately thanked for our service, allowed to board planes in front of the elderly, and applauded at sporting events. Honoring us has become a secular eucharist. Yet when it comes to the devastating issues that disproportionately affect veterans — homelessness, suicide, political extremism — most people look away. Our insularity, our otherness, has done nothing to lift us up. In fact, it has hurt us. A citizen need only render their deference and then be on their way. Be wary of people who pay fulsome respect to your identity, because what they are actually paying respect to is identity's twin: victimhood.

The first time someone called me a victim was at a moment when I was very publicly engaging with my identity as a combat veteran. In retrospect, this correlation between identity and

15

victimhood seems obvious, but at the time it was not. A group interested in international relations had invited another Marine and me to give a presentation about Iraq, specifically our "on-the-ground perspective." This was a little more than a year after I had returned from the war. On that day I wore my olive green "service alpha" uniform with its khaki shirt and tie, and before giving my talk I was generously feted around the room by my hosts. It was a distinguished group and, as we sipped soft drinks and nibbled hors d'oeuvres, I learned that certain of the people in the room held rather senior positions in government, or at least positions many levels above a lieutenant of Marines.

The presentation began and my co-panelist and I made remarks, showed photographs from our deployments, and did our best to describe the conditions under which the war was being waged. We answered questions from a moderator, the majority of which focused on the tactics of the war as opposed to its strategic utility. In short, we spoke only as junior officers with combat experience.

Then, when answering a follow-up question, my co-panelist made a comment about the Sunni tribes in al-Anbar province beginning to organize against al-Qaeda in Iraq. He regarded this as a positive development and contended that the United States needed to fully commit to this effort (which eventually become known as the Sunni Awakening) by "surging" even more troops into the country. He believed the war might soon turn a corner. Suddenly we were not talking tactics anymore. We were talking strategy, and he had veered outside the lane proscribed by his identity as a combat veteran. He was now speaking the language of policy among those who held senior policy positions. This was in 2006, a time when the war in Iraq was becoming extremely unpopular. When the

moderator asked whether or not I agreed with my comrade, I said that I did.

The moderator then solicited the next question. Hands shot up. An older woman went first. She asked how either of us could possibly defend the idea of sending more American troops to Iraq. My co-panelist reiterated his arguments — that al-Qaeda had overplayed its hand, that Sunni fears of Shia dominance in the newly formed Iraqi government created an opportunity that could undermine the insurgency, that it was worth making an effort to salvage the blood and treasure America had already expended. Did counterarguments exist? Of course they did. Did this woman engage us on the basis of those counterarguments? She did not. Her disagreement took an entirely different direction. She explained that we supported a surge because the war had made us victims.

"I'm very sorry for what you've been through," she said. "But you are victims of this war. Given your experience, I have a hard time believing you can see the situation in Iraq clearly. Emotionally, you're too invested." Having made this declaration, she did not sit down, but remained standing in expectation of an answer. Politely, I explained that I was in no way a victim, that I had volunteered to serve in our wars and had volunteered again (I would soon leave for Afghanistan), that my opinions were rooted in my experience and my understanding of it, and that she was free to disagree with my arguments on their merits — but not on some specious claim that I was a victim of the very experience she had come to hear me discuss, and therefore no longer able to think as an individual.

The woman refused to relinquish the microphone until making a final point. Although she appreciated hearing an "on the ground" assessment from a combat veteran and continued

17

to offer the somewhat obsequious respect that my identity commanded, I did not have her permission to repudiate the description of myself as a victim. According to her, the very fact that I refused to view myself as a victim was all the more proof that I was one, that the wars had damaged me. I had been blinded by my time at war to the wrongness of supporting any position except the swift and immediate termination of these wars, regardless of the actual conditions. (Never mind that my support for a surge was itself based on my "on the ground perspective.") The only position that I could properly derive from my experience was one that coincided with her own.

This incident has stayed with me not because it was unique — on later occasions I would again be called a victim — but because it was the first time that my relatively new identity as a combat veteran had served to disempower me. Another combat veteran, J.R.R. Tolkien, who fought in the First World War, provides an analogy. In his *Lord of the Rings* trilogy, Tolkien writes about the Rings of Power, particularly the One Ring which gives its wearer the ability to see and govern the thoughts of others; but it also slowly erodes the wearer's vitality. In Tolkien's trilogy, the humble hobbit Frodo, whom Tolkien modeled on the common British Tommy with whom he served in the trenches, is the only one who can bear the One Ring because of his pureness of heart; but even it calls to him and haunts him, robbing him of his strength and nearly spelling his demise.

Identity, even an identity confirmed by a chest full of ribbons, seduces in a similar way. It is a devil's bargain — not a heaven in which one serves a nobler cause but a hell in which one reigns. When you wear identity, you can feel its power. But in the long run it takes more than it gives, leaving you bereft of your personal difference — a Gollum enslaved to its service.

To escape this system of doctrinaire social evaluation, we must each disarm. Is it possible to displace those who brandish identity as a cudgel from the center of our culture to its fringes? Now that would be revolutionary. This would involve us no longer deferring to a person's identity but rather to their individuality, and recognizing that individuality consists in more than the simple accumulation of sub-identities, the sum total of all our group memberships. Veterans occupy an interesting niche in the politics of identity. As a group our struggles are as real as those faced by other groups. The history of civil rights in America is also the story of America's veterans; and we, too, enjoy inclusion in legislation with special protections, much like those dispensed to racial minorities and other marginalized groups — including equal employment opportunity, access to housing and education, and protections from targeted crimes. The important difference is that we are not born veterans. It is an identity we come to later. We choose it.

When I was beginning my military career as a college midshipman, my enthusiasm to become a Marine was boundless. I wore my hair according to regulations (though I was not yet required to do so) and during vacations I found a way to volunteer for an internship gophering papers around the Pentagon. In certain ways I must have been insufferable. That is why, I suspect, a recently retired Navy SEAL Commander, who worked a few cubicles down from mine as a civilian, stopped by one morning. He stood well over six feet tall, and had fought in Beirut, Panama, and Desert Storm, before being forced into early retirement due to a parachuting injury. In sum, he was an intimidating fellow who embodied much of what I hoped to become. Until that morning he had

never taken much of an interest in me, and with just the two of us in the office, he had my full attention. "Can I give you some advice?" he said. "I've served with a lot of Marines. Some good, some bad. Do you know the difference between the good ones and the bad ones?" Sitting straight in my perfectly creased uniform, I didn't have a clue. And so he told me: "The good ones never forgot who they were before they became Marines. Don't you forget, either."

I tried never to forget that advice, when I went to war but also when I came home. That is what I mean when I say that I'm turning in my card. I am not going to stop being a veteran, any more than someone from a specific racial, ethnic, or gender group will ever stop having the experiences that come with being a part of that group. But I will not allow this single element of my experience, this one personal attribute out of many, to eradicate the core of who I am. I will not play my veteran card in interactions with others, even if it's a very good card to play. And I will not allow myself to forget who I was before I became a Marine, or any of the identities — there were many — into which I was born. If I ever do forget the true core of who I am, however elusive it sometimes is, the self or soul that lies beneath all ascriptions of identity, then please use another word to describe me: call me lost.

20

DURS GRÜNBEIN

Writing and Slaughter

I

The Thousand Year Reich had come to an end after twelve
bloody years.

The "belated nation," which had drawn the short straw
when it came to dividing up the overseas colonies of the world
and so colonized inwards with the expulsion and destruction
of the Jews (this was the writer Heiner Müller's thesis), had
become the scourge of the world, a disgrace among nations.
Germany's dream of expanding eastwards, with military
villages and farming communities all the way to the Urals and
protectorates everywhere, the evil utopia of world domina-
tion envisaged by its Führer, was over. It happened so fast that

all anyone could do was rub their eyes. Had these Germans lost their minds?

After the war, the previously hyperactive nation with its vision of world domination turned inwards. Now the *Volk ohne Raum*, the nation deprived of its longed-for *Lebensraum*, was to focus instead on the last unspoiled bit of *Heimat*, or homeland, left to it — the *Feldweg*, "the field path" or "country path" extolled by Martin Heidegger, the philosopher of the hour, in a short but widely read essay in 1953. Martin Heidegger, forerunner of the eco-movement, secret hero of the Greens? Something abiding had to be found, something tried and tested, unspoiled, something that by its very nature spoke of *Heimat* and made defeat bearable as a kind of renunciation. Because, as the philosopher declared, "The Renunciation does not take. The Renunciation gives. It gives the inexhaustible power of the Simple. The message makes us feel at home in a long Origin."

This was the new program, an ecological manifesto *avant la lettre*, in a mixture of romanticism and the objectivity of the moment, as only a German could write it. There was the lark on a summer's morning, the oak tree on the wayside and the roughly hewn bench, on which "occasionally there lay [...] some writing or other of the great thinkers, which a young awkwardness attempted to decipher." And right there was the vision of a world into which those weary of civilization could withdraw from the catastrophe of modernity. Only they, these few, the abiding, will someday be able, through "the gentle might of the field path..., to outlast the gigantic power of atomic energy, which human calculation has artifacted for itself and made into a fetter of its own doing."

The "jargon of authenticity" was what another German thinker, Theodor Adorno, called it, in his critique of ideology based on what he described as linguistic atavisms at odds with

modern life — a reckoning with Heidegger's philosophical style. His book by that name was perhaps not the last word on the matter, but it was formative in its polemic. The representatives of the Frankfurt School shelved Heidegger as a problem of linguistic aberration, of anti-modern prose. But the thinking behind Heidegger's work was not to be got rid of quite so easily; the seminal eco-sound of his philosophy could not be switched off as one switches off the radio. *Zeitgeist* or not: the debate read like a commentary on the economic miracle, the era of motorway construction and the booming automobile industry with its Volkswagen, Mercedes, and BMWs, all made in Germany. Who was on whose side? Who cared about the objections of the newly emerging discipline of sociology, about Adorno's critique of language, set against the logic of origin in the words of the ontologist Heidegger, who had become suspect as a teacher because he had praised the Führer in his Rector's speech at the University of Freiburg in 1933, believing in the Platonic discourse of "tyrannous education"?

The fixation on overcoming the density of populated spaces had, once and for all, been driven out of the little men of the master race, the descendants of poets and thinkers, who wanted to rule over the peoples of the world. Their territory — which on a map of Europe of 1939, after Germany had gained Saarland and annexed Sudetenland and subsequently all of Austria, stretched as far as East Prussia on the border with Lithuania — had now shrunk to the potent core that the victorious powers divided among themselves.

A yeast dough that could no longer rise, that from now on had to be content with what was left of the burned cake. An area between the North Sea in the West and the Oder River in the East: so little room for such a mighty people. Eighty million people who had to learn their lesson. Several different

23

generations who had to grasp in school, in geography lessons, that this was it, once and for all. No more urge for expansion; all outward movement in terms of territory was at an end.

Hitler's last feint had not been credible even for a second: his attempt to present himself as a protector against the oncoming inundation of Bolshevism, the core of his morale-boosting speeches — his view that *Mein Kampf* was only the expression of a "final argument about the reorganization of Europe." The survivors of his adventure were left with only one option: to turn back into a smaller space, to turn within, to find diligence and modesty. In this, the Germans were well-practiced: fantasists, born dreamers, for whom, once they had repressed their national feelings of guilt, only the worship of silence remained. The silence after the final bell tolls. "It reaches out even to those who were sacrificed before their time through two world wars," said Heidegger. What this really meant was silence about one's own memory of the dead that tried to pass over the millions of deaths of others in silence, too.

A new nation was thus born, a divided one, lifted from the cracked baptismal font by the victorious powers — with the Marshall Plan affiliation with the West on the one side, and on the other side integration into the Eastern bloc under the control of the Soviet Union — forty years of decreed division. Yet after this Cold-War-limbo between the former Allies who had been involved in a coalition against Hitler, the Germans came together again in a Europe characterized by diverse dissolved power blocks, and they now needed to discover how Germany would cope in an epoch of intensified globalization, given its precarious position in the middle of the continent.

The above is how a speaker at the U.N. General Assembly in New York, a German practiced in self-humiliation, might have begun a speech. It could have been me, perhaps. But what am I trying to say with all this? Quite simply, that history, in capital letters, intruded even into my little life one day. I was still at school, on the outskirts of Dresden, when it first dawned on me what I had gotten myself into, without any of my own doing. Beyond the box hedge in front of my childhood home lay an empire that stretched eastwards to the Pacific, to Vladivostok and to Inner Mongolia. Or in the words of Hölderlin, "I am pulled as streams are by the ending of something that stretches away like Asia." Hölderlin, another outsider, a poet and misunderstood artist who baffled authority and who served first the nation (and later National Socialism) as a heaven-sent source of quotations because he changed the course of German poetry forever.

Two scenes from my childhood are still vivid. In the first — a winter's morning in the late 1970s — I pull the garden gate behind me and lift my rucksack onto my shoulder. I am on my way to school when a Russian military convoy made up of Ural-375 troop carriers races past me on Karl-Liebknecht-strasse, and my gaze is caught by the huge, hulking wheels of the vehicles, the felt coats and steel helmets of the soldiers, and I stand stock still in amazement and forget time.

What did I know then of Isaac Babel's *Red Cavalry*, or Mikhail Sholokhov's *And Quiet Flows the Don*, later to be compulsory school reading, or Vasily Grossmann's *Life and Fate*, a book I read only decades later, long after the Soviet Union disappeared? But the image of those Russian troops imprinted itself on me, and from that moment on I began to understand German history from the point of view of the Russians, who were cavorting here in my hometown, right on

Writing and Slaughter

the doorstep. In the beginning it was the cartridge cases that we boys found in the surrounding woods, military badges that we bartered with the Russian soldiers at the barracks gates, not two hundred meters from my parents' house, in exchange for photos of naked women (from the only East German magazine that printed such pictures). It was not until much later that I read Joseph Brodsky, that brilliant Soviet renegade and the first poet of the transition from East to West, whose verses immediately struck home: "In the beginning, there was canned corned beef. More accurately, in the beginning, there was a war. World War II; the siege of my hometown, Leningrad; the great hunger, which claimed more lives than all the bombs, shells, and bullets together. And toward the end of the siege, there was canned corned beef from America."

The second scene is a bit more complicated. We are in the middle of a history lesson in the eighth grade, and the teacher, a strict member of the Communist Party, gives me the task of preparing a lecture. Its theme is the Nuremberg Trials. I head to the Saxon State Library, then housed in the city's largest barracks complex, also containing troop accommodations and weapon depots belonging to the Soviet Army and the NVA, or the GDR's National People's Army. The juxtaposition of scholarship and the military life of the "fraternal armies," as I experienced it on the way to the silence of the reading room, got me thinking. I procured my first library card and set myself up as a permanent fixture among the books, which soon earned me the respect of the staff and years later led them to allow me to view the archive of Viktor Klemperer. At that time hardly anyone outside Dresden knew the author of one of the most important diaries of the Nazi era; he was known only as the author of *LTI*, a groundbreaking study of the

infiltration of the German language by the ideas of Nazism. His extraordinary diary was discovered in Germany, via the success of the America edition in the West, after the fall of the Berlin Wall. Only then was it recognized across the world for what it is: a rare chronicle of everyday life of the Nazi era in a city (Dresden), from the perspective of an academic dismissed from his post, a persecuted Jew, who experienced the increasing loss of rights first-hand, to the point where he himself was threatened with deportation. This coincided with the destruction of his hometown, Dresden's downfall in a firestorm, which saved his life.

The fruits of my schoolboy work gathering facts on the Nuremberg trial was limited. Still, it had the function of opening the poison cabinets to otherwise censored publications from the West. I was able to study Eugene Kogon, Telford Taylor, Joe Heydecker's photographs, and the twelve-volume series of writings of the International Military Court, all the monographs available then on the crimes committed in the concentration camps, the ghettos in the East, and behind the fronts. Raul Hilberg's key work, *The Destruction of the European Jews*, which appeared in America as early as 1961, was not published in Germany until twenty years later. Claude Lanzmann's documentary film *Shoah* was still far beyond all horizons of such "reappraisal." It was through him that I first learned the Hebrew word for the deflated term "Holocaust."

The result, then, was meager compared to the wealth of specialized material available today. But I had been bitten by the bug of historical research, and my work soon began to display worryingly manic features. My lecture to the class did not stop at that one assignment: it kept on expanding, until it took up three whole history lessons — to the great satisfaction of the teacher, who believed my soul had been saved for

the anti-fascist cause. In the end I was pretty clued in about the arms industry and the murderous judiciary in the Third Reich, about Hitler's euthanasia program and the special task forces, the system of forced labor, the extermination camps and the medical experiments performed on inmates.

I can well imagine what a strange impression a fifteen-year-old must have made lecturing the class on racial politics, Jewish persecution, SS massacres, gas chambers, and the role of German companies in the business of extermination. That was when I first learned with absolute certainty that the firm I.G. Farben supplied Zyklon B, that the Erfurt company Topf & Sons built the crematoria, and that the Allianz AG insurance company insured the barracks of Auschwitz. And even today I can still recite, immediately on waking, the new categories established during the trials, against all precedent of jurisprudence: crimes against humanity; war crimes; and (most astonishingly) crimes against peace. Though often disregarded, the Nuremberg ruling outlawing wars of aggression is valid still today.

It was then, almost as an aside, that I first heard about the Declaration of Human Rights. But the dour teacher allowed the mention of it to pass without comment. For the Declaration of Rights touched on a taboo in the self-image of the other German state, because invoking universal human rights was the last resort of the opposition. The argument as to whether the GDR was an illegitimate state still divides people today. The Nuremberg trials, I explained to my classmates, were not a case of so-called "victors' justice," and that, too, remained uncontradicted. Or had it simply been lost in the mass of material? Fired up by my awakening sense of justice, I was able to quote to my class the American chief prosecutor, Judge Robert H. Jackson, without challenge: "That four great nations, flushed

with victory and stung with injury, stay the hand of vengeance and voluntarily submit their captive enemies to the judgment of the law is one of the most significant tributes that Power has ever paid to Reason."

This was a completely new principle, and it sounded so auspiciously redolent of the values of a liberal order that even today, remembering the scene, I am still astonished by the silence in the classroom. It was as if the nations that held court over the mass-murderers and their superiors had wanted for the first time to test out what Kafka in his diaries had called "jumping out of death row." And for me, it was as if I had won a small victory when the teacher, changing the habits of a lifetime, graded the lecture with an A+, because she could do nothing else. I still recall her fixing her gaze on me like a strange toad, and me staring straight back. .

Eleven years later, my first volume of poetry appeared, a year before the Soviet empire began to crumble with the fall of the Berlin Wall. *Grauzone morgens,* or *Mornings in the Grayzone,* was its title, a book in which scenes like the ones just described added to the overall panorama, but which was more of a search image — you would not find any of the crucial terms in it. Viewed from today, one can see that it followed the scenography of a Tarkovsky film. I happened to have seen his masterpiece *Stalker* in a Dresden cinema in the early 1980s, but only later found the key to his enigmatic film parable in Eliot's *The Waste Land*: "'Who is the third who walks always beside you?' 'There is always another one walking beside you.'" Only now am I fully aware of the overlapping motifs. Someone had been walking beside me for a long time. An angel? A superior?

One of my poems from that time that reminds me of those days, and of my trips to the Saxon Library. It is called "Accept It."

So many days with nothing
 occurring, nothing but those
brief winter manoeuvres, a few

mounds of snow in the mornings,
 melted away by evening, and the
strange moment at the barracks

was an exotic handbill: this little
 squad of Russian soldiers in
green felt uniforms, standing in silence

guarding a bundle of newspapers, and I read
 "коммунист" on top and
the line came into my mind: "picture

the wristwatch on Jackson Pollock's wrist."

II

It is no longer the specter of communism that haunts Europe today. It is the afterimage of authoritarian rule, the dream of right-wing populism among the people, realizable through propaganda and political marketing. All those discredited socialist utopias that vanished with the fall of the Soviet Union have been replaced by backward-looking visions of a strong nation with fortified borders and as self-sufficient an economy as possible. Regressive fantasies stoke the flames of the struggle for majorities. Aggressive discourses of power have long since captured command positions here and there in Europe and America. The theatrical spectacle starring real estate tycoon T, the Twitter King Ubu Roi in the White House, finally came to

a close, but it showed where things might be heading in this second millennium.

"Retrotopia" was what the sociologist Zygmunt Baumann called it in his last, posthumously published, book, his critique of a world of nationalist politics that leads of necessity to a restricted sense of nationhood, to trade-wars and the rearmament of the nuclear powers — in sum, to the increasing violence to be seen in all spheres, not least in language. Baumann knew what he was talking about: as a Jew he had experienced political violence early on, and he too became an émigré in his thinking. It is hardly an accident that, after much back and forth between East and West, Baumann, who had been born in Poznan in Poland, finally fetched up in England and died there having found a haven for the time being.

The fixation on the past identified in Baumann's book rests on the need for security for the many uprooted people in Western societies. For a large number of these people, freedom is simply overwhelming: the freedom of the individual as well as that of capital, which dissolves all ties and thus threatens the very basis of their existence. The discomfort with culture goes hand in hand with a transfiguration of the past. The "little people," Baumann explains, want a return to the tribal fire, as if they had not failed more than once in that undertaking. In times of globalization and the migration that comes with it, phenomena that are experienced as the destabilization and dissolution of local and family life, and in times of growing economic inequality and terrorism permeating many of the precincts of everyday life, the fevered visions arise from what Baumann calls "the lost/ stolen/abandoned, but undead past, instead of being tied to the not-yet-unborn and so inexistent future."

But what kind of past is that?
Past that does not pass by
Past that has been managed
Past that has not been managed.
Memory, work of mourning,
So many pasts that each one of us
caught up in the whirl remembers differently,
But it is supposed to be just one
the good one, easily told,
ideally the one where everything was fine
Without the masses of the dead
Without those who went under the wheels,
the murdered, those who died miserably
for whom there was no past
and often not even a grave
'Doesn't a breath of the air that pervaded
earlier days caress us as well?'

That was the idea of history: in any given situation it is the last stage of time handed down and passed on, or the most recent episode of the Great Narrative in the form of a television series. It is the reassuring intermediate state in which the lives of the living rest on the works of the dead, and everything that has been passed down is at the disposal of the most recent.

An extreme form of Fascism: the destruction of the past in the course of the struggle for the survival of the fittest, the apotheosis of vitalism, pure technocracy riding roughshod over the interests of human beings. The commemoration only of one's own dead, to whom monuments and mausoleums are erected. (The march to the Weimar Republic began at the Feldherrenhalle in Munich, the site of Hitler's putsch in 1923 and during the Hitler years a funerary monument to his dead

Nazi comrades.) When the hour of victory struck, the "leaders" of the new Europe came together before the new temples for the commemorative tryst, hands covering their privates. Fascism: "One reason it has a chance is that, in the name of progress, its opponents treat it as a historical norm," observed Walter Benjamin. "The current amazement that the things we are experiencing are *still* possible in the twentieth century is *not* a philosophical amazement."

We should not, we are told, be tempted into drawing historical comparisons to understand what is happening today. We need not look to old models of explanation, nor does the reference to the emergence of National Socialism help us. But it may be pertinent to reflect on a few characteristics of classical fascism so as to rule out the possibility that we are dealing with specters of its return, or derivatives of them — new chemical compounds that could be produced out of old elements.

It is certainly not wrong to see Fascism as a politics of dynamism. (Its synonym, after all, was "the Movement," as in "Munich, the capital of the movement.") In addition to its original history of violence, it was a manipulation of the masses powered by the most modern technological means, especially communications technology — today we would call it a marketing strategy. Opponents were deported to the concentration camps; potential comrades were brainwashed by Goebbels' propaganda; the Jews were excluded as foreign bodies and finally destroyed (this, however, was unique). Class hatred was replaced with racial hatred.

Historians deal with content and process; sociologists inquire into the impact on the structure of everyday life; philosophers concern themselves with the ideas involved and place them in the larger perspective of human thinking.

There is agreement on the fact that fascism was a revolution — a revolution of the right, the only one that has ever really succeeded in Germany and caught the imagination of the people. In comparing the two totalitarian movements, Fascism and Communism, the German historian Ernst Nolte sought to provoke, and for a long time he remained a lone voice. But no one can escape the shift of perspective. Anyone who interprets this move as a sign of revisionism, as the philosopher Jurgen Habermas did in the 1980s during the famous *Historikerstreit*, may be right in a humanist sense, but stands is the way of a proper understanding of political dialectics, of the history of modern tyranny. The two dragons of Communism and Fascism faced each other off snorting with rage. For a time, they competed on the world stage in terms of civilization and aesthetics (as was strikingly visible at the Paris World Fair in 1937), until their totalitarian flirtation descended into war.

But the question as to which dragon was the more successful at courting the masses leads us straight back to the present, and to a decision that faces us. And this is where Umberto Eco comes in, with his list of "Common Features of Eternal Fascism," or ur-Fascism, delivered in a speech marking the fiftieth anniversary of Europe's liberation from Nazism and later expanded into a tract called *Il fascimo eterno*. The semiotician takes the broad view without really resolving the contradictions: on the one hand, Fascism is, for him, part of the cult of tradition, a rejection of modernity ("blood and soil," the fixation on race, the condemnation of materialism and the "evils of democracy," the apotheosis of the Führer-state); on the other hand, it relies on the most modern technology and, over time, even adopts an avant-garde approach, such as Futurism, its aesthetic vanguard. On the one hand, he claims, it is a mythical construction; on the other hand, a praxis, based

on action for action's sake and thus materialist through and through. It exploits natural fears about social disparity (based not so much on income as on background and religion) and exacerbates them.

This much is certain: it is a product of nationalism compounded until it is limitless — which is to say, the exploitation of people based on the simple fact of being born in a country where they grew up and were unable to leave (because poverty or loyalty kept them prisoners). Jews who had lived in Germany for generations, for their part permanent exiles, were to remain outsiders forever. Fascism determines who is an outsider and who belongs to the holy community prepared to give their lives for the nation. Fascism is a construction of belonging, the identity of the *Volk*, including its own people living abroad, beyond its frontiers (in Saarland, the Sudetenland, Romanian Germans and Volga Germans, and so on).

It is also the ideology of the have-nots, who interpret capitalism as a conspiracy of plutocrats, millionaires (preferably Jews), but one which can sustain itself only through investment and campaign contributions on the part of big business. It postulates the struggle for survival and a cult of the strong (invoking Darwin in the process) and it doesn't give a damn if the weak go under the wheels (the tank chains) or drown in the sea. It believes in the idea of a "final solution" for all human problems: away with the weak, the sick, the homeless, the feeble, and the mad, and with any intransigent opponents. A constant war is to be fought, but in the end a Golden Age will dawn in which the biologically superior (not the most intelligent) will lead an orderly family life. It dreams of an elite, but its foot soldiers come from the uneducated levels of society; intellectuals, the educated, the cultured are

35

despised ("the lying press"). Fascism needs heroes, and they must be prepared to go the whole way; they train for death, the final battle, and fight it to the last cartridge. Fascism is a male affair. In the will to battle, women become mere accessories. In Fascism the situation of a woman is always precarious: she is there at best to become the bearer of children and a heroic mother (and a concentration camp supervisor), or even a deputy, an official in the right-wing populist camp, an opponent of abortion. Never a feminist, in any case.

For some time now I, too, have been concerned with the issue of the nostalgic appeal of Fascism. Has the specter really been banished and burned like the poor witches of the Middle Ages? Can you in fact burn specters, as the Nazis burned books in Berlin's Opernplatz?

Is there a myth that has remained alive — preserved under the rubble of the Thousand Year Reich — that may yet resurface? Heiner Müller wrote: "as once ghosts came from the past / now they come from the future as well." For a long time I considered such worry to be the product of hysteria. The question of the return of the past only seemed relevant inasmuch as it was gaining traction among historians and sociologists: surely the experts were in a position to say what caused the virulence of these specters, and as long as they could assure me that we find ourselves in a new situation, and that a revival of horrors, whether as farce or operetta, could be ruled out historically, there was no danger. But now I am not so sure.

III

It may be that the German in me is gripped, every now and then, by a certain disquiet. That is why I stare as if transfixed at the twelve insane years of Nazi rule, and constantly immerse myself in the growing specialist literature on the subject. Just

recently I discovered yet another figure in the generation of young careerists in the Third Reich, a certain Franz Alfred Six. He was one of the co-founders of the Security Service (SD) in what became the Reich Main Security Office (RSHA), the ideal henchman to his boss Heinrich Himmler and a resourceful colleague of his almost contemporary and superior Reinhard Heydrich, who was rumored in the inner circles of the SS to be the heir-apparent to Hitler. Six was one of the pioneers of the "scientific" study of journalism, as director of the Königsberg Institute of Journalism. In 1935 his position as a major in the SS moved him ahead of his colleagues and he was appointed head of the press department at the main office of the Security Service in Berlin; his specialty was research into ideological opponents. It was his office that gathered the huge stream of data concerning all those within Germany and abroad who, whether as organizers or writers or publicists, could be defined as political opponents of the Nazi regime.

Six was the man earmarked for the position of Commander of Security Police in London after the occupation of Britain, according to the wishes of his boss Heydrich. The order came personally from Field Marshal Göering. In the event of a successful invasion ("Operation Sea Lion"), not only did all the operational plans of the various services lie ready in the cupboard, but also the lists of all potential opponents to be found on the island. Six's counterpart at the SS, Brigadier Walter Schellenberg, produced the manual for the planned German invasion, which included the infamous *Sonderfahndungsliste G.B.* (Special Wanted List GB) that fell into the hands of the Allies after the end of the war. It came into being mainly owing to the diligence of the pedantic researcher Six and his colleagues. Among the approximately 2,700 dangerous subjects to be arrested after the invasion (Winston Churchill

was enemy No. 1) are the names Alfred Einstein and Sigmund Freud, but also artists and writers such as John Heartfield, Aldous Huxley, H. G. Wells, and Virginia Woolf.

Six was the typical armchair perpetrator, an inconspicuous civil servant, presumably often in plainclothes, with the international daily newspapers in his briefcase. He would hardly have stood out at a meeting of stamp collectors, with his round nickel-framed glasses. The fact that he had quickly risen to a position that earned him a villa in Berlin-Dahlem (on Thielallee), a chauffeured service car, and a private office in the city center with three secretaries (Wilhelmstraße, Prinz-Albrecht-Palais) is a testament to the enormous opportunities for advancement in the dynamic Nazi state, whose inner workings the ordinary German people could hardly envisage. Six was the author of essays with titles such as "The Fate of the European Community" and "Russia as Part of Europe," but his core business was the creation of comprehensive catalogues of enemies. The walls of his Berlin office were papered with detailed organizational charts in which the world was divided into political groups who presented a threat. He shared with Heydrich the fascination with a certain secret-agent aura, copied wholesale from their British opponents.

His ambitious project was to coordinate domestic propaganda with so-called foreign studies, geopolitics, and research into the various categories of opposition (Marxists, Socialists, Jews, Freemasons, Jesuits, and members of religious sects), on the basis of the "scientific National Socialism" that he espoused, which was analogous to the ideology of the revolutionary Bolsheviks. The concept of a branch of sociologically and historically defined research into the enemy came from Heydrich, the "man with the iron heart," as Hitler dubbed his chief functionary at the pompous

funeral ceremony after his assassination in 1942, when he was Reich-Protector of Bohemia and Moravia. Like his boss Himmler, he was convinced that he was exposed to a huge and disparate army of opponents, especially after the occupation of half of Europe in a territory "with 200 million people of foreign origin and race," as Himmler said in his infamous speech in Poznan in 1943. "To win their hearts and minds will only be possible when the great struggle between the two world empires, Germany and England, is decided. Then we will be able to affiliate these thirty million true Teutons to our own nation."

Thankfully, it never came to an invasion of Britain. Instead England was to be worn down by air raids until it would agree to peace terms, so that the Nazis could finally turn to Russia, which posed the most serious competition for dominance in Europe. And after the attacks on the Soviet Union, we find Herr Six at work once again. With his own motorized SS command, he drives just behind the advancing front to be the first of the security police in Moscow, and to secure official archives and files from enemy authorities.

Historians speak of polycracy in the Nazi state — the competing system of different departments that appeared overnight. Later, depending on the general political climate and the whims of the dictator, they were adapted to the real course of the war. For diplomats, academics, journalists, and born bureaucrats of all kinds, this may have been a nightmare, but in the end they all set about competing to fulfill the Führer's requirements. They were trained to "work towards the Führer," a formula found by Ian Kershaw in the files of a Prussian secretary of state.

This was also what Six and his colleagues from the relevant fields set about doing. In one of the units under his command,

the plans for a coordinated Jewish policy were developed, in close consultation with the Gestapo. One of the most prominent of his protégés was Adolf Eichmann, whom Six immediately sent to Vienna after the occupation of Austria in 1938, where he developed the model of a department dedicated to the expulsion and economic plundering of the Jews: the Central Office for Jewish Emigration. At that time various ideas were still in circulation about the resettlement of the Jews: for example, an agreement with Zionist associations, which imagined a separate Jewish state in Palestine, under British mandate at the time. This led to the adventurous "Madagascar Plan," which soon proved unworkable. Adolf Eichmann, later an expert in deportation, and SS-Sturmbann-führer Herbert Hagen, head of the department called "II/112: Jews" in the Security Department's main office, were sent on a business trip to Palestine, on the orders of Six, in order to explore the possibilities of an orderly deportation. (The British authorities allowed them to stay in Haifa for only a day, September 26, 1937, and then expelled them from the country, so they set about seeing what was possible in terms of negotiations on the Arab side in Cairo.)

As little came of this idea as the plans discussed a year later, at the International Conference on Refugees in Evian, to distribute the Jews as asylum seekers on a quota basis to the participating countries. For now, the borders were closed. The ship was full, as the expression goes — a phrase that appears on cue with every wave of refugees everywhere. After Hitler unleashed the war, the course was set for the extermination of European Jews. Soon the trains began to travel to Chelmno, Belzec, Sobibor, Treblinka, and Auschwitz. Six million Jewish people were fed into the killing machine by the those driving the policy of extermination.

The courts later had only to clarify who was directly or indirectly involved in the great crime. Someone such as Six represents the elite of those planners, those who escaped undetected — he represents the cool functionary of the hour. According to Adorno, this coldness was "the basic principle of bourgeois subjectivity, without which Auschwitz would not have been possible." Or, in the treacherous language of the murderers, "You don't fight rats with a revolver, but with poison and gas." (That sentence comes from a memorandum of the Munich SD headquarters to Reinhard Heydrich.)

In the last years of the war, Six transferred to the Foreign Office, and drove right across Europe, where, as eyewitnesses attest, he spent his time barking at employees of the diplomatic missions and at cultural representatives. For his involvement in the crimes of task forces in Smolensk in the autumn of 1941, he was convicted in one of the smaller trials in Nuremberg, but he walked free after four years in prison in Landsberg, uncorrected and undeterred. He never showed up on the list of the principal authors of Jewish extermination and he was overlooked by historians for many years. It was in reference to his type of person that scholars came to speak of "functional anti-Semitism," as opposed to the virulent ideological sort — but the "physical elimination of Eastern Jewry" was nonetheless important enough to Six for him to give a lecture on the subject, though whether he ever got his hands dirty remains unclear. His name stands for bureaucratic preparation; he was one of many "intellectuals" who prepared the ground for mass annihilation. He is an abbreviation, a kind of shorthand for genocide, a fleeting file note and a large amount of paper which in the end led to the most extreme consequences.

After the war, without missing a beat, Six moved into the automobile industry, as a self-employed management consul-

tant. The specialist for lethal propaganda became one of the leading marketing experts of Porsche-Diesel Motorenbau GmbH. Untroubled by justice, he lived through the building of the Federal Republic and, in receipt of a handsome salary, he offered his reflections on "The Nature of Marketing." Fascist propaganda and its methods had its uses in civilian life. An observation from Paul Celan seems apposite: "The germ-free is the murderous; fascism today lies in formal design."

IV

What refuses to give me any peace is the way a people can make themselves totally available to such purposes. Who would you have been in a dictatorship? I do not have to ask myself this question, because I found myself in the middle of a dictatorship and survived it. Instead I must ask myself the question, who would you have been in the Nazi era, and what would you have done against Hitler? For I, too, would have been inundated by the ubiquitous images and words of the Führer. At the time there was no outside vantage point, so it makes no sense to develop a moral standpoint out of hindsight. The principle of contemporaneity, to which we are bound, excludes us from other historical experiences. All I can say is that as a young child I slept through all knowledge of the Third Reich, and someone might have called to me: keep on dreaming, friend! So the only question can be: can anything be learned from this particular history, if anything can ever be learned from the course of history?

This brings me to the present. I would like to come back to the problem of writing, and the question of why one writes in the first place. Why live without writing? I know that most people do not ask that question quite so urgently, but it was a question for me from early on. You wander

silently within yourself for a long time before you get to the point of scribbling a few lines on a piece of paper, at first only for yourself and naturally without the least understanding of history.

Let us hear what the philosopher Gilles Deleuze has to say about it. "Writing is a question of becoming, always incomplete, always in the midst of being formed, and goes beyond the matter of any livable or lived experience." That is the starting point: we do not know what is driving us, and we can only pull together a few phrases to express what happens to us — to form a provisional response. Writing will sum us up, it shortens what we call life, quite inevitably. The philosopher, Deleuze, standing before the Absolute, then makes leaps and bounds, he is immediately in need of transforming himself — into a woman, an animal, a plant, a molecule — and he is right. "The shame of being a man — is there any better reason to write?"

No, there is no better reason, but I will skip over his other thoughts on the subject and stop at a statement that immediately seized me and would not let go of me when I read his *Essays Critical and Clinical* for the first time. "As Moritz said, one writes for the dying calves." He was referring to Karl Philipp Moritz, an eighteenth-century German writer, a contemporary of Goethe, who was the author of *Anton Reiser,* a four-volume life story told from below, from the perspective of a child born into poverty and a strict religious milieu. It was the first psychological novel in the German language.

I was electrified by the quotation and I followed the trail — and came out at myself. My first story, the first piece of prose on which I worked seriously, started at a street crossing in Dresden. I was sixteen at the time. After visiting my grandparents, I was waiting for the tram that was supposed to take me back to the

43

outskirts of the city, to the garden city of Hellerau where we had been living for a few years. I was standing there, staring out into the rain, when a cattle truck roared past me. I will never forget the sight of the animals, the dark eyes of the cows and the calves, the bodies of those destined for death, clearly visible behind the vents of the van. This is where my text began.

I wrote a soliloquy of a cow being taken to the slaughterhouse. It was written in a primitive stream-of-consciousness style, an interior monologue. I did not know James Joyce or Arthur Schnitzler at the time. I knew nothing of the fact that literature was a technique that could be learned and developed. But with that momentary glance, the glint of a pupil, I had recognized myself in that animal, and the prose began to flow. The piece almost wrote itself. It ended after all the stress and terror of being unloaded on the ramp and driven through a tunnel towards the last station of its suffering, with the moment in which the beast felt the bolt gun pressed against its forehead. I knew the procedure because my grandfather, who spent his life working as a master butcher in the Dresden slaughterhouse, once told me about it.

As the ill-treated creature blacked out, the text suddenly broke off. Quite clearly, an unsatisfactory ending for a story. And I felt my failure acutely and buried the manuscript under other half-baked drafts, overcome with a feeling of shame. I was upset because nothing seemed to work. That is the painful secret of writing — I do not know what to expect, just as a laboratory animal during an experiment on himself does not know where the exploration will lead. "To write is not to recount one's memories and travels, one's loves and griefs, one's dreams and fantasies": that I had understood very quickly. "Literature begins only when a third person is born in us that strips us of the power to say I," as Deleuze put it. But

even without such an "I," I was stuck for a long time. "Health as literature, as writing, consists in inventing a people who are missing": Deleuze's remark sounded pompous, but one day its meaning dawned on me — and so, more or less by chance, I fell into German literature as one of many who dream of a people that does not yet exist.

"'You write for the dying calves,' says Moritz." I read the German novel which included that sentence early on, but only came across the specific reference thanks to a French philosopher. It is there, in *Anton Reiser*, but not in quite the same words. This can happen if one simply reads. It is not about the reading itself; it is about stopping at a certain point. And that was the point I had simply passed over. When I returned to the passage, I found more. Moritz continues: "From this time forward, when he saw an animal slaughtered, he identified himself with it in thought, and as he so often had the opportunity of seeing it at the slaughterer's, for a long time his thought was centered on this — to arrive at the distinction between himself and a slaughtered animal like that. He often stood for an hour, looking at a calf's head, eyes, ears, mouth, and nose — and, pressing as close to it as possible, as he did with a human stranger, often with the foolish fancy that it might be possible for him to think himself gradually into the nature of the animal. His own concern was to know the difference between himself and the animal; and sometimes he forgot himself so completely as he gazed at it persistently that for a moment he really believed he had come to feel the nature of the creature's existence. From childhood on, his thoughts were busy with the question — how would it be if I were a dog or some other animal living among men?"

From the philosophers, above all Descartes, who saw animals as machines, bundles of reflexes, creatures without

reason, one can learn what a discourse is. Literature has always had its own discourses and themes. In this it has always been sovereign and did not need to wait for the social sciences. If asked about my poetics, I would say today that we are working towards a photosynthesis of words and images. Words work at transmission; images reach us from a tiny future that quickly becomes the past. I am referring to the images in all media that overwhelm us every day as a shock experience of the real, right down to our dreams. Every day history drives us out of ourselves and confuses our imagination: history — that brutal translation of time into collective experience. The poet is simply one of many; his problem is how to lay aside the pretentions of poetry. In the end he knows only what anyone can know: that there are so many realities, that they exist independently of us and simultaneously, and the same is true of identities. Even if they are dreamers, the poets, the only thing they do not doubt is that the words and the deeds of our predecessors will catch up with us. In this respect they are especially sensitive, specialists constantly in radio contact with the dead.

There is something the sociologists call transgenerational transmission. No one can jump out of their historical time, and no one escapes being formed by history. Once it may have been possible, perhaps, in the unimaginable times of myth and fairy tale, but today it is impossible. In the same way, the much-vaunted attempt to draw a line under legacy of German fascism is impossible, too. There is no question of a flight from time, or of a flight inward —even there history will catch up with everyone. Instead, history as a history of violence passes though time and imprints itself with all its dates on our bodies. There is something beyond literature that calls writing into question. And there is literature that criss-crosses history

in fictions, literature as what Walter Benjamin called a "secret agreement between the past generations and the present one. Doesn't a breath of the air that pervaded earlier days caress us as well? In the voices we hear, is there not an echo of now silent ones?" As if responding to his questions, Ingeborg Bachmann declared: "History constantly teaches but it finds no disciples."

She had experience with this, no doubt: she was a woman. But we cannot know, fortunately we cannot know, whether this is the last word on the matter.

THOMAS CHATTERTON WILLIAMS

Notes on Assimilation

There is a passage in *Democracy in America* in which Tocqueville observes that in a mass of land spanning the width of the continent and extending from "the edge of the tropics" in the south to the "regions of ice" in the north, "the men scattered over this area do not constitute, as in Europe, shoots of the same stock." On the contrary, "they reveal, from the first viewing, three naturally distinct, I might almost say hostile, races." It was not simply the seeming incompatibility of the customs, origins, habits, memories, and laws — to say nothing of class positions — that separated the whites, blacks and Native Americans from one another: "even their exter-

nal features had raised an almost insurmountable barrier between them."

This blunt observation prompts one of the book's more striking asides, in which Tocqueville recounts pausing during his travels at the log cabin of a pioneer in Alabama, on the edge of Creek territory. Beside a spring he encounters a microcosm of American society in the nineteenth century: an Indian woman holding the hand of one whom he assumes to be the pioneer's young daughter, followed by a black woman. The visual descriptions contain within them the two-pronged tragedy of the American experiment: "The Indian woman's dress had a sort of wild luxury" that preserved and advertised what we would now call her totalizing alterity; "the Negro woman was dressed in tattered European clothes," a simulacrum of the people who would never consent to accept her. Both women lavish attention on the five- or six-year-old white "Creole" girl, who already "displayed, in the slightest of her movements, a sense of superiority." The Indian woman, in Tocqueville's words, remained "free," "proud," and "almost fierce"; the black woman was "equally divided between an almost motherly tenderness and a slavish fear." In both cases, the Native and the African, Tocqueville sees a cursed choice — the fundamental inability to overcome "the thousand different signs of white supremacy" firmly in place in the new world. Indeed, "nature's efforts" to draw the oppressed and the oppressors close here only "made even more striking the wide gap between them."

There can be no serious discussion of American reality without the sober — and I would argue, dispassionate — acknowledgment of the historical fact of European dominance, which nearly obliterated the seemingly "unassimilable" Native and for centuries diminished the African to a

49

state of wretchedness and isolation verging on inhumanity. Whereas the European — however lowly or removed from Anglo-Saxon Protestant norms — came by choice to this new land, retaining her ties to the old countries that shaped her, the Native and the African were left with nowhere else to go, not even in the realm of imagination or conjecture. For both, the link between emancipation and assimilation is inexorable. There might be many ways of belonging, but there was no possibility of not belonging in any way. Oppressed or free, they were *here*. Even their exclusion by white society did not release them from finding a way to live in and with America. Their misery was an American misery, as their happiness would be, if ever it were achieved. The question of how to make a genuine home has always been a question of how to blend into a society that was based on your subjection even if — and in fact, precisely because — you coincided with or predated its foundation. Yet there is nowhere else for you to be.

The psychological reality of this dynamic presented itself fully formed in Tocqueville's time and has remained alarmingly present through our own. Waves of "non-white" immigrants — from southern and eastern Europe, from Latin America, from Asia, and even sometimes from the Caribbean and the African continent, too — were able successfully to integrate into the national mainstream to the precise degree that they could distance themselves from the enslaved and otherwise unfree and their descendants already living here, whose social condition, often but not always, manifested itself in those conspicuous physical characteristics set in opposition to whiteness. One thing that united a multitude of disparate groups over the years was a diligence about separating themselves from black Americans. Without being glib about the depredations that other ethnicities endured, the question

of assimilation in America — of the continuous liberation and integration of a plurality of distinct peoples into a reasonably harmonious mongrel whole — has always been a question that turns on the status and fate of the people deemed "black," the hardest case, the ultimate case, who have always been living here and on whose exclusion various other forms of belonging have been based. This is an old tension that remains highly pertinent today. (Consider the extent to which, in just the past year, we have witnessed extremely contentious discussions of the degree to which Latinos and Asians can even be welcomed under the umbrella term "POC.")

The challenge of finding a place in America was both eased and complicated by those millions of immigrants, whose presence necessarily rendered the question less black and white. If America did not begin as a nation of immigrants but rather as "a white Anglo-Protestant settler society," as Samuel P. Huntington maintained (though the Puritans were also immigrants), it certainly became one, a multiethnic society of many origins. By the twentieth century the idea of assimilation was championed widely, if not by the nativists and the bigots then certainly by the striving members of various new and marginal groups themselves. These men and women weighed their own prospects for belonging and flourishing in a country that was being transformed by transplants, from a Europe ravaged by famine and war and persecution, and from the former Confederacy as well, whose recently emancipated population found itself searching north and west for the liberty and the prosperity that was denied them in the South.

The founding text of the assimilationist ideal was *The Melting Pot*, a mawkish play by a British Jewish writer named Israel Zangwill, which appeared in 1908 and popularized

the phrase that is its title (which, not for nothing, would be considered a microaggression today). It told the story of a young Moldovan man who comes to America in the wake of a Russian pogrom that decimated his family. Here he marries the daughter of his family's oppressor (literally) and composes a symphony that is an ode to a future in which distinctive ethnicities macerate into something bold and new. President Theodore Roosevelt attended the premiere of the play in Washington, D.C.

The premise of Zangwill's play was in its titular metaphor: ethnic and religious differences needed to be overcome and annulled, so that a homogeneous social substance remained. Difference was an obstacle to social peace, and the obstacle could be removed by assimilation, which denoted a large or total erasure of prior identities. Assimilation was a particularly ruthless form of integration, because it implied an embarrassment about origins; assimilation was re-invention. "After the prohibition of large-scale immigration in 1924," Huntington noted in 2004 in *Who We Are*, his controversial book on immigration and the American character, "attitudes toward America's immigrant heritage began to change." By World War II, "ethnicity virtually disappeared as a defining component of national identity." The preponderance of assimilation literature — books with titles such as *How the Irish Became White, How Jews Became White Folks, and Whiteness of a Different Color: European Immigrants and the Alchemy of Race* — presented such an optimistic vision of the rise of European immigrants, who had been considered in the nineteenth century not just ethnically but racially distinct from "whites." This literature ignored Asians and did not know what to make of "Hindus" or Arabs. It was mostly silent about the plight of those deemed black, whose existential predicament was dealt with most

powerfully in the literature of "passing," such as Nella Larsen's fine novella of the same name and James Weldon Johnson's subversive faux-memoir *The Autobiography of an Ex-Colored Man.* Yet, as those texts make clear, passing made acceptance a reward for deception. The only way in was to lie, to compromise one's dignity. This was a curse.

Full assimilation for American blacks, until quite recently, was predicated on the plausibility of self-negation. Immigrants, again, were also expected to conceal or to distort their differentiating heritages, but they were rewarded for this more quickly and easily. Anti-black racism has a special force in the panoply of American prejudices. The civil rights achievements of the 1960s were victories of the legal code, but there is more to society than law: informal and much more rigid rules of habit and custom continued to frustrate full integration for masses of black people (and to varying degrees people of Native American, Latino, and Asian descent), except for upwardly mobile and fortunate individuals who have somehow been able to traverse these inherently porous and frequently contradictory barriers. The ascent of those individuals was an important fact about what was possible in America, but it proved less than its celebrants thought it did. These exceptions were not "Uncle Toms," but they were also certainly not the harbingers of racism's end. With the election of Barack Obama to the presidency in 2008, it did seem, however fleetingly, as though the country had finally reconciled itself to a genuinely pluralistic future in which, at last, blacks had been fully incorporated into the multi-hued national family. But the swift backlash and visceral dissatisfaction — first from the right and then from the left — made it clear that the story of assimilation is very much still being written.

What is race? Or, perhaps more to the point, what is racial difference? These are related questions whose answers cannot be simply taken for granted, and must continuously be spelled out in plain, jargonless language. It is obvious that human beings differ physically from each other, in both superficial and significant ways. Groups of related individuals do tend to broadly share physical traits that distinguish them from other groups. "When these physical differences involve skin color, eye shape, hair, and facial features, people have for centuries labeled them differences in race," Huntington explains. "The physical differences exist; the identification of them as racial differences is a product of human perception and decision, and attributing significance to these racial differences is a result of human judgment." What is decisive is not what we see, but how we evaluate what we see. Or, more fundamentally, that we look carefully. Albert Murray put it most succinctly: "Any fool can see that white people are not really white, and that black people are not black."

The story of racial progress has been the story of seeking to render surface-level and socially constructed differences less and less potent — to dilute the self-reinforcing logic of what Barbara and Karen Fields have called "racecraft," and have shown in their monumental book of the same name to be the illusion of race produced by the practices of racism. (In their formulation, racism — the ideological justification for a preceding economic exploitation — creates race, and not the other way around.) We *choose* to organize our polity along crude color categories even though, in point of fact, and even in the time of Tocqueville — as the presence of that Creole girl attests — we have always been a heterogeneous population.

54

The average black American derives fully 20 percent of her DNA from Europe, and almost entirely from that continent's Anglo-Saxon precincts.

Outside of the great modern black writers — Wright, Ellison, Murray, Baldwin — the fact of our biologically assimilated reality has often been given short shrift in the mainstream conversation. (It is not only that "blacks" contain ample amounts of Europe within them; today millions of "white" Americans possess enough Africa in their DNA to have been enslaved under the laws of hypodescent.) It makes many people uncomfortable to discover that we — as a society and as individuals — already are mixed. The discussion of identity, the sentiment of identity, leads very quickly to a need for purity and a desire for exclusiveness. But it is much too late for purity and exclusiveness: we really do contain multitudes.

The first time I read Norman Podhoretz's "My Negro Problem — and Ours" — an infamous and almost unbearably candid essay whose title I am powerless to glance at without cringing — a flash of recognition overtook me almost against my will. I am the titular Negro, that is a fact, though I don't think he has described me fully. He feared me but he did not know me. Yet what vexed him in the '60s, and what still vexes us, is not even race, it is the myth and superstition of color grafted onto social circumstance and class. That is why my all-American experience, in which encounters with racism and the disadvantages of color did not block the uses of my talents or the free expression of my views, has also made of me the authorial "white" liberal whose discomfort cascades into guilt. I reject that guilt just as I resent the tribal and despairing essentialism that describes my trajectory as "white." What I want to be, in the fullness of my heritage, is the disembodied writer seeking, however implausibly, an exit from this whole

55

dishonest bind. "Will this madness in which we are all caught never find a resting-place? Is there never to be an end to it?" Podhoretz raised an important if completely impolitic point: all of us will need to let go of who we were in order to become who we are capable of being.

The question needs to be continually posed: what exactly is being preserved under the guise and the performance of our inherited racial identities — and at what near- and long-term price? This cuts both ways. What do blacks and other marginalized peoples — groups, it is true, that have always been in flux — cling to by asserting continued difference (regardless of what others would assert on their behalf)? Perhaps more importantly, what do majority and normative populations — which is to say, whites — believe they are maintaining through our exclusion, and what has been that cost?

Passing narratives have always carried more than a whiff of shame about them. In recent years, depictions of immigrant and non-white communities in America have increasingly been judged based on the degree to which they allow a given group's distinctiveness to obtain. We hail Junot Diaz for refusing to translate whole blocks of Dominican Spanish just as we praise Jay Z for, in middle age, suddenly deciding to dreadlock his hair. (We don't know what, exactly, to make of a multicultural cohort of congressional leaders kneeling after the death of George Floyd on the Capitol's polished marble floors in vivid kente cloth stoles.) The word of the day is *unapologetic*. This is no doubt an improvement over meek or diminished. It harks back to the earlier slogan of "black pride." And who can argue against pride? There is,

after all, so much for us to be proud of, as the "assimilationist" themselves certainly believe. But what happens when pride is diminished into mere defiance and is pointlessly glorified? It happened in the 1960s and it is happening again. (We need a new Tom Wolfe to bear witness to this era's bizarre new radical chic.) And what happens to a human being when the part about him that he most cherishes is his defiance? Is that not a travesty, too? Defiance is not the same as self-respect — or it is self-respect turned hysterical, a tensed and defensive perversion of self-respect. A human being is infinitely more than a clenched fist.

Embedded in this discussion is the accusation that people who desire assimilation are attempting to escape from who they *really* are. They are said, by the proponents of separation, to suffer from a psychological disorder, a reprehensible lack of self-esteem. Self-hatred is real, of course, and the constant experience of recognition withheld can inculcate it. But there are at least as many reasons for being ashamed of oneself as there are men and women populating the earth — many of which have nothing to do with racial identity at all. And what if that is a false objection in the first place? What if you do not have to erase anything in order to join? This is what Nathan Glazer and Daniel Patrick Moynihan discovered in the early 1960s: that Zangwill wrote for another age, that melting down was no longer necessary to establish a position and a commonality in American society. Indeed, what if we find ourselves in a society that accepts us — that frequently admires us — for *not* erasing anything, that celebrates our particular and original attributes?

The zero-sum negotiation between authenticity and acceptance deserves to end. Based on a misunderstanding of American pluralism, it has caused too much pain. It is entirely

57

possible to remain aware of histories of exclusion and domination without conceding the motive for wanting to assimilate going forward. What we need is a new discourse, and beyond that, an infinitely more secure means of imagining ourselves and each other, one that abhors unambiguous and intimidating notions of loyalty and disloyalty, and allows for a kind of national project that does not reject one's inherited culture but which, on the contrary, understands it as but one arrow in a shared quiver — a single source of strength among many. The most effective way to combat racism is precisely in the name of pluralism.

What we need is an unpejorative understanding of assimilation that views it simply as a means of experiencing the capaciousness of the world. Assimilation is a welcoming impulse, an expression of nothing more sinister than curiosity. One wishes to assimilate because one wishes during this fleeting life to maximize one's human potential. But the contemporary hyper-focus on racial difference, and above all on the singular, nefarious power of whiteness, frowns on curiosity and prohibits us from forging the inclusive societies — and the inclusive individuals — that we must ultimately will into existence. While it is true that we may have been an Anglo-Protestant culture at the founding — and I am as right to say "we" as you are — we are far beyond the point of no return: we are now, or very soon will be, a minority-majority country. Such changes to the country's hardware require a software update — one that incorporates all of these all-American differences. This in turn requires the confidence to state a basic truth: the things that one wants to acquire by assimilating or integrating into the mainstream — or, ideally, by forming a new and holistic core culture — are not things that white people *own*.

The essence of Homer or Plato is not whiteness. When a black man reads the *Iliad* and the *Republic,* he does not steal them from anybody, or trespass into a territory where he does not belong. Baldwin was liberated by the knowledge that Shakespeare also belonged to him. I relish the thought that Kafka and Borges and Dostoyevsky are mine. Yet we are moving, at warp speed, away from such generosity of spirit — away from an appreciation of the blessings of universalism, and of the extent to which they need not threaten the particular. At New York's elite Fieldston School, to cite but one depressing recent example, even physics has become an identity-based power struggle. "We don't call them Newton's laws anymore," an upperclassman confided to a journalist. "We call them the three fundamental laws of physics. They say we need to 'decenter whiteness.'"

Such a capitulation to racecraft rigs the discussion from the start. Assimilation — or genuine personal cultivation and interpersonal toleration — is a matter of addition, not subtraction. It hungers for more. Newton's genius was not white, it was human. (And it may have been only his own. Think of all the white people who were not Newton.) When we acquire the ability to see the physical world as he did, we transcend a provincial identity, ours and his, an obsession with provenance, to commune with what is objectively true. We are, every one of us, lifted up. Anyone — black or white or brown — who would assert that the notion of Newtonian physics "privileges whiteness" is only betraying the thinness of their own self-understanding.

Behind all of these debates, however high-minded, there always lurks the dire question of sex. Who sleeps with who? Who marries who? Whose physical features, superficial as they may be, will wax and whose will wane? These are primal and delicate questions that do not usually inspire rational analysis. And, beyond that horizon, to whose gods or idols will we continue to bow our heads, if we still bow them at all? In France, where I live, a proudly "universal" culture has been reckoning with the pressures of particularism — specifically, with how much latitude it can afford to extend to a young Muslim population that has grown more desirous of the veil the more it has been commanded to stash it away. Here, too, the question of assimilation — of how to make the de facto reality of a multiethnic society work in theory — has begun to rage again. Where America had its melting pot, Paris-centric France could point to *le creuset français,* which transformed both paupers from the provinces and immigrants from the colonies into raceless Frenchmen equal within the Republican ideal. Assimilationism was the public philosophy, and not much attention was paid to the matter of how much in the way of cultural and ethnic and religious self-immolation the state could legitimately demand.

As early as the 1970s and 1980s, the assimilationist tradition faced a "differentialist" reaction. A popular slogan at the time was the *droit à la différence.* As in America today, such fervent identitarian sentiment in France gained ground on the right as well as on the left. The philosopher Pierre-André Taguieff has written extensively about the multiculturalist "new right" that emerged around the reclusive and prolific thinker Alain de Benoist, whose ideas have recently migrated to America and inspired the likes of Richard Spencer and other organizers of the disgraceful march on Charlottesville. What was genuinely

novel in the French formulation, however, was the xenophilic, counterintuitively antiracist and even egalitarian turn of Benoist and some (but not all) members of the *nouvelle droite*. Cultural and racial differences were taken as paramount and practically sacrosanct, as the reactionaries sought to preserve abstract collective identities — and communal differences — that they perceived as threatened by mixing of any kind. The political rise of Jean-Marie Le Pen shifted the terms of debate. "As a result," the American sociologist Rogers Brubaker notes, "the moral and political ambiguity, and the exclusionary potential, of culturalist differentialism were brought into sharp focus — indeed, much sharper focus in France than elsewhere."

In the wake of an active political right, the slogans had to change. Universalism had to be reaffirmed, politically and polemically. There was less talk in the mainstream about the "right to difference" and more about the right to *resemblance*, or better yet *indifference*, which is to say the right to be treated like everyone else. (Philosophers since the Enlightenment have noted that indifference is a form of toleration.) It seemed that French society was intensely focusing again on the assimilationist goal. That is why the recent spread of identity politics in France has come as such a shock — seemingly another damaging import from overseas. *Les Americains!* It is certainly true that French political culture does not yet possess a natural and homegrown understanding of pluralism.

In the United States, the situation is different. We are losing any natural understanding of universalism. At least since the second Obama term, when the Black Lives Matter movement took off in earnest, there has been, on the consensus-shaping left, a pronounced rejection of assimilation as a fundamentally anti-black ideal. "Assimilationist ideas are racist

ideas," Ibram X. Kendi has ruled in his Manichean book *How to Be an Antiracist*. "Assimilationists can position any racial group as the superior standard that another racial group should be measuring themselves against, the benchmark they should be trying to reach. Assimilationists typically position White people as the superior standard." This is a sorry misunderstanding of the reasons for assimilation. (Who wants to be white?) It is also the hackneyed accusation of race treason.

In a slim book that has been anointed, in multiple didactic iterations, the definitive tool for everyone from toddlers to CEOs, Kendi builds on the success of recent "afropessimistic" discourse, and on the fashionable adulation of (early) Malcolm X over Martin Luther King, Jr., and traces the failure to emphasize cultural specificity and the maintenance of origins back to W.E.B. Du Bois. "The duel within Black consciousness seems to usually be between antiracist and assimilationist ideas," he instructs. "DuBois believed in both the antiracist concept of racial relativity, of every racial group looking at itself with its own eyes, and the assimilationist concept of racial standards, of 'looking at one's self through the eyes' of another racial group — in his case, White people. In other words, he wanted to liberate Black people from racism but he also wanted to change them, to save them from their 'relic of barbarism.' Du Bois argued in 1903 that racism and 'the low social level of the mass of the race' were both 'responsible' for the 'Negro's degradation.'" Kendi continues by citing the master without commentary, wagering that the cultural mood has shifted enough for the offense in DuBois' words to be obvious to his readers: "Do Americans ever stop to reflect that there are in this land a million men of Negro blood... who, judged by any standard, have reached the full measure of the best type of modern European culture?" (Du Bois was

marveling about a population still living with the memory of slavery.) Kendi expects you to recoil from those words. When I read them, I cheer.

Kendi's solution to the enduring reality of inequality in the absence of any assimilationist objective — which has become its own orthodoxy now — is no solution at all. The point is not only that perfect separation is impossible, and would hobble the black community. It is also that Kendi is committing the very sin he has made a career of bemoaning: race-based separatism. Insisting on the perpetual and unalloyed distinctiveness of blacks (or any other historically marginalized group) is as exclusionary as ignoring us had ever been. We are stuck, then. As he argues depressingly elsewhere in the book, "The only remedy to racist discrimination is antiracist discrimination. The only remedy to past discrimination is present discrimination. The only remedy to present discrimination is future discrimination." Orwell would have loved those sentences. Kendi's vision of American society is a perpetual juggling trick in which the balls may never come down.

63

Cultural relativism is bad for culture, because it looks suspiciously on outside influences. It is tribalism through and through. Like all tribalism, it is easily threatened by others and it threatens others easily. What the proponents of this limiting worldview fail to grasp about assimilation is that, even when it is desired and achieved, it can only ever be *partial*. Human beings do not and cannot replace each other. When they undergo changes, and accept influences, there are continuities and discontinuities. The differentialists — whether white or black, left or right — have less to fear than they imagine.

The differentialists loathe a genuinely multicultural society because they are terrified of a genuinely multicultural individual. They lay claim to the entirety of their sons and daughters, every aspect and every dimension of them. They want them to be completely faithful and completely monolithic. They fear that the world is nothing but a slippery slope to defection and betrayal. That is why they subsume the individual, with all her wants and needs, with all her decisions and acts, with all her capacity to self-create, beneath the collective. The individual, except as a loyal representative of her origins, is effaced and forgotten. Individualism itself is regarded as a corrupting deviation from community, which is finally all that matters.

Why are they so afraid? Perhaps they have not transmitted enough of their tradition to sustain their children within it, so that they may carry it into the "outside world" with confidence. Perhaps, ironically, it is their tradition, and its capacity to meet the modern world, in which they have insufficient faith. Either concern is overplayed. Inherited identity, in all its elements, is never completely alienable. There is no such thing as perfect assimilation, nor should there be. We are all amalgamations, whether we choose to recognize and to cultivate this inner diversity or to stifle it. The notion of hybrid vigor is useful here. Arguing for segregation — whether physical, mental, ethical (one set of standards for you and yours, and another for me and mine) or cultural — is arguing for weakness, or admitting to it. To equate assimilation with racism is to shame and intimidate us out of our birthright — as much a birthright as any authenticity could be. The world and my father's house: they are both mine.

If we can intuit why people overemphasize their historical glories, we might also pause to ask what makes them so anxious

about loosening or even severing the bonds of past adversity. Why can't they take yes for an answer? (When it is given, that is. There is still far too much no.) In any case, it is clear that an obsessive focus backward — whether indignant or prideful — hinders the necessary forward motion. It is impossible to transcend racism by doubling down on racial differences. The problem with the anti-assimilationist program of the contemporary left is not that it rejects a diminishing movement by non-whites to an Anglo "core culture" from which everything else is a deviation from the norm, as in Tocqueville's day. The problem — which is mirrored and even amplified in the regressive populism of a myopic Republican right — is that it fails to meet the imaginative task at hand. To make our future society not just function but flourish, we will all have to assimilate into something outside ourselves, something based on all of us that is entirely new.

65

ANITA SHAPIRA

The Fall of the House of Labor

In 1927, there was a deep economic crisis in Palestine. Unemployed workers would gather in a workingmen's club in the cellar of Beit Brenner in Tel Aviv to bitterly vent their difficulties. One evening, David Ben-Gurion, then General Secretary of the Histadrut (Zionist Labor Federation in Palestine), addressed them about the future of Zionism and the primacy of the Jewish worker's role in building the land of Israel. A cry of anger erupted from the audience: "Leader, give us bread!" Ben-Gurion replied: "I have no bread. I have a vision."

This episode provides the terms for understanding what has happened to the Labor movement in Israel. There is no

famine in the country now, and until the advent of the corona-virus there was no economic distress — but neither is there a vision, or anyone worthy of being described as a leader. How did it come to pass that the movement which built and led the nascent Jewish state from 1935, and the actual Jewish state until 1977, and later wrote several important chapters in Israel's history, evaporated into a handful of mediocre Knesset members who were attached like a final appendage, almost vestigially, to a parity government headed by Benjamin Netanyahu, who was indicted on charges of corruption? The party that built a nation, established a state, and gathered the Jews in their ancient homeland seems to be dying slowly, unattractively

In the beginning there was the vision: The Jewish state and the Israeli nation would be built from the bottom up, in a gradual process of shaping society and culture. It was supposed to be a project that combined nation-building and the creation of a new society, a national goal and a social goal. It was to be carried out by Jewish workers animated by universal ideals in a particular place.

The Labor movement did not stem from the Jewish proletariat in Eastern Europe. That proletariat was not enthralled by the Zionist idea. They preferred to find refuge and a better life in America. Of the few who were attracted to the Zionist idea, most were from the lower-middle class, semi-educated, with ties to Jewish tradition and culture, lapsed yeshiva students who adopted the idea of national and social redemption. They fell under the spell of socialist doctrine, and were motivated by the aspiration to establish a state for the Jews in Palestine. It was a dream that seemed highly unrealistic, and certainly unparalleled in the world: a nation exiled from its homeland for millennia returning to the same land.

They drew their socialism from the Russian tradition — the Narodniks, a movement that "went to the people," that sought to reform the Russian nation, and placed the requirement to live in accordance with one's beliefs at the top of its value system. Believing in socialism and occasionally taking part in demonstrations was not enough; one was expected to live every day in accordance with one's convictions. When applied to Zionism, this high ideal of philosophical consistency made it inappropriate to advocate Zionism while continuing to live in the Diaspora. It was similarly inappropriate to strive for a life of equality and continue to live as a capitalist. The demand for overlapping belief and action was unique to the Russian Narodniks, and passed from them onto the leftist Zionists, who would come to call it "realization" (*hagshamah*).

This principle, which is typical of small sects, was supposed to apply to a wide public, an entire society, in Palestine. The extreme expression of this conviction was the work of a small minority who went to live a life of equality on kibbutzim, but in the wider circle of workers who were members of the Histadrut impressive efforts were also made to create equality. Thus, for example, the pay scale in the Histadrut was determined in accordance with the number of people in the family, not the person's standing in the functional hierarchy: according to legend, the person serving tea at the Histadrut, who had a big family, earned more than the head of his department. A Histadrut member was entitled to establish a cooperative in which all the members were partners, but not to employ hired workers, since that was considered exploitation. The aspiration to equality sometimes manifested itself in extreme ideas, such as Ben-Gurion's proposal in 1923 that the Histadrut become the employer of all workers and pay

them an equal salary — a general commune. The proposal was rejected as impractical.

The utopian aspiration to an egalitarian society lent added value to the aspiration to establish a Jewish state in Palestine. It connected nationalism to the lofty ideals that were exciting Western intellectuals at the time. Between the two world wars and in the decade following World War II, "progressive" circles viewed the Soviet Union as a beacon in a world where fascism and Nazism were running riot, where human dignity was being trampled underfoot, especially the dignity of the Jews. In the West, Russia was perceived as a country that granted Jews equal rights and equal opportunities, and where anti-Semitism was forbidden by law. It was only in retrospect that many people in the West recognized the horrors perpetrated, not least against the Jews, by the Soviet regime. (There were some, dissidents and scholars, who knew of the horrors in real time, and there were those, true believers and ideologues, who denied them.) But at the time when the foundations for the Jewish national home in Palestine were being laid, Russia still served for many people as a prime example of the feasibility of establishing an ideal society. This mixture of socialism and Zionism in the Labor Movement served as a force for recruiting the idealistic element among young Jews in Eastern Europe. Socialism conferred moral worth and universal meaning upon a national movement, which, from its inception, was accused by its critics of undermining the country's Arab residents. Belonging to a rising global movement for justice ameliorated the harsh life that Jewish workers in Palestine encountered every day. This was worth waking up for in the morning.

The Labor Movement created an entire philosophy of life that shaped the culture, everyday behavior, folklore,

ceremonies, and myths of the growing Jewish community in Palestine. A "New Jew" — that was the idea. This Jew was a free individual who spoke and read Hebrew, was proud and self-reliant, and prepared to defend himself and his brethren. Added to this was the demand for a life of physical labor. Since the late nineteenth century, many Jews had internalized the anti-Semitic argument that they were parasites who fed on the work of the non-Jews among whom they lived. Although there were in fact Jewish farmers, and a great many Jewish craftspeople, this did not prevent them from being cast as parasites. Only the return to the land, the early Zionists believed, to working the soil in the homeland, to "productivization," could engender a New Jew, and erase the stain on the image of the Jewish people.

This aspiration was congruent with the needs of the Zionist movement to settle the land, and also to provide employment for those coming to the country, which had no industry or commerce to speak of. The default option was agricultural work, which was grueling, tedious, and financially unrewarding. The Tolstoyan Zionist thinker A.D. Gordon's notion of the "religion of labor" provided emotional compensation for the hardship, the boredom, and the poverty in the fields: the New Jew returns to the land, from which he draws vitality and virtue. He (and she) redeems the land and the land redeems him. Thus, hard work was presented not as a constraint or an obstacle, but as an ideology, a spiritual and social opportunity, a philosophy of life. Yitzhak Tabenkin, one of the leaders of the Kibbutz movement, described the New Jew as carrying a hoe in his hand and a rifle on his shoulder.

The equal society and the New Jew were enfolded in social solidarity and assisted by an ideological system. Poems, songs, novels, and innumerable speeches and articles underscored the idea that the Jewish society being built in Palestine is a just and

moral society that seeks to right a historical wrong perpetrated against the Jewish people for centuries. It also served as justification for the fact that Jews were settling in a country inhabited by another nation that steadfastly refused to share it with them. There was, of course, a measure of self-righteousness in this self-image, but it enabled the so-called "Arab problem" to be disregarded for many years, and when it was no longer possible to ignore it, in the 1930s, the new awareness of the problem was accompanied by the conviction that "we" were in the right, "they" were the aggressors, and "we" were merely defending ourselves.

The Labor movement skillfully transformed adversity into a virtue and necessity into a moral advantage. Necessity created abstemiousness, and ideology imbued modesty and poverty with pride. When members of the youth movements sang about their uniform, "The blue shirt is without a doubt superior to all jewelry," it was an expression of a deep faith in simplicity. Ben-Gurion made the unbuttoned collar a characteristic of Histadrut members, in contrast with the bourgeois suit. Of course there were Jewish bourgeois and even industrialists in the land of Israel at the time, and also workers who longed to live in bourgeois Tel Aviv, but the dominant ethos was one of modesty, toil, solidarity, and a willingness to enlist in great national undertakings.

In spite of economic hardship, the culture that developed in the country was high culture. Almost miraculously, people who had come from the small towns of Eastern Europe, where books were the only refining cultural force they knew, discovered in the land of Israel an aspiration for beauty. This manifested itself in cultivating gardens in the kibbutzim, where there was barely enough to eat; in the reproductions of Van Gogh's *Sunflowers* that were hung in the homes of kibbutz

71

and moshav members; in lending libraries that operated in all the workers councils; in music classes, choirs, and concerts held near Maayan Harod in the Jezreel Valley; in workers' housing projects in cities built in the Bauhaus style; in the education system and the non-formal education of the youth movements; in the establishment of a national theater and many publishing houses. The aim was to establish a cultivated society possessing a spirit of service, a task-oriented society that also prized theater and art. And all this was supported by a social welfare system: a sick fund assuring medical care for every worker and an employment bureau that allocated work (and included new immigrants, in contrast with the particularistic interest of the local workers) and a guarantee of a pension fund, and much more.

The above description idealizes a past that was not ideal. There was a degree of coercion in the imperative, "Jew, speak Hebrew!" which made it difficult for new immigrants to integrate into the cultural milieu. There was also coercion in the obligation to be a Histadrut member, which implied acceptance of the principles of socialism, in order to benefit from social welfare programs. And there was always opposition from right and left to the pragmatic compromises dictated by Mapai (the Hebrew acronym for Workers Party of the Land of Israel), which was established in 1930 and expressed what its members viewed as a version of Rousseau's "general will" in Jewish Palestine. As long as the goal — a Jewish state — was the beacon lighting the way, the flaws of a bureaucratic system and the inequities of favoritism were regarded as minor blemishes in an otherwise glowing picture.

All this changed after the establishment of the state. The writer Amos Kenan once exclaimed: "The state destroyed my homeland!" He meant that the landscape of Mandatory Palestine, in physical and human respects alike, was becoming extinct. The Arab villages that blended with the hilly landscape were destroyed, and were being replaced with ugly immigrant housing projects that were mutilating the land he loved. Mass immigration subsumed the old Yishuv (the pre-state Jewish community in Palestine). There is a moment in *Road to Life*, the novel by the influential Soviet educator Anton Makarenko, in which he and his students — abandoned children and adolescents — are about to move from their small and intimate educational establishment, which had nurtured their identity, into a grand institution in which they would become a minority. Makarenko wonders whether his slender disciples, whom he had educated in his collectivist spirit, would be able to prevail over the majority, or if the opposite would occur. This resembles the situation that developed in the State of Israel in the 1950s: within three years, the Jewish population had doubled, and this was just the beginning of an extraordinary process of growth and development. The new state's slogan was "the melting pot": just as immigrants to the United States adapted and integrated themselves to the existing ethos, immigrants to Israel would do the same.

Deep down Ben-Gurion had misgivings, which were expressed in the early 1950s when he wrote that for generations the Jewish people had dreamed, anticipated, and yearned for a state, but it had never occurred to anyone that when the state was finally established there would not exist the nation to build it. He was alluding, of course, to the catastrophe of the Holocaust. He needed a critical mass of Jews in the country, and so he supported mass immigration, and fought against

his advisors who sought to limit it for economic reasons. But like Makarenko, he wondered who would subsume whom. He searched for the miraculous formula that would transform what he called the "torn remnants of tribes" into a nation.

The old ethos did not stand a chance in the new state. The veterans, the standard bearers of the ethos of modesty, physical labor, and high culture, had become bourgeois. The heroes of the War of Independence, of the struggles against the British, were weary. They now favored a less collective and more individualistic society. Very few of them responded to Ben-Gurion's calls to enlist in the work of immigrant absorption. Inertia gripped the old pioneers. Even prior to statehood, many of them would have preferred a more comfortable life, less spartan, but it was impossible in the limited economic frameworks of the Yishuv. Now, as the economic horizons expanded, skilled workers, doctors, teachers, and engineers rebelled against the policy that sought to maintain low wage gaps between manual labor and the liberal professions.

It was a rebellion against the egalitarian state. Equality can be sustained in a small, relatively intimate society in a situation of struggle. Now that the political mission had been accomplished, and the state was established, many people wanted to loosen the pioneering tension. Socialism was still alive, but it had softened and become middle-class, and most importantly it had shrunk into increasingly smaller circles of people who had come of age in Yishuv times. There were still youth movements, and new kibbutzim were still being founded. The Nahal (Fighting Pioneer Youth), a kind of statist continuation of the Palmach (an elite military force in pre-state Israel), was very popular. The songs of the military choirs and bands nurtured the ethos of toil and task, of the willingness to make sacrifices for the greater good. But electric refriger-

ators and washing machines began appearing in homes, and towards the end of the 1950s the standard of living rose. Can an ethos of simplicity and self-abnegation be maintained in an affluent society?

Concurrent with the relaxation of the "veterans" — a category that encompassed anyone who came to Palestine before 1948 — the new immigrants arrived. In the first few years they were mainly Holocaust survivors from Europe. They came after years of war and destruction and displacement, and their landing in the immigrant camps or temporary settlements was relatively soft, since they came from nothing, with nothing, and knew they would have to rebuild their lives. These survivors accepted hardship because they were accustomed to hardship, and also because they understood what the absorbers said — in Hebrew, Yiddish, or Ladino. After them came immigrants from the Arab countries, the Mizrahim. Some of them, like the elites of Iraqi Jewry, left behind fine homes and a good life, but after a flight of just a few hours they transitioned from a life of prosperity and stability to one of difficulty and humiliation. They did not understand the absorbers and the absorbers did not understand them.

The Ashkenazi-Mizrahi rift was born in the 1950s. There was discrimination in favor of Ashkenazim and against Mizrahim. And there was also the standing sociological insult: the melting pot policy assumed that the Mizrahim had to change and adapt themselves to the existing Eastern European socialist ethos. This had implications, among other things, for the foundational status of the father, the traditional family patriarch: he abruptly lost his standing. And there was also the issue of religion.

The Zionist movement internalized the religious narrative of the land of the forefathers, the return to Zion, and the

promised land. The entire Zionist story is founded on it. On the other hand, it made every effort to remove God from the picture. Zionism represented a defiant opposition to historical quietism, to waiting for a messiah to come and save the people of Israel, and instead it sanctified action, the human ability to change the course of history by sheer force of will. The clash between observers of the Jewish faith and secular Jews, who challenged the traditions of the forefathers, began at the inception of Zionism. Herzl did not want to rule on this issue, which could have torn the movement apart. Ben-Gurion, too, wanted to remove the subject of religion from the agenda. He refrained from creating a constitution, recognizing that the dichotomy between secular and religious was a highly charged issue, which was liable to lead to a culture war in a state that was barely standing on its own two feet.

The spirit of compromise expressed in the Declaration of Independence — the expression "Rock of Israel," which satisfied secular Jews since the Hebrew phrase could be interpreted literally as "the might of Israel," and also religious Jews, for whom it was a traditional allusion to God — did not recur in the early years of the state. Most of the government crises revolved around issues of religious or secular education in the immigrant camps and settlements, the public observance of the Sabbath, and the definition of who is a Jew. So long as there was no state, it was possible to live with the dissonance between the secularism of a socialist movement and the moderate religiosity of the Mizrahim. The arguments after the establishment of the state revolved around legislative issues, and mainly touched on the education of the new immigrants from the Arab countries, most of whom were religiously observant.

The attempt to shape the Mizrahim in the image of the

New Jew failed miserably. The New Jew was a program of Westernization that many Mizrahim considered insulting and an obstacle to progress. There occurred a traumatic encounter between two different ideas of modernization. On the one hand, the conservative Mizrahi version sought to maintain the existing order, with gradual adjustments: openness to new professions, economic progress, education, as practiced in the Maghreb countries by the Alliance Israelite Universelle, the French-Jewish organization founded in the nineteenth century to protect the rights of Jews. The Mizrahi intelligentsia sought to climb the social ladder rather than enlist in revolutions. It tried to preserve the patriarch's standing and family honor, and it viewed the extended family unit as its reference group. It strove to preserve what had been its way of life in the past, though it did not stubbornly resist Westernization. It did not want to lose itself. The other view of modernization, by contrast, was the melting pot ideology, which viewed the young generation as the agents of socialization, and regarded the closely knit family with reservations, as a hinderance to social development, and religiosity as one of the elements preventing integration into modern society. There was something aggressive and invasive in the speed with which the veterans attempted to impose change upon the newcomers. What should have taken at least two generations, they tried to implement in Israel in a decade.

The predominantly Ashkenazi veterans — with their ideals of simple dress, restraint in expressions of joy and sorrow, and personal modesty — would come to be called "tight-asses" by Mizrahim. In fact those were traits and customs that did not typify Eastern European Jewry, but rather the socialist tribe in Israel. It was only in the quasi-ecstatic circle dancing of the "New Jews" that the shell of restraint sometimes cracked.

Otherwise they propounded an austere code of conduct. Accepting collective discipline and subordinating the individual to the community, an ethos that was pronounced in the kibbutzim which were considered a model, was the result of this code. How else are we to understand the willingness of mothers to accept the judgement of the group and relinquish caring for their babies?

Mizrahim, by contrast, loved elegant dress — the tailored suit was a status symbol. They loved overt emotionalism, vociferousness, and *haflot* (feasts). In their view, these were all indicators of familial *joie de vivre* and entirely appropriate behavior. In time, they would become the external expressions of protest against the "appropriate" culture that others sought to inculcate in them. In contrast with community as a coalescing unit, they nurtured the extended family, devoutly honoring father and mother. They did not strictly observe the commandments — soccer games on the Sabbath were the norm — but they did observe tradition, and over time the influence of religion gradually increased. Religion became a badge of their identity.

One of the main causes of the rift between Ashkenazim and Mizrahim was their conflicting attitudes to manual labor. The lionization of work that was a central element of the ideology of the New Jew was, for Mizrahim, a symbol of discrimination and subordination, which made them the hewers of wood and the drawers of water for the Jewish state. The predominantly Mapai establishment viewed the construction of hundreds of so-called immigrant *moshavim* (collective villages), and the allocation of some of the means of production to them, as a resounding Zionist success. The immigrants, however, were not asked if this was what they wanted. They would have preferred Tel Aviv over the geosocial periphery,

78

and the fact that they were sent there without being asked, without anyone taking the trouble to explain to them, in their language, what awaited them, created a residue of bitterness and hostility, for which the economic success of the *moshavim*, and the integration of the younger generation into politics, were no compensation. Manual labor in forestry, which the immigrant camp residents were sent to do since they did not have a profession, or because there was no other work available in the difficult early years of the state, again created a situation in which Ashkenazi managers employed Mizrahi laborers.

The government's egalitarian policy — manifested in the austerity program that it implemented in the early 1950s, which rationed essential commodities according to family size, like similar programs implemented in Britain after World War II, and maintained low wages for skilled professionals — was not perceived as especially egalitarian by the new immigrants. They encountered a bureaucracy that was staffed by predominantly Ashkenazi veterans, who did not speak their language and, in the way of bureaucracies, behaved condescendingly. The old workers had become officials. When they preached about the dignity of physical labor, it sounded hollow, coming as it did from people working in a Histadrut or government office. The daily encounter with the clerk in the labor bureau, the receptionist in the sick fund clinic, the teacher, and the school principal was a dialogue of the deaf. Moreover, in the 1960s, a big economic gap opened up between Ashkenazim and Mizrahim. The general rise in the standard of living created the so-called "Second Israel," which was poorer and less educated, and the patina of egalitarianism had eroded and excluded them. After the "Black Panthers" protests during Golda Meir's government, significant reforms were implemented to reduce

the social and economic gaps, and continued until 1977. But it was too late. Inter-ethnic bitterness and umbrage became one of Israel's formative components.

Today, when identity politics ostensibly suspend the contrasts between absorbers and absorbed, between accusers and accused, the difference between Mizrahim and Ashkenazim, which, to a great degree, is identical to the difference between right and left, seems to have always existed. When Ben-Gurion was in power, and also during Golda Meir's premiership, Mizrahi support for Mapai, which went on to become the Labor Party, was taken for granted. For several decades, Menahem Begin's Herut Party, which after the Yom Kippur War in 1973 would become the Likud, was a minority party in Israel's political landscape. The first generation of Mizrahim in Israel accepted the political left, although it rejected the ideal of the New Jew. Despite the discrimination, there were many mixed marriages between the offspring of immigrants from Europe and the Middle East. It was only in the 1970s, after the Yom Kippur War, that the tectonic shift began. This raises the question of whether the identity politics currently dominating the political arena was inevitable. Over the years, the demographic scale has always tipped in favor of Mizrahim. But does that mean that the division between the political left and right should be based on ethnicity?

Historically, the line separating the Jewish left and the Jewish right in Palestine did not revolve around political issues. Although the left was indeed more moderate and pragmatic in its attitude to the issue of the country's partition, the aspiration shared by all was a Jewish state in the Land of Israel. The

left was not "dovish" in today's terms. The differences between left and right were more in the sphere of social and economic worldviews — between socialism, a workers' society, a large public sector, and massive state intervention in the economy, on the one hand, and capitalism, individual initiative, and minimal state intervention in the economy, on the other. This was the situation during the Yishuv years, and also, with minor changes, after the establishment of the state. The issue of "Greater Israel" was not on the agenda: when Gahal, the alliance between Herut and the Liberals, was established in the mid-1960s, which marked the conservative Herut's emergence from the political isolation imposed on it by Ben-Gurion, the Liberals in the coalition demanded that the issue of territory not be included in the party's platform, a condition that Begin accepted. Mapai was perceived as an activist national ruling party.

The transition in the definition of the Labor movement from socialist to "dovish" began gradually, almost impercep- tibly. The shift started in 1967, after the Six-Day War. The messianic enthusiasm over the renewed connection with the expanses of the land of Israel swept up the vast majority of people in Israel. The Movement for Greater Israel was established by people from the left, including notable writers such as S.Y. Agnon, Haim Gouri, Nathan Alterman. In its early days, Gush Emunim, or the Bloc of the Faithful, which would become the nucleus of Jewish settlement in the West Bank, also included secular Jews, and even people from the left. Jewish settlements were established in the "territories" during the Alignment government (a new term for the Labor movement) and were justified for security reasons, but once out of the bottle the messianic demon could not be put back. At the same time, the standard of living rose and the barriers to employing Palestinian laborers were breached — the aspiration of the

Jews for productive work, as opposed to business and finance, was cast aside, as was the romance of manual labor. The former pioneers became contractors and entrepreneurs. The economic frameworks expanded, and as the standard of living continued to rise, socialism receded.

The transition from a leftwing government to a rightwing government in 1977 was experienced as an earthquake by the left, which had always regarded such a turn of events as inconceivable. Of course it was to be expected that the rule of the Labor Party would come to an end at some point. No political power is eternal, and prolonged rule is always accompanied by corruption. The Labor Movement was no exception. After the debacle of the Yom Kippur War, with the removal of familiar and charismatic leaders from the political arena, namely Golda Meir and Moshe Dayan, and the emergence of a duo of leaders who grew up in Israel, Yitzhak Rabin and Shimon Peres, who competed over the leadership, a political turnabout was to be expected. But when it occurred, it left Labor astounded.

When the venerable Labor politician Yitzhak Ben-Aharon announced, after the traumatic election of 1977, that he refused to accept the decision of the people, he demonstrated the tragic disconnection between the old left and the new Israel. Begin was a leader who knew how to pluck the right heartstrings, exploiting ethnic differences and old rivalries between employers and employees, between kibbutzim and their neighboring development towns, between the traditionalism of the Mizrahim and the secularism of the left. Begin — who, immediately after the election, appeared in an elegant suit at the Likud Central Committee, put a yarmulke on his head, and said the *Shehecheyanu* blessing — presented himself and his movement as representatives of those whom the Labor

Movement had rejected, from the old members of the Irgun to the Ashkenazi middle class and, most momentously, the Mizrahi communities. It was an "alliance of the downtrodden" against those who had considered themselves the keepers of the general will of the people in Israel.

Yet the political downfall of Labor did not lead to a resurgence, to an attempt at re-invigoration, to a closing of ranks. Instead it provoked a long lethargy accompanied by a helpless rage. Everyone talked of the need to "go to the people," to conduct in-depth ideological self-criticism, to educate the people so that they would come to understand their great mistake. The question was, who would do the educating and what would be the content of that education.

Setting Mizrahim against Ashkenazim was Begin's strategy in both policy and politics. It was a way to recruit faithful followers, whose political identity would henceforth be the identity of the right. The left could not understand how the Mizrahim, whom they dogmatically regarded as the proletariat, supported the Likud, the party of capitalists, and so it constructed theories about the irrationality of the Mizrahim, about their "false consciousness." The simpler truth is that the Likud's rule benefited them. It opened up economic possibilities and social advancement for them, which they had not enjoyed before. The Mizrahi path to advancement was not education, as in the case of Ashkenazim, but independent business, which in their self-perception suited the capitalism of the right. The Likud did everything it could to dismantle the left's power strongholds: a vilification of the kibbutzim, and high inflation that damaged the economic ability of the workers' society and Histadrut's institutions.

With the implementation of the economic reform of 1985, whose architect was Shimon Peres, then a member of

a national unity government, capitalism came to Israel in full force: privatization and the government's withdrawal from economic intervention. Peres performed a heroic deed that saved Israel's economy, but it was also the final nail in the coffin of the moderate socialism that remained. The dominance of privatization in the Israeli economy turned socialism into an ideology divorced from reality. These were the years when perestroika was being instituted, however incompletely, in Russia: it transpired that even in the beacon of state-directed economy, the reputation of capitalism was changing. Israel fell into line with the new economic-social trend, alongside Ronald Reagan and Margaret Thatcher, and the Labor Movement did not have anything else to offer.

When the left's social and economic traditions ceased to serve as its political marker, and when nationalism and religion became the political markers of the right, the left turned to a general political moderation to establish its difference. It began with the first Lebanon war, in 1982, which created a rift in the nation. The polarization was clear: the left opposed the war, the right defended it, as well as the Begin government that waged it. A new political lexicon emerged on the left: instead of socialism, liberalism; instead of equality, social justice. In the social protest movement that erupted onto the Israeli scene in 2011, the term "socialism" was nowhere heard. In the mass demonstrations, and among the tent dwellers on Tel Aviv's Rothschild Boulevard, the proletariat was nowhere to be found.

In that social justice movement there were no religious people, and no Arabs. There was only the Ashkenazi leftwing-bourgeois tribe, the educated middle class. The composition of the protesters exposed the demographic and sociological origins of the left's decline and fall. It has now

been relegated to the sidelines in Israeli society. It does not represent what is considered important by the majority of the public. Instead of concern for all, it is exercised mainly by individual rights. Liberalism in Israel is identified with defending Israeli democracy, the Supreme Court, and the rule of law. At one time, when Mapai was in government, the person who represented those values was Menachem Begin. They are the positions of an opposition defending the preservation of the existing order. They have nothing important to say about the larger policy questions of security, peace, and economy. And they are now the positions of the marginalized Labor tradition, a measure of the impotence of the left in setting the State of Israel's agenda.

Then there was the matter of the Palestinians and the conflict. In the 1990s there flourished the vision of a peace agreement with the Palestinians. The governments that were formed by the left, the Rabin and Barak governments, made efforts to reach an accord with the Palestinians. The Labor Party's calling card was "two states for two peoples," a prospect that had never before seemed so close, so real. The State of Israel was finding its place in the Middle East, it was being accepted into the regional club. Those were heady days. But they came to an abrupt end with Rabin's murder and the Second Intifada, which broke the public's trust in peace as something attainable. The Palestinians have always had a kind of veto over the fortunes of the Israeli left: when they reject diplomacy or practice violence, they make doves look like fools, at least in the eyes of large numbers of Israelis. Are the Palestinians truly willing to reach a historic compromise with Israel? Perhaps, at this late date, there can be no agreement over fundamental issues, between security for Israelis and justice for Palestinians. The question has become less and less

practicable: which current Israeli political leader is capable of withdrawing Jewish settlements from the West Bank? And how many Israelis still care? In all the recent elections the issues were: yes to Netanyahu or no to Netanyahu, yes to the rule of law or no to the rule of law, a democratic Jewish state or a less democratic Jewish state. The Palestinian question, and the question of peace, hardly figured at all. Two parties with more or less similar rightwing agendas competed against one another — one more liberal, one less, but with no real differences in their political platforms.

What does Labor, and the Israeli left, stand for? The time has come for a historical and philosophical accounting. The Zionist idea was an explosion of historical agency, an extraordinary display of political, social, and cultural optimism. The leaders of the Labor Party were avowed pessimists, who lived in constant anxiety over the fate of the Jewish people, and later of the State of Israel — but at the same time they harbored a profound belief in the elevation of humankind and in the rescue and reformation of the Jewish people. The anxiety never overcame the optimism. The first half of the twentieth century was the single most traumatic era in the history of the Jewish people, and in such a period the Zionist-socialist vision was able to enlist faithful followers who were prepared to sacrifice their lives for future generations — a grand collective mobilization in the name of safety and justice and a morally refined nationalism. This emergency period ended sometime in the late 1950s. When global society began to sanctify the success of the individual, when Israeli society became a sated and self-satisfied society, such grand mobilizations no longer seemed

possible, at least on the left. In the 1980s, I argued that the Labor Movement had lost its creativity with the establishment of the state. I think this assertion was correct. The Labor Party was a victim of its success, of fulfilling its tasks. "The state destroyed my homeland."

The exhaustion of Israeli socialism is not unique to it. Despite the recent appearance of socialist slogans and tropes in American and European protests, socialism is no longer a living political force. It did not succeed in adapting itself to consumer society, to the new technologies, to cultural apathy, to the flattening of public discourse by the new media. Inequality is on the rise all over the world, but the motivation of the workers in the nineteenth century, to organize and to protect their rights, is not re-emerging today. The left-wing populism of today is more concerned with identity and the remedy of psychological injuries than with radical economic reform. And there is the problem of leadership, or the lack of it. Socialists used to attract and create extraordinary political leaders, who knew how to persuade the masses to follow them. The old generation of Mapai, too, produced a series of genuinely formidable leaders, such as Berl Katznelson, David Ben-Gurion, Golda Meir, Yitzhak Rabin, and Shimon Peres. Since the early 2000s, however, there has not been a single impressive figure in the gallery of Labor Party leaders. The problem is not only with the message, but also with the messengers.

What does Labor have to offer its voters? Contempt for Benjamin Netanyahu is right and easy, but it is not a social philosophy or a political program. In an era of social media, there are powerful advantages for radical slogans, fake news, and hate speech. The traditional Mapai pragmatism, which always endeavored to find the middle ground, to create a

practical solution, no longer attracts admiration: it seems disingenuous, compromising, lacking in clarity. Even worse, it seems elitist, in an era in which elitism has become a dirty word.

And so it is hard to avoid the conclusion that the future of the Labor brand is behind it. It has, in a word, expired. The epic story is over. And the really heartbreaking thing about its feeble conclusion is that the challenge of building a just society and a just peace remains, and more urgently than ever before. Here and there we hear the rumblings of social protest, which have not been heard for decades. Will this bring about a change of course in Israel, a serious reassertion of demands for a better and more egalitarian society? Will the old spirit be revived for new reforms? There are reasons for pessimism. I hope that they are proved wrong.

ADAM ZAGAJEWSKI

And That is Why

And that is why I paced the corridors
Of those great museums
Gazing at paintings of a world
In which David is blameless as a boy scout
Goliath earns his shameful death
While eternal twilight dims Rembrandt's canvases
The twilight of anxiety and attention
And I passed from hall to hall
Admiring portraits of cynical cardinals
In Roman crimson
Ecstatic peasant weddings
Avid players at cards or dice
Observing ships of war and momentary truces
And that is why I paced the corridors
Of those renowned museums those celestial palaces
Trying to grasp Isaac's sacrifice
Mary's sorrow and bright skies above the Seine
And I always went back to a city street
Where madness, pain, and laughter persisted —
Still unpainted

Winter Dawn

It happens in winter, at dawn,
that a taxi takes you to the airport
(yet another festival).
Half-awake, you recollect
that Andrzej Bursa used to live
right here, just outside.
He once wrote: *the poet suffers for millions.*
It is still dark at the bus stop,
a few people huddle in the cold,
seeing them you think, lucky souls,
you only suffer for yourselves.

Border

The scent of gasoline crickets
Vladimir Holan

Poor people wait by the border
and look hopefully at the other side
The scent of gasoline crickets
skylarks sing
the abridged version of a hymn

Both sides of the border face east
The north is east
And the south is east

One car holds a giant globe
showing only oceans

A little girl in an ancient Fiat 125
carefully does homework

in a green ruled notebook —
there are borders everywhere

91

Sambor

We drove through Sambor quickly,
almost instantly, it took five minutes.

But my mother, as I recall,
passed her exams here.

Dusk fell
without funeral marches.

A lone colt danced on the highway,
though it didn't stray far from the mare;

freedom is sweet,
so is a mother's nearness.

Over fields and forests
gray silence reigned.

And the little town of Sambor
sank into oblivion again.

Mountains

When night draws near
the mountains are clear and pure
— like a philosophy student
before exams.

Clouds escort the dark sun
to the shaded avenue's end
and slowly take their leave,
but no one cries.

Look, look greedily,
when dusk approaches,
look insatiably,
look without fear.

Translated by Clare Cavanagh

SALLY SATEL

Do No Harm: Critical Race Theory and Medicine

In the winter of 1848, an epidemic of typhus ravaged Upper Silesia, a largely Polish mining and agricultural enclave in the Prussian Empire. Months earlier, heavy floods had destroyed large swaths of cropland, leaving the peasants to subsist on a paltry diet of clover, grass, and rotten potatoes. Weakened by starvation, they readily succumbed to infection. The Prussian authorities tapped a precocious twenty-six-year-old junior physician named Rudolf Ludwig Karl Virchow, at Berlin's Charité Hospital, to perform the routine task of surveying the outbreak. For three weeks, Virchow travelled from town to town, observing that families of six or more often shared single

room dwellings, turning homes into hotbeds of contagion. He noted the stigmata of the typhus rash — angry red spots that mysteriously spared the face and soles of the hands and feet — documented the nature of fevers, coughs, and diarrhea, and performed a few autopsies.

Virchow's report to the Prussian Minister for Religion, Education, and Medicine contained mortality statistics and clinical descriptions. He also dispensed predictable recommendations for flood control and drainage systems. But what exercised Virchow the most — and what his sponsors least wanted to confront — were the deeper causes of the epidemic. "The nouveaux riches" who extracted wealth in metals and minerals from the mines treated their Silesian workers "not as human beings but as machines," he wrote. He blamed the Catholic Church for keeping "the people bigoted, stupid and dependent." "If these conditions were removed," the bold young doctor offered the minister, "I am sure that epidemic typhus would not recur."

Even before he left for Upper Silesia, Virchow was primed to see the threads between social conditions and disease. In Friedrich Engels' treatise on the working class in Manchester and the deathtrap factories in which they toiled, which appeared in 1845, he read about the cramped conditions and the poor ventilation, the gruesome machine accidents, the toxic fumes and the woolen fibers they inhaled with every breath. From Edwin Chadwick's *Report into the Sanitary Conditions of the Labouring Population of Great Britain*, from 1842, Virchow learned that workers in the North rarely passed their thirtieth birthdays. He read of families crammed into half-lit quarters, choking on the stench of human and animal waste, grinding away their years under a sky so thick with soot that it blocked the sun and caused their children's legs to

bow from rickets. In a letter to his father, Virchow said that his immersion in the Silesian typhus epidemic had turned him from "half a man [to] a whole one, whose medical beliefs fuse with his political and social ones."

Ten days after Virchow returned to Berlin in mid-March, the spring riots erupted, one of many protests against monarchy spreading across Europe. He flung himself into the short-lived revolution, brandishing a pistol at the barricades — a feat of activism followed by months of local political involvement that led Charité to suspend him. Fortunately, the University of Würzburg was eager to attract the medical prodigy and offered Virchow a position on the condition that he not use it as "a playground for radical tendencies." He accepted the demand for his depoliticization, and used his new position instead as a proving ground for wondrous advances in medical science. He perfected new microscopic techniques that helped him discover how tumors form, how tissues proliferate, and how blood clots. Virchow was among the first to correctly link the origin of cancers from otherwise normal cells, the first to describe leukemia, and the first to use hair analysis in a criminal investigation. He discovered the life cycle of the parasite *Trichinella spiralis*, or "pork worm," which established the importance of meat inspection in Germany.

Yet the laboratory could not contain him. The experience in Upper Silesia had convinced him that doctors, knowing as they did the true conditions of humanity, made the best statesmen. Thus, after completing in 1858 his magisterial text *Cellular Pathology as Based upon Physiological and Pathological Histology*, a work that is regarded as the foundation of modern pathology, Virchow moved back into politics, this time as a professional. He became a member of the Berlin City Council beginning in 1859 and planned the city's sewage system. He

next entered the Prussian House of Representatives and in 1880, at the age of fifty-nine, the German Reichstag. Virchow's well-justified faith that social reform was necessary to combat disease never left him. When he celebrated his eightieth birthday in 1901, he was hailed by physicians all over the world as the "father of social medicine," or *medecine sociale*. The term was coined by Jules Guerin, a French physician — doing so, coincidentally yet auspiciously, one day after Virchow's return from Upper Silesia — to indicate "the numerous relations which exist between medicine and public affairs."

These "numerous relations between medicine and public affairs" formed the philosophical heart of public health in Europe. In America, however, the field organized itself around technical strategies aimed at the leading causes of death at the turn of the century, which were influenza, pneumonia, diphtheria, tuberculosis, and cholera. It was a time when physicians had little to offer in the way of medical treatment. Opium, laxatives, sleeping powders, bloodletting, and leeches were the mainstays of care. In a speech in 1860, Oliver Wendell Holmes Sr. famously told his colleagues in the Massachusetts Medical Society that "opium, which the Creator himself seems to prescribe, wine which is a food, and the vapors which produce the miracle of anesthesia... I firmly believe that if the whole material medica, as now used, could be sunk to the bottom of the sea, it would be all the better for mankind — and all the worse for the fishes."

Public health experts and doctors worked together closely to contain epidemics, but as drug discoveries mounted — among them penicillin for a broad swath of infections in 1928 (though it was not used until 1942) and the sulfa drugs in the 1930s — the power and prestige of the medical profession grew, and it separated from public health. Boundaries

were established: public health cared for populations while medicine cared for individuals. Within American public health, an occasional champion of European-style social medicine would emerge. Charles-Edward Winslow, head of Yale's department of public health, was one. As he told his colleagues in 1948, "You and I have determined that men should not sicken and die from polluted water, from malaria-breeding swamps, from epidemics of diphtheria, from tuberculosis. Those battles have been, in large measure, won. We must now determine that men shall not be physically and emotionally crippled by malnutrition, by slum dwellings, by lack of medical care, by social insecurity."

Winslow's eloquent plea to address "social insecurity" went unheeded. The field took the opposite route, dedicating itself to individual-level risks for injury and chronic illness. Surgeons General and public service advertisements exhorted Americans to stop smoking, eat more vegetables, exercise, wear seatbelts, and so on. To protect consumers, health warnings appeared on cigarette packs. Within the academy, however, theoretical developments inspired by social medicine were underway. Sociologists and epidemiologists found common interest, for example, in 1950, in a study of the relationship of fetal and infant mortality to residential segregation. The study evoked Virchow's commitment to quantification. "Medical statistics will be our standard of measurement: we will weigh life for life and see where the dead lie thicker: among the workers or among the privileged," he vowed.

By the 1970s, a cadre of epidemiologists were studying the psychological, social, and cultural forces that make people more vulnerable to disease and that shape their choices regarding health. The term "social determinants of health," which came into general usage in the 1990s, captured that

98

formidable notion. Its more abstract cousin, "the social production of health," examined how social inequalities affected health, and often did so with a nakedly ideological slant that implied no limit to the profession. Consider some sample quotations from faculty: "The practice of public health is, to a large degree, the process of redesigning society"; "Every problem is a public health problem"; "A school of public health is like a school of justice." The latter dictum was issued by a former dean of the Harvard School of Public Health.

Interpreting these trends, the medical economist R.G. Evans and the health policy experts Morris L. Barer, and Theodore Marmor wrote in their book *Why Are Some People Healthy and Others Not?*, in 1994, that "for those on the left, health differentials are markers for social inequality and injustice more generally and are further evidence of the need to redistribute wealth and power and restructure or overturn existing social order." Yet not everyone welcomed the infusion of progressive norms into public health academy. "We have nearly converted the school of public health from an institution committed to developing the scientific bases for disease prevention into one of many arenas for advancing social justice," Philip Cole of the University of Alabama at Birmingham and his colleagues sternly observed in 2000. "Broadly speaking, public health is aligned with the left," said the dean of the Boston University School of Public Health, "and there is no sense dancing around this." He appealed to his colleagues to be "a fully inclusive left," to "let go of always taking sides," and to "abandon the hectoring tone [that] radicalism can entail."

99

During the protests triggered by the killing of George Floyd, many health professionals allowed their personal politics to bleed into their professional advice. A much-retweeted message from a senior epidemiologist at the Johns Hopkins School of Public Health instructed that "in this moment the public health risks of not protesting to demand an end to systemic racism greatly exceed the harms of the virus." Three days later, 1,200 health professionals signed an open letter. "We do not condemn these gatherings as risky," they wrote. They are "vital to ...the threatened health specifically of Black people." Speaking to the *New York Times*, one epidemiologist who marched remarked that "I certainly condemned the anti-lockdown protests at the time, and I'm not condemning the protests now, and I struggle with that... I have a hard time articulating why that is okay." His honesty was refreshing, but the answer to his dilemma is that it is not okay. The job of epidemiologists is to inform the public about risks. It is absolutely not to tell them which risks are worth taking and what their moral prerogatives should be.

Months later, when it came time to distribute the coronavirus vaccine, an assortment of authorities, including legal scholars, public health experts, and state officials argued for giving high priority to black citizens in the name of "historical injustice." About that historical injustice there can be no doubt, but the Advisory Committee on Immunization Practices of the Centers for Disease Control and Prevention, or CDC, concluded that race should supersede age as a prioritization category because the oldest cohort in America is whiter than the general population. Elevating "health equity," the task force said, took precedence. The CDC itself told the committee that its allocation plan would result in up to 6 percent more deaths, many of whom would be black senior citizens — the

highest risk group; but the advisers remained loyal to it. Their loyalties, in other words, were to an ideal, not primarily to protecting health.

While the CDC was developing its equity approach, the National Academies, non-governmental institutions that offer independent advice on science policy, proposed an allocation plan that would give priority to communities that rate high on the CDC's Social Vulnerability Index. Using U.S. Census data, the index factors in poverty, unemployment, and health-insurance rates, among other socioeconomic vulnerabilities. Since minorities are more likely to meet criteria for social vulnerability, they would receive the vaccine early under that approach. Weeks later, public outcry forced the CDC committee to reverse itself. Still, on April 1, the governor of Vermont allowed anyone aged sixteen or older who identified as black, indigenous, or a person of color, or anyone who lives in a household with someone who does, to be vaccinated. Whites under fifty, unless they qualified for a vaccine by virtue of being a health care or public safety worker, of having a high-risk health condition, or being a parent or caregiver of someone at medical risk, had to wait.

Across campus at the medical school, the academic tradition was less politicized. Doctor-led activist groups have long existed, most notably Physicians for Social Responsibility, fifty years old this year, which shared the Nobel Prize in 1985 for alerting the world to the consequences of nuclear war, but physicians have mostly confined their advocacy, if they engaged at all, to healthcare financing and delivery. Doctors who specialized in caring for homeless people or pediatricians who treated poor children could not ignore poverty and decrepit housing, and they often collaborated with local social service agencies in keeping with their medical calling.

But by oath and inclination, doctors' eyes are, or should be, on treating the patients before them, not on reforming society.

I certainly acknowledge that the culture of American medicine has been changing over the last decade or so, at least among a vocal contingent. A dramatic validation of the shift took place on December 10, 2014, International Human Rights Day, when 3,000 medical students "died" on the lawns and walkways of medical school campuses across the country. The "national white coat die-in" was the brainchild of medical students who were moved to demonstrate for racial justice in the wake of the police killings of Michael Brown and Eric Garner. At the "die-in," students wearing surgical scrubs and white jackets lay silent for four and a half minutes, symbolic of the four and a half hours that Michael Brown's body remained on the street in Ferguson, Missouri after a white police officer shot him. A group called WhiteCoats4 BlackLives, WC4BL, emerged from the event. Its mission is to "prepare future physicians to be advocates for racial justice," and one of its core convictions is that "policing is incompatible with health."

After George Floyd's murder, WC4BL organized gatherings in medical centers across the country. These took place only a few months into the pandemic. Reeling from a triple tragedy — another black victim of police brutality, a viral death toll that unduly savaged black Americans, and their own bone-weariness from toiling in the plague-infested trenches — trainees and doctors took action. They persuaded almost two hundred state and local governments to declare racism as a public health crisis. The dual premise was that racially motivated police violence is bad for the health of blacks and that systemic

racism is the pre-eminent driver of the overall poorer health of the black population. The American College of Physicians pledged a "commitment to being an anti-racist organization;" the American Psychiatric Association (my trade organization) vowed it "would not stand for racism against Black Americans"; and the American Academy of Pediatrics implored its members to "dismantle racism at every level" of society.

In the wake of George Floyd's death, major journals published numerous essays on racism in medicine, often lifting the paywall for them. In the *New England Journal of Medicine,* for example, a psychiatrist called for "majority taxes" on white colleagues defined by the author as a mandate to "acknowledge your White privilege, no matter how uncomfortable; leverage privilege to highlight medical racism; and humbly and actively implement antiracist policies." In the *Journal of the American Medical Association,* authors insisted that "researchers must name and interrogate structural racism and its sociopolitical consequences as a root cause of the racial health disparities we observe." Writing in *Health Affairs,* six doctors, all closely affiliated with the American Medical Association, the AMA, cautioned that "while naming racism as a fundamental cause of health inequity is a crucial first step, our patients, colleagues, and communities will not reap the benefits of such declarations until racism is exposed, confronted, and dismantled."

Some of these articles specifically cited Critical Race Theory, or CRT, a worldview that interprets social existence for minorities as a perpetual power struggle waged every day and in every aspect of their lives against a dominant group. Differences of any kind — in income, education, school performance, and, of course, health — are manifestations of racism and racism alone. Within the domain of medicine, the critical race perspective casts key institutions — the training apparatus

(medical schools), the knowledge base (medical journals and funders of research) and the treatment enterprise (the delivery of healthcare) — as engines of oppression and exploitation. The practice of "equity," the enactment of critical race theory, permits, if not endorses, unequal treatment of the dominant group in order to arrive at equal group outcomes, even if it is to the detriment of ailing individuals.

Despite the radical nature of critical race therapeutics, its proponents mean to deploy it in the service of a most conventional project: the reduction and elimination of health disparities, that is, the white-black gap in health status and in access to care. This is a fine goal and a decades-old campaign, put forth most prominently by the federal government, notably in a landmark report in 1985, and by foundations such as the Kaiser Family Foundations and the Robert Wood Johnson Foundation. But can approaches informed by critical race theory help to narrow the health gap? And can they do so in ways that do not create a zero-sum scenario in which the health of other groups is compromised?

That question will be tested on a small scale at Brigham and Women's Hospital in Boston in the form of a pilot study designed to give preferences to black and Hispanic patients with heart failure, a condition in which the heart muscle can no longer pump enough blood to meet the body's needs. Minority patients will receive priority for admission to the cardiac specialty unit. According to two Brigham physicians writing earlier this year in the *Boston Review*, a review of medical records going back ten years showed that minority patients were less likely to be admitted to the specialty cardiac unit (with its private rooms and, presumably, more attentive care) than whites. Instead, they were more likely to be admitted to the general medical unit.

Three percent of black patients hospitalized on the general unit died within a month of discharge, compared to under one percent who were cared for on the specialty unit. Retrospective studies such as this one are inherently limited, as the authors themselves admit, because they are conducted in hindsight and thus miss important variables. Even so, the data showed that the strongest predictor of where a patient would be admitted was whether or not they were being cared for by an outpatient cardiologist, making physician advocacy the most likely, though not the sole, explanation for unit of admission.

Non-controversial remedies for differences in the quality of care include strengthening standardized admission guidelines or using decision tools to upgrade physicians' care for heart failure care on the general medical unit. The doctors at Brigham who devised the pilot openly considered these options in a paper in a cardiology journal two years ago, yet still they chose to pursue a pilot that followed a "reparations framework," no matter the legal ramifications. As Bram Wispelwey and Michelle Morse explained in their *Boston Review* article, entitled "An Anti-Racist Agenda for Medicine":

> Offering preferential care based on race or ethnicity may elicit legal challenges from our system of color-blind law. But given the ample current evidence that our health, judicial, and other systems already unfairly preference people who are white, we believe—following the ethical framework of [applicative justice] and others—that our approach is corrective and therefore mandated. We encourage other institutions to proceed confidently on behalf of equity and racial justice, with backing provided by recent White House executive orders.

Do No Harm: Critical Race Theory and Medicine

The physicians who designed the Brigham pilot justified it as "redress [for] the outstanding debt from the harm caused by our institutions."

Similar developments are occurring in medical education. Last summer, the Association of American Medical Colleges informed the medical community and its 155 medical schools that they "must employ anti-racist and unconscious bias training and engage in interracial dialogues." This spring, the AMA advocated "mandatory anti-racism [training]" as part of its vision that all physicians "confront inequities and dismantle white supremacy, racism, and other forms of exclusion and structured oppression." The data on effectiveness of such training initiatives, however, are dismal, with study after study showing that such efforts often backfire by reinforcing racial and ethnic stereotypes while failing to improve morale, collaboration, or diverse hiring within a workplace. Still, Michigan now requires implicit bias training for health professionals and Maryland has made it a condition of obtaining a medical license. Such training often includes the wildly popular Implicit Association Test, or IAT, a computer-administered reaction time test purported to measure unconscious prejudice and thus foretell whether an individual will engage in discrimination. The problem, according to several teams of research psychologists, is that the race IAT has no predictive value.

Curricular reform in medical schools is also underway. At Stanford University School of Medicine, for example, a new "anti-racist" curriculum will instruct students in "confronting white supremacy." Students at Brown University will take a four-week course on Racial Justice and Health Inequity to "gain a deep understanding of topic areas, such as Critical Race Theory, intersectionality, and the inequities that

pervade the U.S. healthcare system." At Kaiser Permanente Bernard J. Tyson School of Medicine, topics covered will include social identity, intersectionality, power, and privilege; history of race and racism in medicine and science; and media bias and literacy. Staple readings of the new curricula are *White Fragility* by Robin DiAngelo and *How to Be an Antiracist* by Ibram X. Kendi.

The integrity of the medical profession has certainly been compromised by a terrible history of racism. Physicians performed medical experiments on male and female slaves, trying to improve surgical techniques and better understand anatomy and physiology. In the Jim Crow era, many Southern hospitals, clinics, and doctors' offices were completely segregated by race, and many more maintained separate wings or staff that were legally banned from mixing with both black and white patients. Even donated blood was kept in separate blood banks. As Vann R. Newkirk II put it, "Within the confines of a segregated health-care system, these factors became poor health outcomes that shaped black America as if they were its genetic material." In 1997, President Clinton apologized for the Tuskegee syphilis study.

Students should also know that the AMA apologized to black physicians in 2008 for more than a century of policies that excluded them from the association, in addition to policies that barred them from some state and local medical societies. As late as 1966, black and white demonstrators picketed the AMA annual meeting to integrate all county and state medical societies. The association also failed to speak against federal funding of segregated hospitals and was silent in the face of pending civil rights legislation. Those transgressions are an important part of the record — but will they and other examples of racial injustice in medicine be taught as part

of the encompassing social history of the field, or as a defeatist narrative that glosses over the moral progress that medicine, though still imperfect in many ways, has made?

The fundamental problem with social justice in public health is that there are no limiting principles to it. And so the new pedagogy prompts other questions. Will coursework in basic medical science, early clinical skills, epidemiology, bioethics, or exposure to the medical humanities be displaced to accommodate the anti-racist curriculum? How will deans respond to students who do not regard the medical classroom as a suitable venue in which to interrogate their social conscience, be told they must "accept America's racist roots," or informed that "we live in a country [with] a political economy predicated on devaluing Black labor, demeaning Black bodies, and denying Black humanity" (as a group of medical educators writing in the *New England Journal of Medicine* would have them do)? Will the moral fitness of such future doctors be called into question?

If health is completely at the mercy of social forces, as critical theory insists, will the importance of self-care be given adequate attention? It is hard to imagine that physicians will desist in discussing with patients matters such as diet, exercise, smoking, and so on — in short, actions they can and should take to improve their health. And yet, following a lecture I gave earlier this year, I was castigated by some psychiatric residents for drawing attention to the dimensions of personal agency in addiction. I was not "blaming the victim," as charged. Quite the contrary. I was drawing attention to their potential, to the remnants of their agency.

Will the anti-racist medical classroom accommodate controversy? Judging from the censorious milieu in some medical schools, I am not optimistic. One of my colleagues

108

— here is one example among many — lost a departmental leadership position after trainees accused him of making them feel "unsafe." The accusation came on a Zoom call during which my colleague objected to a fellow faculty member questioning his "support" for diversity. Surprised, he asked to know what he had said to give such a false impression, but he was never told. In an ethos in which an allegation is a conviction, an insinuation was enough. Another colleague told me that she stifled complaints when her school jettisoned lectures in bioethics to "make room for the anti-racist curriculum. Which is ironic, because that was where students were taught about subjects like the Tuskegee syphilis experiment." A third colleague told me that during a group discussion of stress and suicide in black youth, the tacit rule was that only fear of police aggression and subjection to discrimination were allowable explanations, not the psychological torture of bullying by classmates or the quotidian terror of neighborhood gun violence.

One florid instance of the intolerance for controversy is the case of Dr. Norman C. Wang, a University of Pittsburgh cardiologist. Last March, he published an article in the *Journal of the American Heart Association* titled "Diversity, Inclusion, and Equity: Evolution of Race and Ethnicity Considerations for the Cardiology Workforce in the United States of America from 1969 to 2019." Wang's interpretation of the data on performance persuaded him that affirmative action in medicine was not working. "Excellence should not be sacrificed for short-term demographic optics," he concluded. When news of Wang's peer-reviewed paper hit social media last August (its initial appearance in March 2020 garnered little notice because it coincided with the onset of the pandemic), the reaction was swift.

Physicians savaged him on Twitter. "Rise up, colleagues. The fact that this is published in 'our' journal should both enrage & activate all of us." "Racism is alive, well, and publishable in medicine." "We stand united for diversity equity and inclusion. And denounce this individual's racist beliefs and paper." The school fired Wang as director of the electrophysiology fellowship and banned him from having contact with medical students. The American Heart Association emphatically tweeted that Wang's article "does NOT represent AHA values," and it launched an "investigation to better understand how a paper that is completely incompatible with the Association's core values was published." Once alerted by Wang's own medical school to allegations that his article contained "many misconceptions and misquotes" that "void ... its scientific validity," the journal retracted it.

Diversity is one of the most pressing issues in medical schools today. Nationwide, five percent of physicians are black, under half the national demographic of 13.4 percent. Graduates are more likely to practice in underserved areas, and some evidence suggests that black patients enjoy better communication with doctors of the same race. To bolster those numbers, many medical school admissions committees employ a "holistic review framework," created by the American Association of Medical Colleges to consider applicants' experiences and attributes in addition to academic achievement. "Situational judgment" and emotional intelligence are taken into account at several dozen schools. Some colleges offer special programs to shore up the academic record of aspiring black pre-med students. Yet despite these robust efforts and others, progress has been exasperatingly slow.

Another delicate topic is the relationship between race and disease. Some worry that putting "genes" and "race" in the

same sentence will encourage the fiction that races are discrete entities defined by biological traits. With science literacy among the public so tenuous, the worry is not misplaced. But the fact is that studies involving genes and race are simply about population genetics: the fact that people sharing a geographical ancestry are more likely to have particular gene variants (alleles) in their genome than do people with a different heritage. These variants may code for proteins or enzymes that cause vulnerabilities to certain diseases or determine how robust a response to treatment is likely to be.

Race is thus a shorthand for ancestral descent — and the more precise the ancestral origin the better, as variations in genetic heritage exist even between groups within a geographical region. Genetic admixing, that is, when parents are of different "races" or are mixed race themselves, further complicates the picture to the point where the shorthand of race becomes irrelevant, or too crude a category to be of any help at all. Researchers and physicians agree that the science of pharmacogenomics — the elucidation of the relationship between treatment and individuals' unique genomic finger-print to create personalized therapies — will make the controversy obsolete. But until this gold standard is used widely, group-based genetic analysis will have some value.

Even with the caveats in mind, genetic heritage can be relevant to medicine with regard to appropriate dosing of certain drugs, more accurate prediction of responses to those drugs, clinical decision-making via algorithms (an especially controversial matter that scientists are currently debating in good faith), and heightened risk for certain conditions, such as cardiovascular and renal disease.

A recent study in the *Journal of the American Medical Association* uncovered an interesting finding correlated with race.

In a sample of about three hundred patients at a New York medical center, blacks had stronger expression of the gene that codes for Transmembrane Serine Protease 2, a protein known as TMPRRS2 than did white, Asian, Hispanic, or mixed-race patients. TMPRSS2 sits on the surface of cells lining the nose and is involved with entry of the coronavirus into those cells. Will that finding hold up on replication? Perhaps not. And if it does, the protein likely accounts for a small part of the racial variation in COVID-19 infections, the lion's share accounted for by social factors. Still, the investigation yielded potentially important findings. Science, after all, is provisional, cumulative, and, eventually, self-correcting.

Yet this study, too, provoked a swarm of angry responses from doctors and health professionals. "This is sounding way too much like blaming and rings of eugenics." "Race IS NOT genetic." "Stop ...systemic racism is why [black, indigenous, and people of color] are disproportionately harmed by COVID-19." "I think this would hold water if by 'TMPRSS2,' you meant 'racism.'" "Shame on this publication for perpetuating racism." "Biomedical racism to a T." A team writing in *Health Affairs* warned researchers who planned to publish on health disparities to "never offer genetic interpretations of race because such suppositions are not grounded in science." They also proposed that medical journals "reject articles on racial health inequities that fail to rigorously examine racism." The article-review process, they say, requires "editors who are well versed in critical race theory." But why? For genetic inquiry across groups is emphatically not "racial science" or scientific racism. The objectivity of research is not a form of complicity in structures of power; it is the very condition for the discovery of treatments that are genuinely universal.

Concerned by the disavowal of such studies, experts

spoke up. "For some applications, race may continue to be the best variable to capture the influence on health," wrote John P. Ioannidis, Neil R. Powe, and Clyde Yancy in *the Journal of the American Medical Association.* "Quick dismissal," they cautioned, "may worsen outcomes, especially for the most disadvantaged populations." In the *New England Journal of Medicine,* five genetics experts, who identified themselves as black, declared that "ideally, race will be replaced with genetic ancestry as a variable in medical research and practice. But until more ancestry data are available, ignoring race and extrapolating research findings from European-ancestry populations to others is neither equitable nor safe." The authors expressed disappointment that some "curricula promote ideologies that downplay the medical achievements of genetic studies."

Several months after Rudolf Virchow returned from Upper Silesia, he started a weekly newsletter. Although *Die Mediz̧inische Reform* lasted only a year, many of the aphorisms enshrined in its pages live on. The masthead dictum — "physicians are the natural attorneys of the poor" — is among the most famous. In Virchow's time, a physician was able to make a powerful case to politicians that the major scourges of the day — contagion, malnourishment, and starvation — required effective sanitation, adequate nutrition, and the alleviation of extreme poverty. In short, significant social policy. The connection between health and reform — civil engineering and food — was direct and obvious, "a remedy against the recurrence of famine and of great typhus epidemics," as Virchow told the Prussian minister. (This was especially the case because antibiotics did not yet exist.)

113

Under a regime of critical medical theory — CMT? — the mandate for change — "dismantling racism" — presents doctors with an unworkable challenge. For one, physicians are wholly ill-prepared for such a task. Their primary job is to diagnose and to treat — and to do no harm in the process. They have no expertise in the redistribution of power and money — nor can triage or surgery wait for such a redistribution. By urging reform of this kind in the name of health, good intentions aside, they risk abusing their authority, using the profession as a vehicle for politics, and, ultimately, eroding the trust of the public.

Moreover, the mission itself is too ambiguous. Even for seasoned policy analysts, teasing out a strong causal link between health and sprawling upstream economic and social factors is very difficult. With so many "intervening variables" at play, manipulating policy in the service of health may not have its intended effect, while the odds of creating unwanted repercussions elsewhere in the system are significant.

None of this is to elide the fact that much of black disadvantage in health is the cumulative product of legal, political, and social institutions that have historically discriminated against them, either explicitly or through passive disregard to the differential brunt of policies, and in certain instances still do. As a result, blacks lack comparatively fewer opportunities for better health. The neighborhoods in which they are more likely to reside attract lower levels of civic investment. This in turn leads to underfunded hospitals, fewer emergency services, pharmacy deserts, worse air and water quality, and fewer supermarkets and safe options for outdoor exercise.

There is indeed a race-based story to tell about why, in aggregate, black Americans suffer poorer health and receive less care than whites. It is a story that delivers real and painful

truths. The pandemic served as an object lesson in differential exposure to the virus, with rates of coronavirus infections that were three times as high in blacks as whites. With jobs as lower-paid essential workers (e.g., transit workers, building maintenance staff, grocery store employees), dependence upon public transportation, and residency in dense quarters, African Americans were at higher risk.

And yet "systemic racism" is not a useful medical diagnosis: it may have explanatory value but it doesn't yield realistic prescriptions. So what are physicians supposed to do now? Only when explanations are able to bring causal dynamics into sharp focus will they reveal efficient points of entry into the healthcare apparatus for minimizing health gaps. In California, for example, too many black patients with colon cancer were falling through the cracks. When such patients in California were treated at an integrated health care system — a point of entry where all aspects of care were delivered under one roof — black patients fared much better than black patients treated in other settings. As a result, survival was the same for black and whites. Such initiatives are hard at work in cities across the country.

The totalizing narrative of race, like all totalizing narratives, dangerously simplifies things. It discounts other ways to illuminate the black-white gaps in health. Consider, for example, the constellation of disadvantages called Adverse Childhood Experiences, which bear a well-documented relationship to future health. Imagine a succession of deprivations and insults, toppling one after the other like dominoes across the lifespan. Start with mothers who receive little to no prenatal care. Their poorly thriving babies are born into an often fatherless world full of chaos, physical and emotional abuse or neglect, and domestic and community violence. These

are not hostile stereotypes; they are real-world phenomena that must be faced if their consequences are to be understood — and, optimally, prevented, buffered, or reversed.

The stress of sustained trauma can alter children's neural maturation and hormonal function, predisposing them to problems such as poor emotional regulation and stunted cognitive development, including working with memory, attentional control, and cognitive flexibility. These deficits, in turn, may disrupt the formation of healthy attachment to other people, lead to weak performance in school and low educational attainment overall. As often lonely teens with a foreshortened sense of the future, they are prone to risk-taking with drugs and alcohol, reckless driving, and unprotected sex. As adults, they are often burdened by depression and despair and tend to smoke heavily, drink to excess, and abuse drugs. Next comes disease, mainly in the form of cancer, cardiovascular disease, diabetes, and renal illness. Then, premature death. The more adverse experiences, the greater the odds of these otherwise avoidable health consequences. Racial and ethnic minorities and Appalachian youth, as epidemiologists have shown, are at greater risk for more adverse experiences.

The *medecine sociale* that Jules Guerin defined and the noble Rudolf Virchow once practiced was about the "numerous relations between medicine and public affairs." Social medicine today, having been irradiated by critical race theory, has mutated into a belief that only one relation matters: systemic racism. From this monocausal vision, so constrained by its nature and animated by grievance as it is, has emerged a host of unhealthy developments. The worst of them is a doctrinal intol-

erance of explanations that lie outside the oppression narrative.

Add to this an intensely politicized environment that threatens academic collegiality, open inquiry, and unapologetic discourse. Round out the project with contempt for the notion of personal responsibility in health, and permission to erode the boundary between personal politics and professional obligations. Perhaps the apotheosis of the critical medical imperative is the dispensation that it grants a group of Boston doctors to miss the real question — how a hospital can deliver the best care for each patient it serves — in favor of a righteous trial of racial preferences that might harm other patients.

Whether critical medical theorists represent the tip of an iceberg or the far tail of a bell curve seems moot, given their formidable influence at elite medical schools. Many deans and chairmen are doubtless too intimidated to resist. At the same time, however, their youthful colleagues are likely to be sympathetic to the critical justice project. Over the past decade, according to an analysis at Stanford University in 2019, young physicians have been moving so "sharply to the left" and flocking so densely to urban areas — "ideological sorting," the authors called it — that rural areas are suffering from shortages of physicians.

The spirit of social medicine is precisely what should inspire some of those young doctors to set up practice in a rural minority town. If being anti-racist is their priority, it is probably the best gift they can give. That spirit should also prompt us to challenge the status of the black-white gap in health as the dominant measure of our wellbeing as a population. Just as a hammer is predisposed to see all problems as nails, emphasizing such gaps — now routinely called "health inequities" — leads inexorably to the quixotic conclusion that dismantling racism is the medical answer. And the tyranny

117

of this gap forecloses another, more universal definition of disparity: the differential between a person's current health and their optimal health, between the quality and quantity of the care that they are currently receiving and what, as a matter of right, they deserve.

The strict imperatives of clinical practice may be the best buffer against ideology. The surgical suite, the emergency department, and the examining room are the definitive, consequential spheres of clinical intervention. When applications to medical school rose steeply last year in the wake of the pandemic, a phenomenon dubbed the "Fauci effect," the young applicants were surely inspired by the extraordinary heroism of doctors and nurses and the technical prowess of medical science.

Physicians are still the natural lawyers for the disadvantaged, but in their way. In the clinic and at the bedside, they argue most eloquently through their specialized knowledge and their compassion. In medical journals, they spread knowledge though dispassionate, truth-seeking methods that speak to all. And in the realm of social medicine, they do their best work aiding those who are most vulnerable and in need, regardless of group affiliation. The best way to be an anti-racist doctor is to be a good doctor.

R. B. KITAJ

Three Tales

MONDRIAN

Mondrian's closest friend was the Dutch painter Eli Streep, a Jew who was caught in a raid in Paris in 1942 and murdered. Mondrian had escaped by then, via London to New York. Streep and Mondrian saw each other almost every day in Paris during the many years they both lived in the same shabby building on the Rue du Depart by the Montparnasse railway station. They had been schoolboy friends in Amsterdam, and they were among the first young painters to notice the death of the almost unknown Vincent van Gogh, a few of whose strange paintings had attracted them. They even visited Theo van Gogh's young widow, Jo, to see more of her brother-in-law's

pictures after she had married the painter Cohen Gosschalk.

Mondrian seems to have painted the first of his purest signature works around 1921, those with the first slightly thickened black lines, vertical and horizontal. He and Streep had always been struck by van Gogh's intense, sometimes black outlines, his way of outlining faces and bodies as well as houses and trees. These painting-drawings of Vincent's last few years, done in the insane asylum near Arles and then in Auvers in the north, where he killed himself, became, for Mondrian, depressed images from which he plucked the outline, and blackened and straightened them out upon his own white canvases until the lines depressed his own art, or so he thought.

Streep encouraged Mondrian each day · so that their poverty — they subsisted on bread, potatoes, and coffee more days than not — was little noticed. Streep thrived, if that is the word, on Mondrian's radical ambitions for his unhappy black stripes, so new to the practice of art. Streep *became* Mondrian, in the sense that he enhanced Mondrian's work and meager life. I mean that Streep's excitement about his friend's painting was becoming to them as any pleased audience is becoming to a drama or a comedy. When one of them sold a picture, which was rare, they ate out in a little bistro and then went to a brothel, as Vincent and Gauguin used to do in Arles when they lived together.

The thickened black lines of Mondrian began to cast a spell, even a black spell one might say, on some of the few visitors to Mondrian's room. This room in Paris served as a studio, bed-corner, and hidden little kitchen. When visitors arrived at 4:30 in the afternoon, Streep would usually be there too, having come down from his own room for the company. Paris often gets dark early and Mondrian would put a single dangling naked light on above his canvas, above his black lines.

Three or four people would huddle around the easel in the darkness. Streep would be in his element. He rejoiced for his Dutch brother and for himself.

Mondrian's black lines became talked about in Paris and even back in Holland, among a very few, of course, and hardly any buyers.

"I love Mondrian's stripes," a woman in a café would say.

"Mondrian's black lines are so sad," said another woman, "sad and good."

"And right," someone added.

"How do you mean?"

"Right for me and my sadness. Right for the sadness of everyday streets."

"Yes, one line going up and down and two lines across town. No let-up, just new sets of paths from picture to picture."

If someone did buy, only a few francs were involved and usually in installments. Paris began to feel war in the air. Streep said that the Jews were in trouble as usual. Half of those few interested in Mondrian were Jews. Jews in trouble. Some left Paris and Europe. Mondrian's stripes saddened more and more days. Primary colored blocks of flat color between some black lines didn't help to lift anyone's spirits. But when the canvases were without color, fear could strike some timid souls.

Mondrian and Streep embraced and took leave of each other.

"I'll follow you soon," said Streep. He had some family concerns to take care of first. Mondrian and a lady friend of his got to New York together. Paris fell. A refugee, who made it out of France, told Mondrian that Streep was dead.

Mondrian painted his black, black lines in New York, in his small room there. No color. He lived alone but he saw the woman he left Paris with once or twice a week. They went

dancing and then slept together. Mondrian's pictures of the Passion back in Europe became loved by some of those who loved art in New York.

"His crossed lines are about his Jewish friend Streep now," wrote a critic.

Mondrian was my favorite teacher at the Cooper Union when I went there as a teenager in 1950. He and I became good friends. I will never forget him, his suit and tie, his white painting smock, his combed-back hair. But the real great memory for me was in his darkened room, huddled with him in front of his easel upon which he had placed a little picture, a single light dangling above.

"Is this really about what happened in Europe during those years?"

"Yes, but it is also about now, and it is also about tomorrow. Black lines which began then, crossed, and kept on their way."

HOW TO PAINT A PICTURE

"Paint on a very small canvas," said the aged painter to his listener.

"Why?"

"Because small is now better than large. Taste has shifted. Well, really, *my* taste has shifted and that's what counts."

"But will people take the time to scrutinize small pictures? I mean, people lead busy walk-by lives."

"Sure they will, even if only because they do lead such busy lives. People will like to slow down and sort of stop the world to study a little picture closely. That's called Culture."

Then the painter put a small canvas on the easel. He was in a plastic chair in front of it. The listener stood behind him, rapt and apprehensive.

"What have we here?" asked the painter, mostly to himself. "I see a face of Jesus the Jew," he said to the blank little canvas.

The painter, who was about seventy-five years old and not in good health, got up and went to a bookcase, from which he withdrew a fat Rouault book from a section of about a dozen books and catalogs about Rouault, a painter who had fascinated him for many years, but not really one of his core or important painters from Giotto to Matisse. He slumped back down in his chair and flipped through the book until he came to the tipped-in color plate he was looking for. It was a head of Jesus and the text about it said: "It is one of the most monumental works ever produced by the brush of an artist." The painter read that out loud to his listener, as if the opinion of the writer was a stunning thing. After a lifetime of, well, art, it was stunning because the Rouault plate, although he rather liked it, did not seem so extraordinary as all that. Undaunted, the painter put the book down by his chair on top of a pile of other books, which included a Mondrian book, a Greenberg book, a book of van Gogh self-portraits, an Auerbach book, a Bomberg book, a Cezanne watercolor book, and a few others. Then he went up to his canvas and drew a Jesus face very quickly with a few lines using a charcoal stick. It looked like an abstract group of about a dozen black strokes.

"There, that's a good start. It could be as good as the Rouault, but I hope my pictures will be better, whatever better means."

The listener, a very young painter, said she would come back in a few days and left him alone there.

She was anxious to leave because she was having a hard time with her boyfriend and was determined to end her affair. At the same time she was excited to learn how to paint a picture from this old painter who was doing it in a way she

had never known before. The old painter was lonely and he encouraged her to drop in whenever she liked. He enjoyed her young, untried company. She reminded him of Audrey Hepburn. Let's call her Audrey.

When Audrey left, he studied his abstract Jesus. He had just read a book called *Rabbi Jesus* by an Oxford scholar who placed Jesus among the great Jews. What if he made his pictures quite more abstract? He was devoted to the idea of painting a face unlike the faces any other painter had done before. Giotto had done that, and so had Picasso, and so had many painters. The attempt was quite a tradition, you might call it a revolutionary tradition. He got out a tube of Mars Black and began to brush in more abstract lines and splotches until you could hardly make out the features of a face at all. Some of the faces of Cezanne's bathers are like that, are they not? He really started that radical idea to change the face. So Jesus kept changing until the painter achieved a kind of Mondrian Face, with four different lines describing the sides, top, and bottom. The face of the face seemed to be in chaos, or, as in some Kabbalist descriptions of God, Nothing.

But the painter did not believe that Jesus was God, so he rescued his Jesus from Nothing and kept re-introducing human features after all. Color. Should there be color in the face on the little canvas? Perhaps not. How about a face decided by black strokes? Crucial black strokes if one was lucky, but maybe not final, as Jesus is not final. The painter hobbled over to a wall full of art clippings. A Mondrian self-portrait and a Manet head of Monet were pinned next to each other. Each was a collection of crucial strokes verging on abstraction. Each face was good to read because each was like new after all these years. Back in his chair, he squinted at his Jesus. It looked very unfocused, but then so were the Mondrian and the Manet. The

124

painter talked to his dead wife, to his tall, last portrait of her just before she died when she was forty-six. In the portrait she was in a black Armani suit, leaned on the wall behind Jesus the Jew on an antique easel.

"Love means that I want you to be," he said to her, quoting Augustine, which was Hannah Arendt's favorite saying.

Silence.

His wife had been dead thirteen years. He felt half-dead himself. He was. He was also surrounded by his latest little paintings, many almost finished, like his life.

He went to his wife and kissed her on her lips. "Kiss me back," he said to her, "to death, to the After, so I can go looking for you in the Great Whatever. Meet me at the Station, hold my hand and lead kindly light."

Silence.

Back to Jesus, he glanced at his other Jews, those faces on the dozen little pictures he was working on around the room. Proust as a boy, Scholem, Kossoff after Auerbach, the author of the Zohar, Max Liebermann, an abstract Einstein, an Impressionist Pissarro, Hannah Arendt in Jerusalem... Then he surveyed his studio walls as he always did again and again. Photos of faces: his portrait of Isaiah Berlin, his snapshot of Guston, reproductions of Auerbach faces, Matisse faces, Rembrandt faces, an Ingres profile, dozens of van Gogh self-portraits. He was walled in.

The next few days the painter kept changing the Jesus lines — arabesques, short stabs, straight abrupt lines, wedges, curls, angles, broom-like swathes, mouth lines, eyebrows with loose hairs, eye lines, wrinkles, grooves, jaw and cheek lines.... all composing themselves, disappearing and always changing. But Jesus was still there — a Jesus. There were still only about twelve or fifteen lines, all in Mars Black. Abstract Mondrian

lurked in the face and so did late Rembrandt — especially his face of Julius Civilis. It was a little line painting, cavalier as to contour. It was a little culture.

Audrey returned one day, having broken with her lover.

"The little Jesus looks dense, oblique, slant, difficult, ongoing," she remarked, delighted. "Is that how to paint a picture? I mean, surrounded by ideas?"

"Yes," he said. "For now it's a way. Come over here." He put his arm around her waist.

"Where did you move when you left your boyfriend?"

"Back to my mother."

"Come and live in my spare room. No rent. I just like you here."

"I don't trust you to be good."

"C'mon, I'm as old as your grandfather."

"So was Picasso."

"I can't get it up anymore. And don't I show you how to paint a picture?"

So Audrey moved in with him, as with Professor Higgins.

THE GIFT

Ron's father owned much of Westwood Village in Los Angeles and when he died he left it all to Ron, who had just graduated from the Royal College of Art in London in 1962. Ron was already very wealthy because his maternal grandmother, who had been born to a Hassidic family in Podolia, had long before married the owner of Maggs Bros., the great rare-book sellers in Berkeley Square in London, and Ron inherited that business and its building when he was still a student. He lived above Maggs Bros., in his own flat and top floor studio. Maggs

Bros. lived on in the good hands it enjoyed plus Ron, who loved books and art and women. He took great interest in his new book business, aside from his life as an emerging young painter.

Ron and David Hockney were close friends, having been together at the Royal College. They had begun to draw each other there. When he graduated, Ron was put under contract by the hugely successful Marlborough Fine Art in nearby Bond St. In the early 1960s, Marlborough also represented other young Jews such as Frank Auerbach, Leon Kossoff, and Lucian Freud, along with the estates of David Bomberg, Mondrian, Eli Streep, and Jackson Pollock. Ron commissioned Auerbach and Freud to paint his portrait and those paintings were duly hung in the tall house in Berkeley Square full of books and pictures. Like rich young painters before him, such as Caillebotte and Bazille, Ron collected the paintings of extraordinary painters he knew and grew up with in London during a period when London was home to an unusual number of world-class artists, of whom Francis Bacon was probably supreme. Ron's own paintings were avidly bought by museums as well as collectors in Europe and his native America as well as in England. And his rare-book business continued to flourish.

Of course many gems were plucked from the thriving international book trade in his ground-floor shop and spirited upstairs into the private rooms of the young owner, and a surprising number of these books, upon being read, would inspire the picture-making in the light-filled studio high in the house. Later the pictures that Ron made would travel back downstairs to Berkeley Square and around a few corners in Mayfair to Marlborough Fine Art Ltd., often to be sold within days or weeks. For many years, Ron could not or did not keep any of his paintings for his own collection. Selling his own

paintings made him triply rich and by the time he was thirty he had more money than maybe any painter ever had in history.

He lived rather simply, though. He had no car, no country house, he paid no attention to his clothes, did not drink alcohol, ate very little, and hardly ever left London, or Mayfair for that matter. Even the various attractive young women in his life had to cope with whatever life they found in the tall house in one of London's most expensive and famous squares. Just about his only extravagance, aside from the rare books he chose from his own store, such as Pound's first book, *A Lume Spento*, or the first printing (Munich) of Kandinsky's *Uber das Geistige in der Kunst*, was his picture-collecting. As early dusk fell and the light failed at his easel, Ron would go out and stroll around the art galleries close to his house. At least once a week he would find a picture to buy. A Sickert or a Bomberg or a Cezanne watercolor or a Degas brothel monotype, as well as paintings by his London contemporaries. From time to time he would buy a very expensive painting at auction. He owned six or seven paintings by Cézanne, his favorite painter.

Mayfair in those days was also what one might call a red-light district, up-market from Soho, beyond Regent Street. The Street Offences Act had driven working girls out of the streets and doorways of the West End of London into flats upstairs. These flats could be found behind the art galleries that Ron loved to wander. It was his habit, now and then, to walk around his district after having prowled the galleries, perhaps having bought a Morandi just as the gallery closed at night. First prowl art, then prowl sex. Ron most often called upon his favorite girl, or woman. Her name was Denise. She was French and about the same age as Ron, in her early thirties, when Ron started to visit her. Her flat was in Bruton Mews, which curled into Berkeley Square itself.

Bruton Mews was right behind art galleries such as Lefevre and Tooth's, where examples of Ron's own paintings were sometimes on view.

A little card in the doorway said FRENCH MODEL (DENISE) ONE FLOOR UP. Denise looked a little like Jane Fonda as she played the prostitute in *Klute*, though her hair, cut like Fonda's in that movie, was blonde. Of course *Klute* had not yet been made. Denise was handsome, square-jawed, and very obliging, which many whores hardly are, believe it or not. I mean to say, after studying them all my life, I can say that about half these magical women act, what shall I say, relatively unfriendly to their clients. And the other half are, well, friendly. Nice and not nice.

Denise was a nice person, never in a hurry except that the usual drama, from the first embrace to the end of the act, rarely took more than a half hour, often less. Of course, sometimes Ron had to wait if Denise was busy. A maid would open the door and usher Ron into a room with erotic magazines on a coffee table, saying "Denise will see you soon." He studied the pictures on the wall, which tended to be pin-ups of naked women. Before long, he would hear the activity of the last client leaving and Denise would appear smiling and wearing a short housecoat. They would then go into her bedroom, which had a large mirror alongside the bed, and a bathroom. Half an hour later Ron would stroll to the end of the Mews feeling good and not at all the shame that Flaubert said he felt upon leaving a brothel.

Ron could see his Maggs Bros. shop across the night square and that felt good too, just thinking about all those writers whose books were on those shelves in the dark. His books. Joyce, Svevo, Babel (his scarce Benya Krik film script), Gissing (who married a prostitute), Hart Crane's *The Bridge* in

129

its Black Sun slipcase, hundreds of rare books for sale garbled in Ron's mind with paintings and women. Ron was often not in full possession of his faculties, not free from confusion or giddiness.

Denise. Ask her out to dinner. One night he did. She was so nice she said OK, amused to be asked. She said she took days off, so how about next Sunday. All that Sunday Ron painted in his studio, upon one wall on which he kept his art books, the twenty-five painters he liked best, from Giotto to Mondrian and Matisse. He had never asked a working girl out before and as he painted on a small canvas inspired by a Lautrec oil sketch in his possession he was excited by its bravado technique. The theme of Ron's painting was Jacob wrestling the angel, which he had tried before and failed.

In his journal, Delacroix said he could hardly paint through the day without promising himself a woman at night. Or he said something like that. At table, in the restaurant, Denise told Ron that she had been in London eight years, having started in her profession in Paris. She had a ten-year-old boy at boarding school in France and she saw him quite often.

"Are you OK, I mean happy?" asked Ron.

"Reasonable happy," she said. "I mean I'm not depressed or anything."

"I'm glad," Ron said, "because my life so far has been very lucky. I'm rich as hell and someone like you makes me even richer, it seems to me."

"Why is that?" asked Denise.

"Because you seem magical to me," said Ron. "Your daily and nightly life, as I can only imagine it, is so original and traditional and secretive and daring and, well — public."

Denise smiled her winning smile and said, "Yeah, I suppose it's all those things."

"Has anyone asked you out before, like this?"

"No, but one or two of my regulars seem almost like friends."

"That's because you act beyond the call of duty. You bring out the best in a guy like me."

"Well, I sort of like what I do. I like the daily grind of it, the sameness, and what you call daring — the daring sameness. Even though guys want to do a lot of different things with me, it all seems like sameness, and yet every time I'm with a new man I'm sort of aware it's unusual to do what we're doing — daring sameness."

"Sounds like painting," said Ron the painter.

Back in his fabulous house, he put on the lights for her in hushed Maggs Bros. and then they went up two flights to his flat and then up the next flight, which was all pictures he had collected on the walls and on easels which stood everywhere like a small forest.

"What's this?" she asked, "It's beautiful."

"It's a watercolor by Cézanne."

"Oh, I've heard of him."

"He's my favorite painter of all," said Ron.

"Why?" she asked.

"Well, it's a long story. He's considered to be the father of Modern Art. He was the first painter to break away from the sort of realistic painting people expected, so he was laughed at by almost everyone, and he and his pictures were always insulted. I just love him for having the audacity to re-invent the human figure in extraordinary ways. He died in 1906, when a few people had begun to appreciate his revolution. He lived in Aix-en-Provence. Have you been there?"

"No, I never went to the Midi."

"He was quite rich because his father was a banker in

131

Aix, so he always returned home from hostile Paris, but they thought he was crazy in Aix, too."

"What's this? It's so sexy."

"That's a little line drawing by Egon Schiele. He died when he was twenty-eight. He was also mostly attacked. He drew beautifully, didn't he?"

Then they went upstairs to Ron's studio. She said she had never been in an artist's studio and that she knew nothing about art. Ron said that he had made the top floor into one large room with a skylight that let in northern light, which painters liked best. The concept of lofts had not yet become common and many of the London painters worked in rooms or small studios built for artists long ago. Denise walked around looking at the dozen or so paintings, some on easels, that Ron was working on. She said very little, but Ron tried to explain the few pictures to her in the context of what he called Modern Art.

She was amazed by the hundreds of oil-paint tubes all around and said that she had no idea there were so many different colors. Ron said he would like to paint her if she would pose nude for him, but it would take a few sessions, maybe as many as ten. He would pay her well, he said. She smiled and said she would think about it. He pulled a Manet book from his long Manet shelf and showed her *Olympia* and *Nana*, and he told her that these were very great paintings of working girls like her, but that sadly he could not paint as well as Manet, though he lived in hope. He told her that these paintings and Manet's art were hated and ridiculed in his lifetime, and that he died when he was fifty-one.

"This is all so new to me," she said. "My mind is spinning with the pleasure of all you have shown me. I want to, how do you say — digest it."

"Will you work tonight?" asked Ron.

"I don't know. It's still early for me."

"I'll walk you home, neighbor." So he did. It was about 11.

Back in his house, Ron felt sort of excited. He imagined Denise back at work. He picked up a little brush and painted a few strokes of Mars Black, deepening the outline of a head of Spinoza he was trying to do. He loved Spinoza and had been reading his difficult *Ethics* as well as Valentiner's book *Rembrandt and Spinoza*. The two geniuses probably knew each other in Amsterdam's Jewish Quarter, where they both lived, but no one has ever been able to prove it.

Ron cleaned his brushes in turpentine, turned off his studio lights, and went down to the floor below where he kept so many of his pictures by other artists. After a while he left his house and walked across the square to Bruton Mews. The lights were on and he read the little card: FRENCH MODEL (DENISE) ONE FLOOR UP. Up he went. A man hurried past him down the stairs, having emerged from Denise's flat. Ron rang the bell of the door on which another card said just DENISE. She opened the door herself. She was in her short housecoat and high sandals.

"Ron!"

"I felt like seeing you again."

"Come in."

They went into her bedroom.

"Now what?" she smiled.

"I've got something for you," he said, and pulled the little Schiele nude drawing from a plastic shopping bag.

"For me?" she said, astonished. "But it must be so valuable."

"So are you. I only paid a few hundred dollars for it when I was a student in Vienna many years ago. Yes, now it is quite valuable, so try to keep it safe. Here in your bedroom would

Three Tales

be a good place. No one will think it's an original drawing by a famous artist."

"How do you spell his name?"

"S-C-H-I-E-L-E. Egon Schiele."

"You are crazy. Crazy and rich and so sweet. I'll put it up over the bed where it belongs. Thank you. Thank you. Thank you."

Denise dropped her little coat. Naked, she urged him onto the bed and he joined her there. The bedspread stayed on the made-up bed as usual. While they were having sex, the doorbell rang and they heard the maid let someone in.

MATTHEW STEPHENSON

Honey and Poison: On Corruption

I

For as long as human beings have had governments, they
have worried about public corruption. The Hebrew Bible
warns repeatedly that those in authority — especially judges
— should not take bribes, "for bribes blind the clear-sighted
and upset the pleas of those in the right." The *Arthashastra*, a
third-century Indian text on the art of statecraft, cautioned
that just as one cannot avoid "tasting honey or poison on the
tip of the tongue," government officials will inevitably be
tempted to steal public money for themselves. Countless other
examples — from classical Greece and Rome to Imperial China
to the Islamic empires of the Near East — testify to the perva-

siveness of public corruption across cultures and across time. Indeed, from the ancient world up through today, corruption has been a central concern of statesmen, philosophers, and journalists — and the undoing of powerful figures and the catalyst for major reform movements. Anxiety over corruption also figures prominently in culture across the centuries — from Shakespeare's Brutus accusing his friend Cassius of having "an itching palm, to sell and mart your offices for gold to undeservers" to Lin-Manuel Miranda's Alexander Hamilton rapping that "corruption's such an old song that we can sing along in harmony."

And yet the problem of corruption, for all its ubiquity, is often neglected. Perhaps most strikingly, for a very long time the international development community — a shorthand term for the various government agencies, multilateral institutions, and non-governmental organizations focused on improving the well-being and opportunities of the residents of poorer countries — paid scant attention to corruption. This may have been due in part to the belief that corruption, while immoral and unjust, was only marginally relevant to economic development. The comparative lack of attention to corruption was also related to concerns about the political sensitivity of the issue: to talk about corruption is almost always to talk about politics. Indeed, at the World Bank in the 1980s and early 1990s, officials rarely uttered the word "corruption" in public, and referred to it behind closed doors as "the C-word" — a nod to the fact that this was a problem that everyone knew existed but agreed should not be discussed openly.

Roughly a quarter-century ago, this began to change. As is often the case, the process was gradual and the causes complex, so it would be a mistake to attribute the emergence of anticorruption as a central international development issue to any

one person or event. Still, at least symbolically, a breakthrough moment occurred in October 1996, when James Wolfensohn, then president of the World Bank, gave what came to be known as the "cancer of corruption" speech. Addressing the annual meeting of the World Bank and International Monetary Fund, Wolfensohn declared in no uncertain terms that to fight global poverty, organizations such as the Bank needed to promote "transparency, accountability, and institutional capacity," and, more specifically, "to deal with the cancer of corruption." Though Wolfensohn did not dwell on the issue — his remarks on corruption took up less than two minutes of his address — he did provide a succinct explanation of why corruption was a development issue: "Corruption diverts resources from the poor to the rich, increases the cost of running businesses, distorts public expenditures, and deters foreign investors." Today such a statement would be unremarkable. But back in 1996 it was a big deal, especially since, as Wolfensohn later recounted, he had been warned shortly after the start of his presidency not to talk about "the C-word." He ignored that warning — and, crucially, he did so by reframing corruption not as a purely political or moral issue, but as an issue that directly affected economic development. Corruption was now squarely on the international development agenda, and it remains so to this day.

137

Over the generation since Wolfensohn's speech, leading multilateral organizations, including the World Bank, IMF, United Nations, and OECD, have paid increasing attention to this issue, forming divisions and sponsoring projects devoted to anticorruption activities. We now have an international anticorruption agreement, the UN Convention Against Corruption (UNCAC), to which most countries in the world are parties (even if compliance is uneven at best); there are also

regional anticorruption agreements in the Americas, Europe, Africa, and elsewhere. Donor agencies, such as USAID, the UK's Department for International Development, Germany's GIZ, Sweden's SIDA, and many others, support extensive anticorruption programming. Anticorruption, in short, is on the map.

But despite this progress in the cause of anticorruption — the more sophisticated conception of it, the protocols and agreements — the idea that the international development community should make the fight against corruption a high priority is not universally accepted. Among the many objections to the emphasis on anticorruption as an integral part of international development, I want to highlight — and debunk — three quasi-myths that have gained more traction in these debates than they deserve. I call these ideas quasi-myths, rather than simply myths, because each of these them does have a kernel of truth. But each of these three arguments is, on the whole, more false than true, and more misleading than helpful.

The first quasi-myth is that corruption is a culturally relative concept, such that practices that wealthy Western countries consider corrupt are acceptable in other societies. The familiar refrain here is that in some cultures what "we" would consider a bribe, "they" would consider a gift — or more generally that Western norms regarding the line between the public sphere and the private sphere do not apply in many non-Western societies. Thus, the argument continues, when organizations such as the World Bank or USAID or the OECD promote an anticorruption agenda in developing countries, they are in fact imposing a set of values that are inconsistent with local customs and traditions. In its strongest form, the argument

accuses those promoting an international anticorruption agenda of engaging in a form of "moral imperialism," or even that these efforts are intended to advance Western economic interests (say, in lowering trade and investment costs) while stigmatizing non-Western modes of government and social practices as morally inferior.

The idea that "corruption" is a culturally specific concept, such that practices that would be seen as outrageously corrupt in the West are considered legitimate elsewhere, has a long history. Consider, as one particularly infamous example, the impeachment trial of Warren Hastings, the first British Governor-General of India, which began in 1788 (and dragged on, with frequent delays and interruptions, until 1795). Hastings was impeached for mismanagement and corruption. In his defense, he argued, among other things, that it would be inappropriate to apply British moral standards to his conduct in India, because practices that Englishmen would deem corrupt were part of the normal operation of government in Asia. Edmund Burke, who served as chief prosecutor at Hastings' trial, denounced this argument as "geographical morality." To the contrary, Burke insisted, "there is no action which would pass for an action of extortion, of peculation, of bribery and of oppression, in England, that is not an act of extortion, or peculation, of bribery and oppression, in Europe, Asia, Africa, and all the world over." Despite Burke's pleas, the House of Lords acquitted Hastings. To be sure, many of those who accuse modern anticorruption campaigners of moral imperialism would condemn Hastings for his conduct in India — he was, after all, a literal imperialist. Yet Hastings' appeal to "geographical morality" — what we might today call "moral relativism" — has a strong family resemblance to this more modern critique of the international anticorruption agenda.

139

Is there any truth to the argument that the international anticorruption campaign seeks to impose — deliberately or unintentionally — a set of values, practices, and institutions that are inconsistent with local norms and cultures in non-Western countries? The short answer is no. The overwhelming weight of the empirical evidence — derived from surveys, interviews, in-depth case studies, and other sources — indicates quite clearly that Burke was right and Hastings was wrong. At least when it comes to what we might think of as the "core" forms of corruption — bribery, embezzlement (what Burke called "peculation"), and the like — there is actually remarkably little variation in attitudes and moral evaluations across societies and cultures: these practices are broadly understood as corrupt and wrong, and are roundly and nearly universally condemned.

To be sure, there is more variation across societies with respect to what we might think of as "grey area" corruption, as well as with respect to when certain kinds of corrupt acts might be justifiable given the circumstances. This is the kernel of truth to the argument that different cultures have different attitudes toward what counts as (wrongful) corruption. Even here, though, we need to be careful about the implicit cultural condescension of assuming that what "we" consider corrupt, "they" would consider appropriate. Very often the difference runs in the other direction. After all, campaign contributions and lobbying activities that many countries would consider blatantly corrupt are treated in the United States as not only lawful but as constitutionally protected. More importantly, the extent of cultural variation in the understanding of corruption is relatively modest, and not pertinent to the forms of corruption that Wolfensohn and others like him have in mind. The idea that bribery and embezzlement are

the concerns only of wealthy Western countries, and that the prominence of an anticorruption agenda is therefore a form of Western neo-imperialism, finds essentially no support in the extensive research on what the residents of non-Western countries actually think.

Where, then, does this myth come from, and why does it persist? I have three conjectures. First, some who push this idea are as blatantly self-serving as Warren Hastings. The employees of Western multinationals who pay bribes to government officials in non-Western developing countries, and the officials who take those bribes, have an incentive to suggest that in the countries in question these so-called "bribes" are actually a manifestation of a rich and longstanding cultural tradition of offering gifts as a sign of respect. Second, some of those who advance the "moral imperialism" critique of the anticorruption agenda seem to harbor a deep (and perhaps understandable) mistrust of Western governments and multilateral institutions generally; these skeptics are primed to be receptive to the idea that an anticorruption campaign spearheaded by such entities is likely to have a hidden agenda.

The third possible explanation, which I would guess to be the most important, is that it is easy to mistake cynical or fatalistic resignation about corruption — an attitude that *is* quite widespread in much of the developing world — for the cultural legitimacy of corrupt practices. But these are not at all the same thing. Many people tolerate corruption, or even participate in petty corruption themselves, out of a feeling that they are trapped, that corruption is inevitable, that the system is rigged and there is nothing they can do about it. Such tolerance and participation can be misperceived as "cultural acceptance," especially when accompanied by rationalizations

that invoke venerable cultural tropes. But grudging tolerance and rationalization are not the same thing as moral assent and legitimacy. And when it comes to corruption—at least to core forms of corruption like bribery and embezzlement — there is far less variation in attitudes across countries and cultures than one might expect.

The second quasi-myth that is sometimes offered up as a reason to object to the international development community's focus on anticorruption is the idea that, at least in developing countries, corruption can actually help the process of economic development. Rather than being sand in the wheels of the economy, the argument goes, corruption may instead grease those wheels, enabling entrepreneurs and investors to cut through burdensome red tape and enter markets that would otherwise be inaccessible. This idea was nicely captured by Samuel Huntington, in 1968 in his book *Political Order in Changing Societies.* "In terms of economic growth," Huntington wrote, "the only thing worse than a society with a rigid, over-centralized, dishonest bureaucracy is one with a rigid, over-centralized, honest bureaucracy." What he meant was this: if the government has put in place excessive and inefficient rules and regulations that stifle economic activity, then the economy will be better off if the public officials charged with enforcing those regulations take "grease" payments to look the other way, rather than insisting on rigorous and scrupulous enforcement of the misguided rules. It follows from this that vigorous action to suppress corruption — for example, by monitoring bureaucrats more closely and imposing stiffer penalties on those caught offering or accepting bribes — may, if unaccompanied by other reforms to the regulatory system, actually worsen a society's economic prospects.

We should give the argument its due, because it too contains a kernel of truth. When the formal rules are inefficient — for example, when securing a business operating permit through the normal channels would take an inordinate amount of time and expense — then corruption may indeed function as an efficiency-enhancing grease. That said, even proponents of this view would acknowledge that in such circumstances corruption is at most what economists would call a "second-best" solution. Those who endorse the efficient grease hypothesis would also presumably acknowledge that *other* forms of corruption can have substantial negative impacts on the economy — for example, when corruption facilitates the subversion of government programs that enhance productivity and welfare. So the question whether corruption is, on the whole, more likely to grease or to sand the wheels of economic development is ultimately an empirical question.

There has been quite a bit of research on this empirical question since Wolfensohn delivered his "cancer of corruption" speech, and while the issue is not entirely settled (issues like this rarely are, given the challenges of isolating causal relationships in the available data), the overwhelming weight of the evidence suggests that Wolfensohn was more correct than Huntington. Corruption is far more often an impediment to economic development than a facilitator of economic development. One of the reasons for this was identified by Gunnar Myrdal in 1968 in his classic *Asian Drama: An Inquiry into the Poverty of Nations*. Writing in response to Huntington and others who had argued that corruption was a way for entrepreneurs to cut through bureaucratic red tape, Myrdal pointed out that much of this red tape had been deliberately imposed precisely to create more opportunities for extracting

bribes. While excessive red tape may lead to corruption, corruption also leads to the proliferation of red tape — which suggests that effective anticorruption measures can make it politically easier to eliminate needless regulations.

An even more important reason why corruption is more often associated with worse economic outcomes is that, while it may be true in certain contexts that corruption enables the circumvention of excessive business licensing requirements and other inefficient rules, there are a whole lot of other things that governments do that are important to economic development — things such as investing in infrastructure, supporting health and education, maintaining order, providing impartial courts and dispute resolution services, and enforcing rules that protect the integrity and efficiency of markets — that are undermined by widespread corruption. So while we should not dismiss out of hand the idea that corruption can sometimes function as an efficient grease, and we should certainly be mindful of the fact that excessive, inefficient regulations can both encourage corruption and inhibit economic growth, the idea that fighting corruption in developing countries will prove counterproductive because of corruption's supposed efficiency-enhancing properties seems by and large inconsistent with the best available evidence.

The third quasi-myth that sometimes comes up in debates over whether anticorruption should be a high priority for the international development community suggests a quite different reason for skepticism. Even if one believes that endemic corruption in developing countries is both immoral and economically detrimental in those countries, some critics

contend that there is still no point in making anticorruption a central agenda item, because there is nothing that can realistically be done about corruption, at least in the short to medium term. On this view, cultures of corruption are so deeply embedded in certain societies that corruption should be treated as an unfortunate but unavoidable constraint on a society's development prospects — like being landlocked, or located in the tropics, or having deep ethnic cleavages. In this pessimistic view, even though widespread corruption is a problem, few of the reforms or initiatives championed by anticorruption advocates have a realistic chance of making more than a trivial difference. It is just not a problem that can be effectively addressed through new policies or institutional reforms; the best one can do is to hope that long-term historical trends eventually produce a cultural change — but even that might be optimistic, given the alleged persistence of cultures of corruption across extended historical time periods.

Here again, there is an element of truth to the argument. Systemic corruption often does have self-reinforcing and self-perpetuating tendencies — corruption begets corruption, creating a vicious cycle that can make entrenched corruption very difficult to dislodge. But the idea that corruption is the inevitable product of some deep cultural tradition that developed centuries ago, and that only those countries lucky enough to have inherited a "good" cultural tradition (say, from northern Europe) have much hope of making headway against the corruption problem, is not only tinged with racism, but is inconsistent with most of the available evidence.

For starters, there is no systematic evidence — when one controls for other factors (like per capita GDP) — that particular cultural traditions have a robust correlation with present-day corruption. I should acknowledge an interesting

145

caveat: some researchers have found that, all else equal, majority-Protestant countries have lower levels of perceived corruption than majority-Catholic or majority-Muslim countries. But when one looks more closely at individual-level data, there is no strong evidence that individual Protestants have different attitudes toward corruption than do individual Catholics, Muslims, or others, and it seems much more likely that the apparent correlation between Protestantism and perceived corruption at the country level is spurious.

But the more important evidence against the notion that countries are locked into particular levels of corruption by their cultural heritage is that this view is inconsistent with the historical experience of those countries that today are viewed as relatively less corrupt. Consider Scandinavia. Today we have a stereotype of the Scandinavian countries as being very clean — which is fairly accurate, at least if we compare Scandinavia to other parts of the world. We sometimes imagine that this is because of some longstanding and essential feature of Scandinavian culture. But if we were to step into a time machine and go back a couple of centuries, things would look quite different. Things were rotten in the state of Denmark not just in Shakespeare's imagined medieval period, but up through much of the eighteenth century and beyond. The fight against corruption in Denmark got underway after the establishment of an absolute monarchy in 1660, but the Danish state did not get corruption under control until a series of reforms adopted over the course of the eighteenth and early nineteenth centuries. As for Sweden, at the turn of the nineteenth century the Swedish state was extremely corrupt, particularly with respect to rampant nepotism and the purchase and sale of offices (and there was a fair amount of garden-variety bribery as well). To observers at the time, before the significant reform

146

processes that took place in these and other countries, it might well have seemed that corruption was deeply embedded in these countries' cultures. The "clean" Scandinavian culture that informs our contemporary stereotypes really only emerged in the mid-to-late nineteenth century.

The extent to which modern "good performers" did not simply inherit a cultural tradition of clean government is illustrated even more vividly by the United States. To be sure, even today the United States is no paragon of government integrity. In comparison to most other countries in the world, though, American government has relatively low levels of bribery, embezzlement, and similar forms of corruption. But it was not always thus. Throughout much of the nineteenth century, corruption in the United States was rampant — especially at the state and local level, but at the national level as well. We do not possess international corruption indexes that go back to the nineteenth century, but if we did, and if such indexes were on a common scale, it is quite likely that the United States in the 1840s and 1850s, and perhaps as late as the 1890s, would receive corruption scores comparable to the scores that developing democracies like India, Brazil, South Africa, and Ukraine receive today.

Certainly it seemed that way to domestic and foreign observers at the time. In 1849, in his book describing his travels in the United States, the Scottish journalist Alexander Mackay remarked that he had heard several Americans declare "that they believe their own government to be the most corrupt on earth." Nearly a decade later, another foreign observer, the British MP William Edward Baxter, expressed his shock at the level of corruption in New York, reporting that "as great corruption exists [there] as was ever brought to light in the days of the Stuarts." And it was not just foreign

observers who made such damning comparisons. In 1858, the same year Baxter published his book, Senator Robert Toombs of Georgia lamented that while Americans may "speak of the corruptions of Mexico, of Spain, [and] of France, ... I do not believe to-day that there is as corrupt a Government under the heavens as these United States." A small-town newspaper editor who visited Washington D.C. that same year expressed his shock at the brazen purchase and sale of offices brokered by party leaders in the Senate, the White House, and various government bureaus, with "the actual sum of money to be paid for an office ... as publicly named ... as the price of dry goods are named between a dealer ... and his customers." These anecdotal observations, though perhaps a bit hyperbolic, have been largely corroborated by historians. The United States was, for much of the nineteenth and early twentieth century, mired in forms of systemic corruption not so different from those afflicting much of the developing world today.

Why does this matter? It matters because if countries such as Denmark, Sweden, the United States, and others suffered from widespread and systemic government corruption at an earlier point in their histories, then we should question the notion that countries that today have corruption more under control have achieved this because of some deep and immutable cultural inheritance, by a lucky historical break, and that countries where corruption is entrenched and systemic are likely trapped in that state due to inherited norms that are too deeply ingrained in their cultures to be dislodged through institutional and political reform. If countries such as the United States managed to make the transition from a state of endemic corruption to one in which corruption, while of course still present, is aberrational and manageable, then this warrants the hope that other countries that today face a

seemingly intractable regime of corruption might be able to make a similar transition.

II

But how can modern developing countries make such a transition? The historical examples are encouraging illustrations that such changes are possible and help to debunk the view that cultures of corruption are immutable — but they are less useful in supplying a template for modern reformers, given the dramatic differences in historical, economic, and political context. Even if we endorse the view that James Wolfensohn laid out back in 1996 — that anticorruption should be front and center in the international development agenda — we still need to ascertain what institutional reforms and policy initiatives can help to effect, under modern conditions in the contemporary developing world, the sort of transition that took place in wealthy Western countries much earlier.

One popular prescription — though not one that institutions like the World Bank can openly advocate — is democratization. The logic here is straightforward and compelling. Corruption thrives when those who wield power are not accountable to those they are supposed to serve; and since democracy makes public officials accountable to the populace through regular elections — and because people in just about every country find corruption objectionable — more democratic countries are likely to have substantially lower levels of corruption than less democratic countries, all else equal. The global democratization project, on this view, is also a global anticorruption project.

Matters are more complicated, however. It turns out that the evidence that democratization regularly results in improvements in government integrity is not terribly

149

strong. It is certainly the case that, even when one controls for national wealth and other confounding factors, countries that have been strong democracies for quite a long time are less corrupt (or at least are perceived as less corrupt) than other countries. But if one excludes from the analysis the relatively small number of countries that have been full democracies for over forty years (mostly though not exclusively Western European countries and the former European settler colonies in North America and Oceania), there does not appear to be a robust and consistent relationship between the level of democracy and the level of (perceived) corruption. In other words, while old, established democracies do seem to be notably cleaner than other countries, new democracies and partial democracies do not appear less corrupt, on average, than non-democracies. (Some studies have even suggested that new democracies and partial democracies might be somewhat *more* corrupt than autocracies, though the evidence here is not as strong.) More anecdotally, it is not hard to come up with numerous examples of politicians suspected or known to be quite corrupt who regularly win elections.

What explains the puzzling lack of strong empirical support for the view that democratization reduces corruption? One possibility is that democracy does indeed have corruption-suppressing effects, but only when democracy has become fully entrenched and institutionalized. If that is so, then we would have cause for optimism that some of the newer democracies will eventually see significant improvements in public integrity; we just need to be patient, and work to further strengthen democratic institutions. It could also be the case that new and partial democracies actually do have lower levels of corruption than autocracies, but autocracies are, on average, better able to suppress evidence of corruption,

thus leading the international corruption indexes, which rely substantially on perceptions, to systematically underestimate the extent of corruption in autocracies relative to (newer) democracies.

Maybe. But there is also a more pessimistic reading of the available evidence. It may be that "first wave" democracies are systematically different from second- and third-wave democracies, perhaps because the defining characteristic of a "democracy" (reasonably free and fair elections held on a regular basis) is not, by itself, sufficient to promote clean government. Without other norms and institutions in place, elections may become little more than competitions between rival patronage networks. Moreover, the expense of running a modern election campaign, coupled with the fact that electoral victory may be the key to (illicit) access to state resources, may actually encourage certain kinds of corruption. Indeed, many new democracies have seen an upsurge in corruption that is directly associated with the democratic process. Even though most citizens claim to find corruption reprehensible — and this claim may well be sincere — it may nevertheless be the case that in newer democracies in less developed countries, certain forms of corruption are helpful, perhaps essential, to winning elections and maintaining coalitions. If this more pessimistic view is accurate, then even though we can and should support democratization, we need to be more circumspect about the impact of democratization upon the attempt to eliminate corruption, at least in the short to medium term.

Another common prescription for addressing systemic corruption through broad institutional reform focuses on shrinking the size and the scope of government. The idea here is that a root cause of much of the corruption that afflicts developing and developed countries alike is a bloated state

151

sector, and an outsize role for the government — rather than impersonal market forces — in allocating resources. This is allegedly a recipe for corruption, because those with power over the allocation of resources (politicians and bureaucrats) will seek to leverage that power to obtain wealth, while those with wealth or connections will leverage those advantages to influence the public officials responsible for allocating public resources. Perhaps the most well-known proponent of the view that reducing government size is the key to taming systemic corruption was the economist Gary Becker, whose views were succinctly captured in the titles of two opinion pieces he penned in the mid-1990s: "To Root Out Corruption, Boot Out Big Government," and "If You Want To Cut Corruption, Cut Government."

Yet this hypothesis fares even worse than the hypothesis that democratization is the key to reducing corruption. It turns out that government size (typically measured by government consumption spending and/or government revenue as a percentage of gross domestic product) is strongly and consistently correlated with *lower* levels of perceived corruption, even if one controls for other factors like per capita GDP. In other words, those countries with governments that do more taxing and spending, relative to the overall size of the national economy, are generally perceived as cleaner than otherwise similar countries with smaller governments.

While this relationship is quite well established, the reasons for it remain unclear. One possibility is that a larger government is associated with a stronger social safety net and lower levels of economic inequality, and this may reduce forms of corruption that are driven by economic insecurity. Another possibility is that larger governments tend to spend more on things such as education, which may have corruption-re-

ducing effects. Larger governments may also have better paid, more professional, and more effective bureaucracies, and may invest more in effective law enforcement and judicial institutions. These and other hypotheses essentially suggest that the projects on which larger governments are spending public money are often things with corruption reducing-effects that tend to outweigh whatever increase in corruption may be associated with giving government officials a greater role in resource allocation.

Alternatively, or in addition, perhaps citizens demand more integrity from their governments when those governments are doing more, and when a broader and more affluent set of citizens are the beneficiaries of government programs. Put another way, larger governments may be associated with stronger citizen demand for clean government. That possibility also suggests that the relationship between larger governments and lower levels of public corruption may be due, at least in part, to a kind of reverse causation: perhaps citizens are only willing to support significant growth in the size of government when the public sector has a reputation for integrity; where corruption is widespread, expanding government programs may be less popular and therefore less likely. Relatedly, government decision-makers may not try to tax or spend as much if they expect a greater share of the revenue or expenditures to be stolen or misappropriated. On this account, political support for government expansion tends to rise as (perceived) public corruption declines.

While there remains considerable uncertainty about the mechanisms and direction of causation — whether expanding government tends to reduce corruption, or whether cleaner governments are more likely to expand — the simple hypothesis, propounded by Becker and others, that cutting govern-

ment size is likely to be associated with significant reductions in public corruption finds little support in the available evidence. That prescription also does not accord well with the historical experience of countries such as the United States, where the period of greatest success in fighting corruption — roughly from the turn of the twentieth century through the end of the New Deal — was also a period of extraordinary expansion in the size and scope of government, especially at the national level. None of this is to deny that there are some governments, and some specific government programs, that are bloated and consequently vulnerable to corruption. It is also not to deny that other forms of excessive government intervention — such as the needless red tape and inefficient regulations that Huntington and others worried about — may contribute to corruption, and that certain forms of deregulation might therefore have corruption-reducing effects. But as a general matter, the neo-libertarian view that smaller governments are more honest governments finds precious little empirical support.

154

If democratizing the political system and shrinking the state are not the magic keys to promoting government integrity, what sorts of measures are more promising? There is probably no single answer. Corruption is not one thing — it is an umbrella term that covers many related but distinct forms of misconduct, which may require different remedial approaches. Corruption takes different forms, and has different roots, in different countries. Therefore, as is true in so many areas of public policy, effective anticorruption efforts must be appropriately tailored to the local context. Those who work in this

field are well aware of all this. Indeed, the assertion that there is no "one-size-fits-all" solution to corruption is repeated so often that it has become a truism.

Still, while we should be cautious about making strong and unqualified claims about "what works" in fighting corruption, it would be a mistake to err in the opposite direction by neglecting the lessons that we can draw from the last twenty-five-odd years of academic research and practical experience in this field. And what emerges from that combination of research and experience is that, while there is not One Big Thing that can transform a corrupt system, there are a number of smaller things that often help.

The items on this list are not all that surprising. Strong laws, enforced by efficient, effective, and nonpartisan prosecutors and courts, while not sufficient, are very important. (A brief digression here: Many countries have created specialized anticorruption agencies with investigative and prosecutorial powers; some countries have even created specialized anticorruption courts or judicial divisions. These measures may sometimes be useful, if the creation of a separate entity helps ensure both institutional independence and sufficient capacity, but the track record of specialized anticorruption bodies is mixed. Operational independence and capacity seem to be what's most important; formal specialization is, at most, a means to those ends.) Effective law enforcement is essential not just with respect to those laws specifically targeting corrupt acts such as bribery and embezzlement, but also in what we might call corruption-adjacent areas such as money laundering and corporate secrecy. "Follow the money" is especially good advice when it comes to addressing grand corruption, as it is often easier for bad actors to cover up evidence of their underlying corruption — or to escape legal

accountability in their home countries — than it is for them to hide or explain away the proceeds of their illicit activity. So, some of the most effective anticorruption measures of the last decade or so target the money, seeking to locate, freeze, seize, and eventually return or otherwise redistribute stolen assets.

Within the bureaucracy, in addition to the enforcement of criminal laws and ethical rules, audits of government programs turn out to be quite effective in reducing theft and other forms of misappropriation. This might not sound that surprising, but it is nonetheless important. Rigorous empirical research has found that even in what we might think of as challenging environments for fighting bureaucratic corruption — such as Indonesia, Brazil, and Mexico — the knowledge that a local government or department's accounts will be subject to an audit substantially reduces irregularities that are likely attributable to corruption. More generally, the promotion of a professionalized, semi-autonomous civil service, with personnel decisions insulated from partisan political actors, appears to be consistently associated with lower levels of corruption. (Interestingly, civil service salaries do not seem to have as clear or strong an association with corruption levels, though at the extremes — when civil servants are paid very well or very poorly — there is anecdotal evidence of an effect on integrity.) What we might think of as the classic Weberian vision of bureaucracy — characterized by autonomy (at least from partisan politics), norms of professionalism, regular monitoring and oversight, and merit-based personnel decisions — is associated with less corruption.

Other measures that can help reduce corruption are those that facilitate the discovery of what would otherwise remain hidden misconduct. In this regard, legal and institu-

tional protections for whistleblowers, both inside and outside of government, are extremely important. At the very least, potential whistleblowers need to have access to reliable reporting channels that can credibly guarantee confidentiality, and whistleblowers must be protected against retaliation. Some countries, including the United States, have gone further, instituting schemes for paying whistleblowers whose tips lead to significant fines or other monetary recoveries. While systematic evidence on the effectiveness of such reward programs is not yet available, the anecdotal evidence thus far is encouraging.

In addition to protecting and rewarding whistleblowers, governments can help to reduce corruption by promoting transparency more generally. For instance, appropriately designed freedom of information laws, though by themselves insufficient, can facilitate monitoring by outside groups, such as the press and civil society organizations. Speaking of which, while the evidence that democracy reduces corruption is mixed, there does seem to be fairly strong evidence that within democracies, a freer and denser media environment, with more newspapers and radio and TV stations, tends to be associated with lower levels of corruption, and higher probabilities that corrupt incumbent politicians will be punished at the polls. (Perhaps unsurprisingly, there has been a fair bit of optimism in some quarters that modern information technology — especially the internet and social media — will have an even greater corruption-reducing effects, but the impact so far seems relatively modest.) Transparency may be especially important with respect to government management of valuable resources, such as oil and mineral wealth.

These, then, are some of the ingredients for an effective anticorruption strategy. Strong laws enforced by effective

and impartial prosecutors and courts; a professional Weberian bureaucracy subject to regular oversight but insulated from partisan politicians; and measures that promote transparency and facilitate monitoring and accountability. This list is incomplete, of course, and there is still a lot that we do not understand, but the basic components sketched above provide the appropriate foundation for an effective anticorruption framework.

III

If we know, at least in broad terms, a fair amount about the kinds of tools and techniques that are effective in reducing corruption, why does corruption remain such a systematic and pervasive scourge in so much of the world?

Though part of the problem may be a lack of capacity, the fundamental problem is political rather than technical. On the one hand, those with the greatest ability to change a corrupt system — those in positions of political and economic power — have the weakest incentives to do so. After all, these political and economic elites are, almost by definition, the winners under the prevailing system. On the other hand, those with the strongest incentive to change a corrupt system have the least ability to do so, because — again, almost by definition — these are the people who have been denied access to political and economic power. This is a familiar problem, hardly unique to the fight against corruption. There is an inherent small-c conservative bias built into most political systems, insofar as those who achieve power typically benefit more from the status quo than those who do not. But the problem may be especially acute with respect to endemic corruption, not only because many of the "winners" owe their power and wealth to the corrupt system that they have mastered, but also

because they (and their supporters and associates) might be held personally accountable for their misdeeds if that system changes. Convincing the elites in a corrupt system to support genuine and effective anticorruption reform is a bit like trying to convince turkeys to support Thanksgiving.

We know far less about how to overcome this fundamental political challenge than we do about the tools and techniques that, if fully and faithfully implemented, can substantially mitigate corruption. That said, the political hurdles to anticorruption reform are not insurmountable — after all, some countries have surmounted them, at least in part. A look at those (partial) success stories suggests at least three models for overcoming the inherent political resistance to genuine anticorruption reform.

One possibility, which we might call the "wise king" approach, is to centralize power in a strong and far-sighted leader who can push through dramatic and comprehensive anticorruption reforms without much resistance. If this leader is both a person of high integrity (or at least someone who wants to have that reputation) and sufficiently secure in his or her power, then the leader may be willing to take drastic action to transform a corrupt system. Such a leader would gain much more — in reputation, authority, and legacy — from fighting corruption than from letting corruption persist. Former Singaporean Prime Minister Lee Kwan Yew, who for all his faults deserves credit for the clean-up of Singapore in the 1950s and 1960s, is the most well-known modern example of this model in action. President Xi Jinping of China, who has made anticorruption a central theme of his presidency, seems to be trying to follow in Lee's footsteps, though his methods are unacceptable to supporters of a liberal order. Yet this approach is not limited to autocratic

159

countries. Some democratic systems concentrate substantial power in the chief executive, giving that person the ability to mandate sweeping anticorruption reforms that might be difficult or impossible in a system with more dispersed power and greater checks and balances. (Mikhail Saakashvili, who became president of the Republic of Georgia in 2004 after the Rose Revolution, is one of the most well-known examples.) And many a populist politician has campaigned on the pledge that, if the voters just give him power — and allow him to sideline or co-opt other institutions that might obstruct his initiatives — then he will clean up the system from top to bottom.

The "wise king" model is understandably attractive to those who are frustrated with the ability of corrupt elites to work the system to block anticorruption reforms. But it is an awfully high-risk strategy. Monarchy under a wise king may be among the best systems of government (at least if one cares only about outcomes rather than process), but monarchy under a bad king, or a mad king, is catastrophic. And the track record of powerful chief executives who have pledged to clean up corruption is not great. Many of the populists who emphasized the fight against corruption both as a campaign theme and as a justification for eroding institutional checks on their authority have proven not only ineffective in fighting corruption, but just as corrupt, or worse, than their predecessors. (Jair Bolsonaro in Brazil and Viktor Orbán in Hungary are particularly prominent examples, though there are plenty of others.) And when anticorruption policy is driven solely by the chief executive and his or her inner circle, there is a substantially greater risk that the fight against corruption will be weaponized, disproportionately targeting political opponents of the regime. So while it is possible that

the political impediments to meaningful anticorruption reform can be overcome by a sufficiently far-sighted and skillful leader, the risks of reliance on a powerful leader likely outweigh the benefits.

A second way in which it may be possible to overcome the political headwinds that make it so hard, under ordinary conditions, to sustain effective action against entrenched corruption is to take advantage of moments of crisis that give outsiders, or previously overmatched internal reformers, the opportunity to effect genuine change. We have a number of historical and modern examples of this model in action. The catalyst for Sweden's significant efforts to promote clean government over the course of the nineteenth century was Sweden's military defeat by Russia in 1909, and the resulting fear that Sweden's very existence was in peril. The widespread view that the country's disastrous military performance was due in large part to the corruption and dysfunction of the Swedish state (especially the role that nepotism and sale of offices played in placing incompetent people in key positions) inspired Sweden's liberal reformers and gave them more influence with the monarchy, and produced opportunities for reforms that threatened the interests of the entrenched nobility. A more recent example comes from Indonesia, where the Asian financial crisis of 1997 finally brought down Suharto, the corrupt autocrat who had ruled Indonesia for three decades. Suharto's fall ushered in the so-called *reformasi* period, which saw not only the democratization of Indonesia's government, but also numerous significant anticorruption reforms, including the passage of new laws and the creation of an unusually powerful and independent anticorruption commission, as well as a specialized anticorruption court. When a popular movement manages to topple the government, this

may also be a moment when good governance reforms that were previously politically unthinkable become feasible.

Of course, for reformers desperate to take on the corruption that is strangling their economies and undermining their governments, it is not so helpful to be told to wait for a major disruptive event like a disastrous military defeat or a financial crisis or a popular uprising. Still, there is an important lesson here, one that recalls the adage that fortune favors the prepared. Pressing for anticorruption reforms in a politically inhospitable environment can be frustrating, and developing carefully crafted legal or institutional reform proposals can seem pointless when the powers that be have little appetite for doing anything that could threaten the sources of their wealth and privilege. But one never knows when a moment of crisis — and opportunity — will emerge. What may have seemed like fruitless efforts to design and to promote politically infeasible changes can pay enormous dividends when the window of opportunity suddenly opens.

The third model for achieving a transition from endemic corruption to manageable corruption might be termed the Long Slow Slog. Rather than a single transformative moment — driven by a wise and powerful leader or a disruptive crisis — a movement away from endemic corruption can result from the slow accumulation of smaller victories and incremental reforms that gradually squeeze pervasive corruption out of the system and alter the norms of politics in a healthier direction. This process typically involves a combination of top-down and bottom-up efforts, with shifting coalitions of activists, journalists, professional elites, and business interests making common cause with reformist politicians who — out of genuine interest, strategic calculation, or some combination — make cleaning up corruption, or improving

government more generally, a high priority. The process can be frustratingly uneven and slow, with periods of progress followed by periods of stagnation or backsliding. And it is not really one political struggle, but rather a series of struggles involving various reforms, not all of which are explicitly or primarily about corruption. Yet the cumulative effect of these reforms, if they are sustained and expanded over a sufficiently long period, can be extraordinary.

There are those who are skeptical that the Long Slow Slog model for fighting systemic corruption can possibly work, given how corrupt systems tend to be self-perpetuating. But in fact this model may be the one that holds the most long-term promise. For what it's worth, the Long Slow Slog is the model that best captures the transformation that occurred in the United States starting around the end of the Civil War in 1865. As noted above, the United States in the mid-nineteenth century was, in many respects, a developing country, with levels and forms of political corruption not too different from modern-day developing democracies such as India or Brazil. By the start of World War II, corruption in the United States — though still very much a problem — was much less pervasive. And in the post-war decades, though corruption scandals continued to make headlines, matters continued to improve. This was not a quick or easy process — there was certainly no "big bang" moment. True, there were a few periods of particularly intense reform activity, especially the Progressive Era at the dawn of the twentieth century; there were also a handful of especially influential reformist leaders, including Theodore Roosevelt, Woodrow Wilson, and Franklin Roosevelt at the national level and Governors Charles Evans Hughes of New York and Robert La Follette of Wisconsin at the state level. But there was no dramatic moment of radical change comparable

163

to Indonesia's *reformasi* period in the late 1990s, nor a single transformative leader comparable to Singapore's Lee Kwan Yew. Rather, the reform process in the United States was a struggle on many fronts, one that was spread out over at least three generations.

Take, as one example, the struggle for civil service reform. Civil service reform is of course not only about fighting corruption, but it is an important aspect of the anticorruption agenda. The so-called "spoils system" — a form of what political scientists sometimes call "clientalism" — is arguably corrupt in itself, and indisputably facilitates and encourages other forms of corruption. In the United States, the first serious civil service reform bill was introduced in Congress in December 1865, by Representative Thomas Jenckes of Rhode Island. It went nowhere. President Grant did implement some modest internal reforms to the executive branch during his first term, and he formed a commission to recommend broader changes to the civil service, but the commission's ambitious recommendations provoked vigorous resistance, and by 1875 the push for federal civil service reform looked dead. But it rebounded, thanks in large part to a revitalized coalition of reformist activists and sympathetic politicians. The reformers' efforts received an unexpected boost in 1881 from the assassination of President Garfield by a disappointed campaign worker bitter over the fact that he had not received a government job in return for his political services. The political momentum for reform — boosted by the rallying cry that President Garfield had been, in effect, murdered by the spoils system — finally led to the passage of the landmark Pendleton Civil Service Reform Act in January 1883, just over seventeen years since Representative Jenckes had introduced his first bill.

Yet the Pendleton Act, while hugely significant in its creation of a "merit system" for a portion of the federal civil service, was quite limited in its coverage, applying to only about ten percent of federal employees — and even that limited reform provoked a great deal of hostility from politicians and party operatives. Notwithstanding this resistance, the merit system gradually expanded, albeit in fits and starts, over the next several decades, thanks to a combination of ongoing pressure from reformers and the political calculations of successive administrations. By the time Theodore Roosevelt took office in 1901, the merit system covered roughly 46 percent of the federal civilian workforce; by the time he left office in 1909, that figure had risen to roughly 66 percent. And by the time the United States entered World War II in December 1941 — almost exactly seventy-six years since Representative Jenckes had introduced his first civil service reform bill — the merit system covered approximately 90 percent of federal civilian employees, and almost every state had adopted and implemented a comparable system that covered most state employees. The U.S. civil service merit system was certainly not perfect, but if one compares the shameless and corrupt clientalism of the 1840s and 1850s to the much more professional administration that was established a century later, even the most jaded cynic would be hard-pressed to deny the extent or the significance of the progress that had taken place.

This is but one example of something we see in many countries and in many historical periods. Measures to fight corruption, and to improve the integrity and performance of government more broadly, may take a long time. But not only is incremental progress often possible, these incremental changes can also add up to a meaningful transition away from

a system that runs on endemic corruption to one in which corruption, though always a serious problem, is at least manageable. That observation — that the Long Slow Slog approach to fighting systemic corruption can be effective — may seem obvious, even banal. But this conclusion contradicts both the widespread fatalism about the impossibility of making significant progress against entrenched corruption and the view that making progress against entrenched corruption requires a "big bang." And though the conclusion that the fight against entrenched corruption may often require a Long Slow Slog might seem disheartening, the fact that such a strategy can ultimately bear fruit should be cause for optimism. Those who are engaged in the battle against systemic corruption — including both those who are fighting for change within their own countries and communities, and also those who are seeking to support change from outside — can take heart from the fact that although the problem may often seem intractable, a series of small victories, which may not seem by themselves to do much to change the fundamentals of a corrupt system, can add up to something bigger and more transformational.

166

This is not to say that corruption can ever be defeated. The temptations to use one's entrusted power for private advantage, or to use one's wealth and influence to improperly influence public decisions, are just too strong. And even as the "core" forms of corruption, such as bribery and embezzlement, become harder and riskier, those who want to use their power to acquire wealth, or to use their wealth to exercise power, will find other ways to do so — a point emphasized by those who criticize the political finance and lobbying systems in the United States and elsewhere as forms of "legal corruption." Yet it would be a mistake to be fatalistic or cynical. The

battle against corruption may not be a battle in which we will ever declare final victory — this cancer is not one that can be cured — but progress against this chronic disease of the body politic is possible, so long as those engaged in the fight do not lose heart.

HELEN VENDLER

The Enigmatical Beauty of Each Beautiful Enigma

Above the forest of the parakeets,
A parakeet of parakeets prevails,
A pip of life amid a mort of tails.

(The rudiments of tropics are around,
Aloe of ivory, pear of rusty rind.)
His lids are white because his eyes are blind.

He is not paradise of parakeets,
Of his gold ether, golden alguazil,
Except because he broods there and is still.

Panache upon panache, his tails deploy
Upward and outward, in green-vented forms,
His tip a drop of water full of storms.

But though the turbulent tinges undulate
As his pure intellect applies its laws,
He moves not on his coppery, keen claws.

He munches a dry shell while he exerts
His will, yet never ceases, perfect cock,
To flare, in the sun-pallor of his rock.

<div align="right">

THE BIRD WITH THE COPPERY, KEEN CLAWS
WALLACE STEVENS

</div>

———————

When I was a girl in my twenties, I had no idea what to make
of Wallace Stevens' mid-life poem "The Bird with the Coppery,
Keen Claws." I had come to feel indebted to Stevens' work; I
knew there was always a valuable presence inside every poem.
But I postponed thinking about "The Bird" because it seemed
too surreal, too unrelated to life as I understood it. The birds
I knew in verse, from Shakespeare's lark to Keats' swallows.
were mostly "real" birds, easily metaphorical birds, flying
and singing. Stevens' enigmatic bird, by contrast, was not
recognizably drawn from the real thing. The bird is offered
as a parakeet, but resembles no real parakeet, if only because
he is the "parakeet of parakeets," a Hebrew form of title for a
supreme ruler ("King of Kings, Lord of Lords") and because
he is characterized, Platonically, as "perfect." I couldn't make
sense of the described qualities of the "bird" because they were
wholly inconsistent with those of real birds, with those of any

imaginable "perfect" bird, and with each other. Stevens' bird (a "he," not an "it") is especially disturbing, because he possesses the powers of intellect and will, powers thought to distinguish human beings from the "lower animals": his "pure intellect" applies its complement of "laws" and he consciously "exerts / His will." And it is only late in the poem that we learn that the bird has intellect and will. What strikes us more immediately is that the bird lacks almost everything we expect in birds: he cannot fly, or see, or mate, or form part of a flock; he remains blind, perched immobile "above the forest" on "his rock." Put to such puzzlement, I fled, at first, the enigma.

And there was also the problem of the peculiar stanza-form: three five-beat lines per stanza, rhyming in no form I had even seen before — an unrhymed line followed by two lines that rhymed (*abb*). I had seen tercets in Stevens and other poets, but never this kind. In those other tercets, sometimes all three lines would rhyme (*aaa*), or sometimes they would interweave to form Dante's *terza rima* (*aba, bcb,* etc.). There were reasons behind the rhymes — *aaa* becomes emblematic in George Herbert's "Trinity Sunday," and *terza rima* was chosen to point to Dante in Shelley's "The Triumph of Life". But what could be the reason for this strange *abb*? There were *abba* poems, there were *aabb* poems, but there were no *abb* poems. It was an emblem of a lack of something, but of what? I was left guessing about content and form alike. And the stanzas were peculiar in another way: each of the six stopped dead at a terminal period. The reader is instructed, by the insistent conclusive period closing each stanza, to take a full breath between stanzas. Stiffly isolated, stopped after each venture, they did not seem to belong together, nor was there any ongoing narrative to connect them. Most stanzaic poems are more fluid than these representing the bird. Here, one

encounters obstruction after obstruction.

"The Bird with the Coppery, Keen Claws" made me ask why a poet would write a poem that seemed unintelligible even to a habitual reader of poetry. Why, I wondered with some resentment, would a poet offer me a poem that presented such obstacles? Only later did I learn that Stevens had said that "the poem must resist the intelligence almost successfully", with the "almost" saving the day by its compliment to the persistent reader. There was, then, work to be done by the reader before the linear string of stanzas could be wound up into a perfect sphere. I knew Blake's promise from *Jerusalem*:

> I give you the end of a golden string
> Only wind it into a ball
> It will lead you in at Heaven's gate
> Built in Jerusalem's wall

No memorable poem is devoid of art — and the art in the artless is often as difficult to find as the solution of the enigmatic. The "work" of the reader is normally a joyous one; but I was recalcitrant before "The Bird" because I did not yet know how to do the work Stevens expected of me. To be at ease in the poem seemed impossible.

What was the work the poet was demanding of me? It was to inhabit the poem, to live willingly in its world. To do that, one must believe that every word in a poem is, within the poem, literally true, and the first step must be to collect the literal facts from the words. From the title, we know that there is a bird, and the bird has claws. Facts of absence are as important as facts of presence. It is clear that the bird — because he does not sing in the poem — cannot sing, that the bird — because he does not fly in the poem — cannot

fly. Although some catastrophe has massacred all the other parakeets of the forest, the parakeet of parakeets has escaped that collective death. Once I understood that I had to take the bird literally, peculiar as that seemed, I became his ornithologist, recording the bird's traits, his present and past habitats, his powers, his hindrances, and his actions.

Stevens' bird strangely possesses an "intellect" and a "will," powers traditionally ascribed solely to human beings precisely in order to differentiate them from "the lower animals." But in spite of his possession of these formidable powers, the bird is strikingly deprived of the actions we most expect in birds: singing and flying. He remains mute, fixed "above the forest" on "his rock." Horribly, he also lacks a bird's keen sight; in a diagnostic logic inferring an inner disease from a bodily deformity, the poet declares dispassionately that "His lids are white because his eyes are blind." "Real" birds, like all organic beings, seek sustenance; they peck for food like the sparrow in Keats' letters, or sip water like George Herbert's birds which "drink, and straight lift up their head." But Stevens' bird is starving, and for lack of anything else feeds on a nutritionless "dry shell" (making it last as long as possible by "munching" it in slow motion). And for Stevens' parakeet there is no mate in this dreadful landscape of parakeet carcasses, this "mort of tails." (The dictionary reveals that the infrequent word "mort" means "a large quantity. . .usually with *of*," but it also hints, via "mortal," at the French *mort*, "death.") The bird is, in fact, the only "pip" of life remaining in his "paradise". (Keats, in a letter, wrote that "I am sorted to a pip," where "pip" means an ordinary numerical playing card, not a court card.) Although the bird's southern atmosphere, his "gold ether," is indeed paradisal, he, although he is its "aguazil" (a minor Latin-American official), cannot be its "*golden* aguazil," a fit inhabitant of his gold air.

The only thing paradisal about him is that "he broods there and is still," like Milton's Holy Spirit at the opening of *Paradise Lost*, who broods "o'er the vast abyss." Although the bird is the only living presence (with no rivals as well as no mate or progeny), this exotic creature, despite the gold ether, lives in radically imperfect surroundings. Of possible tropics-yet-to-be, there exist for him only a few unpromising "rudiments": an ivory species of aloe (a succulent that grows in arid soil) and an unappetizing pear with a rind made "rusty" by lethal pear mites. It is doubtful that these "rudiments" can ever again blossom into golden fruit and flowers.

Yet this flightless, blind, and starving bird is — as one continues to encounter his qualities — surprisingly active. The verbs describing his internal motions render them perhaps even superior to flight. He broods in his golden atmosphere, he applies laws with his "pure intellect," he spreads his tails, he munches (even if fruitlessly) on his shell, he exerts his will, and he brilliantly and unceasingly flares ("to display oneself conspicuously," says the dictionary). His flaring outdoes in radiance the sun itself, making the "real" sunlight on his rock seem merely a "sun-pallor." The bird's glory lies in his capacity to "deploy," to fan out, his splendid tail-feathers, which undulate in hue — by command of his psychedelic will — in "turbulent tinges." His obscure "tip" is an omen of the future: it is now merely a drop of water but is potentially "full of storms."

Although the bird is externally so immobile, mute, blind, and starved as to seem almost dead, he has begun to experience the feathery stirring of a new creation, in which a generative green turbulence will expand "upward and outward," populating the desert of carcasses with resurrected golden companions and a regenerated golden self. The powerful golden parakeet-to-be will be able to command, to sing, to

173

see, to fly, to mate, as he did in the paradisal past before all his earlier parakeet-companions were reduced, by some as yet unspecified agent, to a heap of corpses.

Stevens writes such a resistant poem in order, for once, to speak in his "native tongue," to offer not so much an intended communication as a private display. In general, writers want, in at least one work, to express in an unfettered way what it is like to possess a unique mind and speak a unique idiolect (think of *Finnegans Wake* or Raymond Roussel). An unforgettable account of the difficult gestation of such a "resistant" poem can be found in the Romanian-Jewish poet Paul Celan's "*Etwas*," or "Something," which narrates the undertaking and completion of a poem and speculates on its future in posterity. The poet, writing in German, painfully senses within himself an invisible and chaotic residue of excruciating feelings, splintered thoughts, piercing memories, and memorable words — shards of a lost whole broken into pieces by a catastrophe. Celan names the past catastrophe "*Wahn*," or "madness." Amid the shattered fragments of his former state, the poet rises to the task of creation, of bringing his past whole to life. And his hand, intent on conveying through words the almost unintelligible contour of his broken internal state, brings into a destined proximity the multiple "crazed" fragments of past wholeness, thereby creating on the flat page a hitherto absent unity, the archetypical perfect geometrical form, a circle, symbol of an indisputable completed whole. A circle cannot have parts; it is indivisible, without beginning or end:

174

Aus dem zerscherbten	Out of shattered
Wahn	madness
steh ich auf	I raise myself
und seh meiner Hand zu,	and watch my hand
wie sie den einen	as it draws the one
einzigen	single
Kreis zieht	circle

That is the poet's account of the silent period during which he watches his scribal hand — intent on retrievement — as it goes about its work of selection, consolidation, and abstract shaping, through which it finds its perfection. The hand magisterially draws the fragments together into a new shape — a shape that does not mimetically resemble the lost past; rather, it reflects the arduous work of bringing the past into intelligible form. In that moment of rapt success, of sequestered achievement, there is no one else present, no audience — no thought, even, of audience.

But there will be posterity, and Celan prophesies what the perfect silent drawn circle will become when, later, by the alchemy of a reader's thirst, it mutates from its two-dimensional visual form into an unprecedented "something" ("etwas") miraculously aural. From its flat two dimensions that singing "something" will in posterity lift itself into three dimensions, like a fountain, toward a thirsting mouth that will, by a unique reversal of the original silent writing, speak the dead poet's own words aloud in the reader's mouth:

Es wird etwas sein, später,	Something shall be, later,
das füllt sich mit dir	that fills itself with you
und hebt sich	and lifts itself
an einen Mund	to a mouth

To slake our thirst, the circle on the page reforms itself into the mysterious future fountain transmitting the lines on the page into nourishment for us. A life, shattered into fragments, has been re-constituted by the poet's drive to make not a reminiscence of the past but a work of art, a pure geometrical abstraction (Celan's "something"), powerfully satisfying a human reader's insatiable thirst for aesthetic and emotional accuracy.

I must confess that I have presented Celan's stripped poem in narrative order: first the creative assembling under the scribal hand, then (in posterity) a formed refreshment as the reader speaks its sounds. But my narrative order violated Celan's own chosen order: he puts first the poem's astonishing anonymous survival into futurity, and then looks back, now inserting the first person "I," into his own ecstatic work in creating the impregnable unshattered and unshatterable circle:

Es wird etwas sein, später,	Something shall be, later,
das füllt sich mit dir	that fills itself with you
und hebt sich	and lifts itself
an einen Mund	to a mouth
Aus dem zerscherbten	Out of shattered
Wahn	madness
steh ich auf	I raise myself
und seh meiner Hand zu,	and watch my hand
wie sie den einen	as it draws the one
einzigen	single
Kreis zieht	circle

176

Celan asks his reader, implicitly, Has my poem not been for you a relief of an unapprehended thirst? Wordsworth conveys a comparable relief in a poignant passage from Book IV of "The Prelude":

Strength came where weakness was not known to be
At least not felt; and restoration came
Like an intruder knocking at the door
Of unacknowledged weariness.

Stevens' native language in "The Bird with the Coppery, Keen Claws" is one of diction archaic and modern, of unsettling images, of strange assertions, resulting in a startling idiom. Like the language of any poetic style, it can be learned by "foreigners" such as ourselves, and, relieving our demanding thirst, can sound out aloud from our lips. The symbol will recreate the shattered. A poet composing a hermetic poem believes — as Celan here intimates — that posterity, helped by time, will make its sounds "come alive" again.

We can infer, from Stevens' self-portrait as a bird, the crux animating his creation: the shock of having to regard himself in his forties as the survivor of a "madness" of his own. Appalled, he sees that he had been, as a youth, desperately mistaken about himself, his judgment, his marriage, and his aesthetic ideals. His biography — when we look to it — confirms the psychological story of the youth-become-bird. Stevens had to leave Harvard without a degree because his lawyer-father would pay for only three years of schooling — the equivalent of the law school program he himself had followed. The young poet tried ill-paying appren-

177

tice journalism, but wanting to marry, he eventually conceded (like both of his brothers) to his father's wishes and went to law school. He encountered no ready success in his first jobs as a lawyer, but nonetheless married (after a five-year courtship conducted mostly in letters) a beautiful girl, Elsie Kachel, to whom he had been introduced in his native Reading.

She had left school at thirteen and, barely educated, was employed to play new pieces on the piano in a music store so that customers would buy the sheet music: Stevens had idealistic dreams of educating her to his own tastes for Emerson and Beethoven. Elsie's parents had married only shortly before her birth, and although her mother remarried after her first husband's death, Elsie was never adopted by her stepfather and retained (as her grave shows) her birth surname Kachel. Stevens' father disapproved of his son's choice of wife, and unforgivably neither parent attended the wedding. Stevens never again spoke to his father or visited the family home until after his father's death; at thirty, he was left fundamentally alone with Elsie. The marriage was an unhappy one, and Elsie, according to their daughter Holly, declined into mental illness. She did not permit visitors to the house, not even children to play with her daughter. Stevens did his entertaining at the Hartford Canoe Club; Elsie gardened and cooked at home. She did not visit her husband during his ten-day dying of cancer in a local hospital.

Several of Stevens' poems reflect both anger and sadness at the failure of the marriage: "Your yes her no, her no your yes" ("Red Loves Kit"); "She can corrode your world, if never you" ("Good Man, Bad Woman"). The poet suppressed many of those lyrics; they did not appear in his *Collected Poems* in 1955. But he left, in "Le Monocle de Mon Oncle," one transparent account of a marriage in which sex has occurred but there has been no meeting of minds or hearts:

If sex were all, then every trembling hand
Could make us squeak, like dolls, the wished-for words. . . .
[Love] comes, it blooms, it bears its fruit and dies. . . .
The laughing sky will see the two of us
Washed into rinds by rotting winter rains.

Humiliating realizations seeped in over the years of the erroneous marriage, eroding Stevens' youthful belief that his thinking was reliable, his personal judgment trustworthy, his aesthetic confidence well-founded, his religious faith solid, and marital happiness attainable. Such a crushing extinction of youthful selves left the poet immobilized in his marriage (he never complained publicly of Elsie, nor contemplated divorce). Starved of sexual or emotional satisfaction at home, working hard at the law, without the company of fellow-artists, unable to sing or soar, brooding in an arid world in which a lost paradise seemed to preclude any domestic hope, Stevens stopped writing poetry (publishing only a few minor pieces) for six years. Although he resumed writing, he did not publish his first book, *Harmonium*, until he was forty-four.

As time went on, Stevens' bitterness became occasionally ungovernable: even the Muse had become deformed and mad. In "Outside of Wedlock," when Stevens is sixty-six, the muse is an unrecognizable Fate:

The old woman that knocks at the door
Is not our grandiose destiny.
It is an old bitch, an old drunk,
That has been yelling in the dark.

And in 1944, in "This as Including That," a poem of self-address, he lives on a rock and is attended by "The priest of nothing-

The Enigmatical Beauty of Each Beautiful Enigma

ness": "It is true that you live on this rock/ And in it. It is wholly you." When at length he exchanged profitless bitterness for stoic resignation, he could, he discovered, still exert intellect and will in a single remaining channel — a hampered but energetic aesthetic expression. Against the "flaring" of beautiful tumultuous undulations Stevens sets the cruel portrait of himself as a bird living on a rock, isolating in his title — of all possible aspects of the bird — only the harsh successive sounds conveying its grating predatory talons, its "Coppery Keen Claws."

Eventually I became at home in Stevens' poem, and could ask why it took the strange shape I had found so off-putting. The first half of Stevens' self-portrait reproduces a bitterness and hopelessness untranscribable in ordinary language, as he had discovered in trying to write it down literally, jeering (in one suppressed poem) at his youthful romantic mistake with the graffito-title "Red Loves Kit." None of the specific facts of Stevens' life can be deduced from his poetic lines: his discretion and his taste required a departure from any transcriptive candor. Yet this allegorical leaf from a modern bestiary dryly transfuses into the reader the living state of its author — a blind starving bird in a charnel-house of former selves who nonetheless has not lost his brooding spirit.

The reader concludes that the massacre of the former forest-parakeets was carried out (since no other agent is mentioned) by their own ruler, the "perfect" parakeet of parakeets, his claws demanding their predatory use. In 1947, almost a quarter-century after "The Bird With Coppery, Keen Claws," the sixty-seven year-old Stevens, in the sequence

"Credences of Summer," bids farewell to the "slaughtered" selves of past infatuations and the raging misleading forces of his springtime. By this self-slaughter of memories and past actions he can even imagine a new fertile Indian summer, created by resuscitated generative flares:

> Now in midsummer come and all fools slaughtered
> And spring's infuriations over and a long way
> To the first autumnal inhalations, young broods
> Are in the grass, the roses are heavy with a weight
> Of fragrance and the mind lays by its trouble.

The parental and marital relationships that had as they occurred seemed so disastrous, causing that "trouble" in the mind, are now seen to be "false disasters," as, in the eternal return of the seasonal cycle, new energies promise to resurrect the lost parents and the lost lovers:

> There is nothing more inscribed nor thought nor felt
> And this must comfort the heart's core against
> Its false disasters — these fathers standing round,
> These mothers touching, speaking, being near,
> These lovers waiting in the soft dry grass.

Stevens could not always muster the laying aside of trouble. Three years later, in "World Without Familiarity," he rediscovers the very troubles he thought he had banished:

> The day is great and strong —
> But his father was strong, that lies now
> In the poverty of dirt.

Nothing could be more hushed than the way
The moon moves toward the night.
But what his mother was returns and cries on his breast.

The red ripeness of round leaves is thick
With the spices of red summer,
But she that he loved turns cold at his light touch.

A few lines later, he gathers together those troubles: they become "the poverty of dirt, the thing upon his breast, / The hating woman, the meaningless place." At seventy, the poet, speaking in ordinary language, can permit himself the literal truths that were so impossible to reveal in 1923. The outspoken words — "the hating woman, the meaningless place" — have become natural only because he has abandoned the old disasters as false ones: he sees they are in fact only what always happens in the everyday world, disasters not peculiar to oneself but held in common with all mortals.

The tumultuous green undulations of the bird never cease, but they ceaselessly modify their angle of motion. They are produced by the inevitable and necessary fluctuation of the mind in time, "that which cannot be fixed" (the subtitle of "Two Versions of the Same Poem"). Stevens' bird is so unhappy because he is fixed miserably everywhere in his life except in his plumes. He is a modern and depleted and clawed descendant of Marvell's beautiful bird in "The Garden":

Casting the body's vest aside,
My soul into the boughs does glide;
There like a bird it sits and sings,
Then whets, and combs its silver wings;

And, till prepared for longer flight,
Waves in its plumes the various light.

Upward and outward (one could say) Stevens' mythological self-bird waves in its vivid plumes the various light of its pallid sun.

What Stevens had before his eyes at forty-three, as, in his loneliness, he inspected his middle-aged marital and landlocked destiny, was a person immobilized in a life he would never be able to abandon, isolated from his birth-family, unable to see any rewarding emotional future, starved of erotic nourishment and companionship with others, brooding in the spectral company of his past foolish or infuriated selves, looking down at the inert heap of corpses over which he presides, yet still living in the desolate hope of a possible renewed paradise arising from those pitiful rudiments of aloe and pear. That person still possesses intellect and will, knowledge and memory, but is capable, trapped as he is, of interior actions only. Those internal actions awaken sensory, emotional, and intellectual desire: the bird's imagination is still stormy and turbulent, ever-capable of infinite creative variations in energy and hue, ever-flaring, obedient to his will; in its realm, he exercises his ultimate function, to "flare."

How carefully, searching for their symbolic counterpart, Stevens tallied each diagnosed deprivation, finding a convincing equivalent of each! One can only imagine the inventive rapture as each of his personal throng of deprivations found its chimerical name, one after another. The whole abjection of a past and

present existence lies on the page transformed into words of sharp-featured literalness and self-lacerating implication.

Most poems that touch a reader originate in a pang. (As Stevens said, "One reads poetry with one's nerves.") The pang is the nucleus generating the poet's literal bird. The pang is not "hidden." It is usually — as it is here — in plain view. Inhabit the literal world of this bird who is now you, as you recognize your emotions and write them down: you are immobile and alone, your companions are gone, you lack a mate, you cannot see at all, and you cannot sing. Yet this silent but tumultuous poet is witty in his correspondences: in the world of symbol, metaphor is true; the world is everything that is the case. There is no "hidden meaning": the poem is its own expression of a state of affairs, embodying actuality as its words come alive in our mouths. The poet longs for a depiction of reality as he has known it, and finds that he must resort to representing himself as an enigmatic figure in his own imagined forest, the supreme ruler of nobody. It is the unconcealed chill of the bird, transmitted by its cruelly sonic claws, that convinces us that this parakeet of parakeets slaughtered the fellow-parakeets of his youth when they proved delusory; yet the authorial distance and the cartoon-assemblage of the bird, in its "antic comedy," prevent Stevens' self-portrait from a transcriptive self-pity.

The enigmatical beauty of each beautiful enigma — says Stevens in "An Ordinary Evening in New Haven" — replaces (like Celan's perfect circle) openly revelatory autobiography. In the art of creating and displaying symbolic selves, men willingly lose "that power to conceal they had as men":

It is as if
Men turning into things, as comedy,
Stood, dressed in antic symbols, to display

The truth about themselves, having lost, as things,
That power to conceal they had as men.

As Stevens assembles the shattered fragments of his youthful delusions, he invents the mimetic geometrical form of an "incomplete" three-line stanza, one that can neither make its three lines rhyme nor find a fourth to make the stanza whole. If seeing the bird's plight makes us claim the misery — and self-reproach — in Stevens' words as they become our own, and feel the ever-available cruelty of our own keen claws of intellect and will, and ratify the necessity of our slaughtering the fallacies of youth for authenticity in later life, then we know we have thirsted for the chilly truth welling up as the beautiful enigma unveils its enigmatical beauty. In suppressing his own domestic history, Stevens avoids the misogyny of his complaints in earlier poems: by suppressing Elsie, he assumes sole responsibility for his own condition. When Desdemona is asked who killed her, she says "Nobody: myself." The once paradisal, now ugly world of the bird contains no company.

185

DAVID HAZIZA

Illusions of Immunity

In an already classic episode of *Black Mirror,* called "Arkangel" and directed by Jodie Foster, a single mother has her daughter grafted with a cerebral implant connected to a screen. The system, known as Arkangel, allows Marie to monitor Sarah's every action, and also to suppress stimuli that might cause her daughter distress. The system is equipped with a filter that can blur any troubling vision or sound in order to make her perfectly "safe." In this way Sarah grows up absolutely unaware of all the dangers that lurk along her way — starting with the barking of the neighborhood dog, which Arkangel prevents her from hearing.

When Sarah turns ten, a classmate entices her to watch graphic violence and porn. With the system still operating in her mind, she is unable to experience the attendant mental pain, and decides to draw blood from her finger in order to figure out what the fascinating fluid really is. At this point, realizing the harm that her own extreme worry about her daughter's vulnerability has caused her daughter, Marie disposes of Arkangel. (A psychologist tells her that it is anyway soon to be banned.) But it is too late. The implant cannot be removed from Sarah's brain. There is no way back. Years later — Sarah is now fifteen — Marie suspects that she has been lied to about a party that her daughter was supposed to attend. Crushed with anxiety, she turns on Arkangel, on the pretext of checking that her daughter is safe — only to witness Sarah's first sexual experience, peppered with the clichéd vocabulary gathered from the porn movies that she has been free to watch since she was left to her own devices.

This horrific tale — a parable, really — addresses helicopter parenting as the symptom of a broader and more formidable malaise. The real subject of "Arkangel" is the ideology of safety. To live a longer but narrower life; to see risk and its inherent poetry as a secularized version of sin; to renounce death and danger, hence renouncing life as well — those are its objectives, its prescriptions for happiness. "Everything in the modern world functions as if death did not exist," Octavio Paz wrote in *The Labyrinth of Solitude*, but the problem is that "a civilization that denies death ends by denying life." As a result of our rejection of death, Paz observed, it has slipped in through the interstices of the walls that we have built against its power. "Death enters everything we undertake... The century of health, hygiene, and contraceptives, miracle drugs and synthetic foods, is also the century

187

Illusions of Immunity

of the concentration camp and the police state, Hiroshima and the murder story."

Our dream of perfect immunity does not strengthen us, it leaves us weaker. On the assumption that, by scientific and technological and political means, we can make endurance moot, there is more and more that we find it harder and harder to endure. Safety, remember, is the opposite of resilience. We believe we can lock up life, but death resurfaces in the most brutal manner — in campus shootings or on Capitol Hill. A certain sense of hygiene, a kind of demiurgic pretension to complete control, has made us forget that we are animals, not robots. It is the animal within men that snarls and finally kills. We have chosen plastic over blood; but blood will strike back, and in such a ferocious way that we will wish we had found the balance between perfect safety and utter barbarity for which we were too lazy to search, too enamored of our fantasy of total protection.

To Roosevelt's Four Freedoms, we have added a fifth: the freedom from risk. In practice, it is the negation of freedom. Thus we have rid ourselves of privacy, as well as of humor and free-thinking, "wokeness" being in part a political avatar of the same phenomenon. In my view, there is nothing specifically liberal or progressive about it, and, to paraphrase the French title of Michel Houellebecq's first novel, it is merely a society-wide and culture-wide extension of the domain of safety. While many African-American or gay students may embrace it in order to foreclose freedom of speech on campus, it is certainly white in its provenance — if we are to understand this word as referring to a certain ethos rather than an actual incidence of melanin. That white ethos is, in a word, Puritanism, or more generally the long ferocious tradition of forbidding knowledge and protecting people

from sin and contamination, from any idea or experience that is dogmatically defined as an evil or a peril. In this regard, frantic suburban parents are no different than outraged BIPOC undergraduates. African-American or Native American activists show just how well they are now able to speak the language of any Long Island Sunday-lawn-mowing family man. (Cultural appropriation!) As in Ishmael Reed's *Mumbo Jumbo*, the vital — swinging and dissonant — force of the minority has surreptitiously given way to the majority's (or the noisier minority's) stiffened morality and exemplary nature. Puritan and white is the obsession with hygiene and toxicity (as in "toxic masculinity"), with stainlessness and spotlessness replacing salvation from sin. Puritan and white is the obsession with safety, with unbreachable havens, with "safe spaces" on campuses that are the spiritual successors of the believers' equally ardent craving for "being safe and secure in Christ."

But being safe is not enough. Even more urgently, we need to *feel* safe. America, after all, is the world capital of emotionalism. This desire is so widespread and well accepted that "feeling safe" has become a magical expression in everyday America. Your upstairs neighbor awakes you at four every morning? The landlord will not lift a finger to remedy the inconvenience unless you notify him that you feel unsafe, which will prompt him to act swiftly on your behalf. An Amazon package that you were expecting has not yet arrived? Write them that you "don't feel safe," and they will make every possible effort to assist you. People feel safe or unsafe being invited here or strolling there, entering a place that is or is not nut-free, discussing this subject or that. Our infamous "trigger warnings" stem from the idea that students may not only be offended, but actually imperiled, or at least feel so.

Some of these feelings, while not exactly rigorous calculations of risks and probabilities, have a basis in reality. Fear is not always an illusion. There are indeed threats which we need to recognize and to measure objectively. When we speak of the security provided to its citizens — or denied to them — by the state, we mean such things as objective "threat assessment" and the empirically grounded procedures developed to counter the elementary exposure of people to harm. But "insecurity" is also, and in our language more often, a reference to an inner fragility, a subjective inability to master fear, an incapacity for self-defense. Those who beg for "safe spaces" crave not the objective stability that one might legitimately expect from the state, but an inner insulation, a demarcation from challenge and disturbance, a locked-in and publicly guaranteed peace of mind. And because they want to be free from fear and contradiction, they mean to ensure it by a rigid regulation of speech. One of the instruments of safety is silence.

Conservatives limit their scorn for the contemporary crusade for safety to the political instances that suit their own purposes — "safe spaces" or campaigns for "cancellation" — while ignoring their own obsession with safety. Liberals, to be sure, are not consistent when they ultimately call for a new social approach to sex and love, which includes the suggestion of such authoritarian measures as getting rid of the statute of limitations on sexual harassment or assault; some of them advocate a quasi-totalitarian vision of safety while criticizing the Patriot Act as a fascist infringement on their freedom. In this sphere, ironies and hypocrisies abound. Yet conservatives are no more consistent, since many of them endorse every surveillance measure

across the board, refusing to see that these are a significant part of the general expansion of the domain of safety that they otherwise deplore.

Those *"petites règles compliquées, minutieuses, et uniformes"* which, Tocqueville holds, are instrumental to the social despotism that may deform a democratic order, now come down mainly to our obsession with safety. Modern states issue laws and regulations focusing on the most minute details of our private and public lives, from seat belts to smoking. We are living in a renaissance of technocratic paternalism, abetted by new developments in economics and social science. It is not entirely malign, of course. The twentieth century was a golden age of insecurity, with its world wars and wars of decolonization, its mass terrorism and migrations, its cultural uprootings and dislocations, not to mention the breakdown of the family unit, the spread of drugs and AIDS, and a general loss of stability. The fetishization of safety in the twenty-first century seems almost like a response to the decades of fear and dread that preceded it. This is a society in permanent need of reassurance. Some of our recent Covid19 policies had a performative quality that seemed to address a need for mental security rather than the virus itself. Even the anti-vaccine movement relies on a version of the precautionary principle — a baseless and paranoid version, a truly perverse instance of "safetyism."

Georges Bernanos saw the danger in the modern refusal of danger. In *La France contre les robots*, which appeared in 1947, he addressed the rise of generalized surveillance, observing that, although it had been initially promoted by democratic states, it resulted in the crushing of civil freedom by the fascists, the Nazis, and the Bolsheviks — and the destruction of millions of lives. To a nostalgic monarchist such as Bernanos, the fact that totalitarianism came to power in the West as the dark

face of democracy was no paradox: it promised the protection that "the people" desperately wanted. Bernanos made a striking observation about something we all take for granted — passports and fingerprints. Twenty years earlier, he wrote, no respectable Frenchman would have been fingerprinted, such a formality being reserved for labor camp prisoners. One could even travel with a simple business card, and someone else's name could well be printed on it. The ideal of safety could never justify the sacrifice of a person's right not to be spied on.

The quasi-anarchism that Bernanos admired was a matter of dignity and trust. Today his grievance sounds utterly archaic. Every citizen is, for his or her own safety, treated as if he or she were a soldier or a convict. It is awful — and in the case of the tech companies, it is nothing more than corporate avarice — but most of us accept it. If, on the one hand, we are more of a global village, with borders seemingly obsolete (in Europe, for example), those borders are on the other hand more hermetic than ever — as if a robotic kind of control were actually replacing traditional humane borders, just as an infantilizing and intrusive pedagogy has replaced more rigid yet also more empowering forms of education. Our panic about immigration is not unrelated to this terror of a loss of perfect control.

Our society has chosen surveillance over overt violence. This has deeper ramifications than the Patriot Act or biometrics. Your fingerprints are not only checked at the airport, where a certain degree of anxiety may be justified. As they are now able to monitor and to control — in a painless and almost invisible manner — their children's comings and goings, modern parents often prove to be exceptionally intrusive. The surveillance state is made up of surveillance families.

Parents who would gladly accept seeing their nine-year-old children change sex do not hesitate to regulate strictly, through sweet and safe suggestions, the way they interact with other children and learn how to live. Not in centuries have parents — and educators — so tightly swaddled their little ones' minds and wills: smooth-voiced policing is more manipulative and effective than the rod. Go to any playground. Back in the day — as many films, photographs, and books attest — parents would encourage their kids to go off and play with their peers, to brawl, scratch themselves, kiss one another, graciously lend toys and clothes to their little friends. Children were encouraged to experience life at their own immature and delightful level. Nowadays the perfect mom never loses track of her child, and harasses him or her with pointless words of caution or congratulation: "Good job, Cassidy!" Because, you know, Cassidy needs to feel empowered. Empowerment used to prepare one for risk. Now it prepares one for the avoidance of risk.

From their earliest age, children are deprived of time to daydream as well as of the opportunity to graze their elbow. Curiosity is regarded as just an invitation to trouble. "It's not polite to stare at people!" "Don't touch this: it's full of germs!" "Don't go there, you'll hurt yourself!" And once the children become teenagers, their parents will gently try to geo-locate them: after all, didn't they hide a camera in their nursery? They will be safe and healthy — healthy kids, then "healthy sexual citizens." "Healthy," meaning that you do not know what disease is, and "safe", meaning that you have never experienced freedom. From the vantage point of any philosopher, writer, or artist that lived during the past fifty centuries, the children will grow into half-dead human beings. They will be as dull as a plastic lid.

When you teach these grown-up children at university, it is no mean feat to make them realize that risk is not always the same thing as danger, nor is being challenged in one's instincts or beliefs the same as being threatened. After having been constantly praised for their prowess in the playground, they will have a hard time accepting that their research is unoriginal or flawed, or that they have shortcomings in art history, literature, or even pop culture — which is often more their parents' or instructors' fault than their own. Judith Shulevitz memorably reported in 2015 that students at Brown claimed they had been "triggered" by the presence on campus of a right-wing anarchist pundit named Wendy McElroy. In order to recover from their "trauma," they set up a "safe space" equipped with cookies, coloring books, pillows, and videos of frolicking dogs. In other words, they recreated a nursery.

What one has to understand is that the problem with "safe spaces" is not so much an ideological as an educational one. An entire generation — there are exceptions, of course — seems to have grown up in a paradise where God's universal mercy has the wondrous ability to make everyone the elect, and their every whim just so many strokes of genius. Parents of all political persuasions have sacrificed everything on the altar of safety, raising their children like Marie raises Sarah, sheltered from barking dogs. In an ethos in which failures and painful experiences are deemed harmful in themselves and lacking in any benefit or reward, high intellectual standards are fatally perceived as cruelty. Interestingly enough, elite parents are probably those least likely to see that our mind is like our immune system, or like any political entity — that it must be challenged to keep from ossifying. As a result, universities are teeming with *demi-habiles* who discover on arriving that a few seductive ideas could spare them the challenges of a more

thorough education. Affirm them, protect them, promote them, congratulate them.

But is there any more encompassing definition of privilege than this walled world of phony positivity? When one thinks of the many millions of children growing up in places that are not "unsafe" but *unsafe*, the present-day cult of protectiveness looks very unattractive indeed.

This puritanical safety is sought everywhere now, although it remains, by definition, out of reach. Once deemed wrong, sex is now deemed unsafe. From the rise of AIDS to the MeToo movement, we have been incessantly told that there is no such thing as safe sex — safer sex, maybe. In fact, the idea that the sexual revolution drew to a close with AIDS can only be understood against the backdrop of previous attempts at demonizing the sexual revolution. A few years earlier the curse was the spread of herpes, described as "the dark underside" of the flesh-pots of the 1960s and 1970s. For many commentators, AIDS was a new opportunity for a sex panic, and to impose their prudish agenda. Venereal disease — or STD, as we less poetically call it — had a moral meaning. Sexual guilt was part of the previous generation's frenzy. There was a sense that it had all gone too far, that the end would therefore come, that people might even get killed, like Sharon Tate, for the havoc that their hedonism had wrought. Disease, rape, and murder were now numbered among the results of freedom. The AIDS-related obsession with safe sex made a kind of sense in the general atmosphere of extreme anxiety.

Obviously, it was not only Patrick Buchanan who believed that "the sexual revolution has begun to devour

its children." More recently, this was made unexpectedly clear by the wide acceptance, in enlightened circles, of the reactionary interpretation of the sexual revolution as being "sexual predation," and, as such, the key to understanding Harvey Weinstein's and other crimes. As if no Sardanapalus had existed in previous centuries, freedom has been described as the true culprit. Desire is on trial. Lust is in the dock. As a response to the naïve Aquarian belief that eros could redeem mankind, there emerged the equally naïve but more depressing dogma that caution would save us. Abandon, wantonness, spontaneity, brazenness, audacity: in sexual relations these are now the slippery slopes to violation and injury. Our ongoing prudish moment is the Augustinian response to the *sola fide* cheerfulness of the 1960s. The ubiquitous insecurity of our era, the insistence upon omnipresent sexual jeopardy, is a backlash against that candid optimism. In both cases, the risks inherent to life are either ignored or bluntly delegitimated, with a new kind of temperance being now more or less officially advocated. Unlike in the Victorian age, this abstinence is espoused on behalf of safety rather than virtue.

196

None of these observations are meant to deny that there are risks that are real, and not worth taking; and that many men have treated many women, or many other men, odiously; and that rape is hateful and rapists are monsters; and that power has hitherto not been distributed to the advantage, or the parity, of women; and that offices should be more characterized by respect. But these alarms should not be confused with other concerns, which may seem similar but are emphatically distinct, in kind and in degree. We have carried our proper horror of abuse into regions of human ambiguity and excitement where it does not belong. It is not only rape, it is also lust

and its sort of love, that scares us. What has always made sex an occasion for awe is precisely its disruptive and destabilizing power, its inalienable riskiness. (Observers such as Norman Mailer in America and Romain Gary in France noted that this sense of awe was missing in the sexual revolution of the 1960s.) Sex is ringed with the dangers — of pregnancy, of death, or, more simply, of frenzy and fury and the loss of self. Spinoza distrusted *titillatio* because it shattered the soul-body equilibrium. The moral strictness of the Victorian age, the public rigidity of the 1950s (the private reality was more complicated), and our own cult of safety only point to a deep fear of wildness and confusion, of the instinctual life, of the explosive confrontation with finitude — of ourselves.

Moreover, we love to be scared and we love to be repulsed. "*J'aime avoir peur,*" Belle suggestively tells her monstrous lover at the end of Jean Cocteau's adaptation of *Beauty and the Beast.* Fear and disgust are part of the erotic experience, of life itself. When asked by the Beast if she does not find it repulsive to have him drink from her cupped hands, Belle replies: "*Non, cela me plait.*" It delights me! Those transgressive words bring to my mind another aesthetic memory. In Octave Mirbeau's *Diary of a Chambermaid,* Célestine, the eponymous heroine, sleeps with a young bourgeois, a certain Monsieur Georges, who is dying from tuberculosis. The passage in which she begs him to spit his bloody saliva into her mouth is probably one of the most ghastly in French literature — and also one of the most sublime. I have taught this text to American and other non-French students. Many expressed an understandable revulsion, but I have been struck by the fact that others, especially younger ones, seemed to enjoy the gorgeous peril depicted, the disturbing representation of a fanatical desire. As if a need for extremity was resurfacing in a tepid world.

197

In the 1980s, only Republicans and priggish WASP ladies advocated just saying no. A few years ago, I brought to the attention of my students a survey on Generation Z's sexual mores. It highlighted the fact that young adults — or teens from the age of fifteen on — were less sexually engaged than previous generations, did not take their driving tests, and were unable to understand facial expressions less simplistic than emojis. Many in the classroom laughed at the ingenuousness depicted in the article, but I remember that some self-described progressives did not see any problem with being abstinent until a certain age. Isn't it safer, they mused? In my literature class, a handful described the lascivious poetry I assigned to them as "objectifying" and therefore "wrong."

Many students actually enjoy going against the grain of the new orthodoxy, but what bothers me is that it is graduate students in the humanities who tend to think in the conformist way, and that most of those who share such puritanical qualms are not buttoned-down Episcopalian missionaries but radicals and progressives. The very people who will write a thesis on the question of transgenderism in French Polynesia are disturbed by sex when it appears in a novel. They feel threatened by it, they distrust the flesh, they want representations of sexuality that are sanitized and consistent with their apprehensions and their beliefs. Foucault even taught them that sex did not exist after all (though he certainly lived as if it did). As a consequence, they treat it as they do literature or art — as a social construct, a personal policy.

The war on passion and its indeterminate consequences extends also elsewhere. In the matter of transgenderism, it is interesting to see that what once undermined the safe borders of gender and identity — Myra Breckinridge-like — through sometimes aggressive and Dionysian rhetoric and art has now

become just another identity, as stable and cliché-ridden as all identities. In utilizing the acronym LGBTQ, we not only defend the rights of homosexuals and transgender people, we also disenchant them — inhibiting, in my view, a more genuine fluidity. Androgyny has been the most creative force in art and literature because it subverts the rigid definitions that we have inherited and damages the fences that morals and politics try to put around the sexual abyss. The pseudo-gender-fluidity currently promoted on campuses is a new type of fence. For the beauty of masculinity and femininity — which includes flamboyant androgynous men who are actually like women, and *garçonnes* as well — is indeed a threat to safety. There *is* something at once divine and demonic in beauty. Our puritans do not want our campuses to look like Plato's Academy, or our art history classes to be redolent of Eleusinian mysteries. Things have to be strict and neat. They do not want the Stonewall rebellion to happen again between the gates of our universities. The promotion of shapeless — and really asexual rather than transgender — body positivity falls within the scope of those institutions' increasingly intrusive control of their students' sex life. It is meant to circumvent the dangers of erotic experience.

Consent once pertained to the realm of the gift. The medieval *belle dame* who rewarded her devoted knight with her *don de merci* would thereby dominate him while also being somehow alienated by his power. It had to do with initiation and ritual, with magic. But the consent that latter-day feminists brandish at every turn resembles a notarial certificate more than this sacred gift of flesh. To be sure, most people still enjoy sex as they see fit, but many of them have been persuaded into believing that every step of a sexual encounter needs to be clearly, mutually, prudently established. The Antioch College

Sexual Offense Prevention Policy seemed awkward many years ago, when it was released. These days you are notified on entering college or graduate school that you cannot have a sexual interaction with anyone unless he or she has unequivocally consented. Ambiguity has been banished, as if it were an alibi for misogyny.

Safe sex, a postmodern Carrie Nation once expounded to me and hundreds of other graduate students, means that you have to ask permission before every step, from touching hands to French-kissing and so on — and I recall the words "enthusiastic yes" flitting through the PowerPoint on the podium. Whereas "no" certainly means no, "yes" is always suspected of not meaning yes. According to the current code, staring at someone in the library (I no longer recall for how many seconds) is inappropriate and threatening. Speaking flirtatiously to someone without having been encouraged to do so might also be an unsafe practice. You would think that Title IX enforcers have shares in dating apps. And this legalistic madness also demands complete prior transparency about oneself: in this climate the bill recently backed by New York Democrats, which would amend New York State's penal code to define consent as "freely given knowledgeable and informed agreement," makes much sense. Lying to a prospective sex partner about one's wealth or one's intention or even one's name would be considered an infringement upon consent. Mischief and play and deception will no longer be charitably interpreted.

One should be careful about strangers, to be sure — but strangers are also exciting, and every social and sexual relationship, beautiful or ugly, can only begin with a first meeting between strangers. There is certainly never a justification for coercion. Yet the unpleasant fact remains that

consent, valuable and even sacred as it is, is seldom easy to delineate. Attraction happens so fast. We must be wary of the expansion of the notion of consent, as of the expansion of the notion of safety. Efforts to construe it as more objective and palpable than it may reasonably be are potentially totalitarian, and certainly puritan, and anyway they will not preempt mistakes and misunderstandings. Such an unremitting quest for individual perfection, and for the perfect management of circumstances, is as futile in a secular context as it was in a religious one.

Germaphobia, the pathological fear of contamination, is a bipartisan disorder. Trump's wall against Mexican immigration was an expression of right-wing "safetyism," and the former President's description of himself as a germaphobe was consistent with this overemphasis on safety and purity — the alt-right's version of identity paranoia. If we remember that a great many parts of the American South are originally Mexican (as the names of its cities, mountains, and rivers attest), then Trump's stigmatization of Latino migrants must be read as an overall distortion, typically puritan, of America's roots — of the Latin substratum of a country desperately described as white. His contention that Mexican migrants are "rapists" only makes it more obvious.

Danger, contamination, and sex are interconnected in this worldview of fear and contempt, and they all relate to a certain part of the society that it wishes to hide or to erase. In Trumpian rhetoric, the Mexican plays the same role as the blacks and the Native Americans did one or two centuries ago (and in some quarters still do). He is the *Schatten*, the Jungian

shadow of the "civilized" white, and he is frightening for that very reason. (Jung remarked in *Symbols of Transformation* that white Americans often imagine the lower part of their own personalities in the guise of a "Negro" or an "Indian".) It is never safe to stare into one's own inner abyss. Southern whites championed family values and were obsessed with black rape, but they were merely projecting their own guilt onto the former slaves. Accusations against black and foreign sex maniacs, dropouts, or drug addicts only mirrored the immense and all-too real chaos that they, the whites, had themselves sparked. Had not slavery massively disrupted black families, while also allowing rape and consequently miscegenation?

To see the excesses of MeToo as, among other things, a revival of the puritan mentality amounts to realizing that the roots of this movement also lie in certain elements of the white American tradition — to recognize the MeToo aspect of those "honest" Southern ladies of previous centuries, shivering with fear (and probably fascination) on seeing a black male, and of Kenneth Starr and his lawyerly prurience, and of those who call President Biden "Creepy Joe" because he is more touchy-feely than their new propriety can tolerate. Trump's rallies were sometimes described as "safe spaces for Trumpists," and this was more than just an irony or an analogy: the Trump cult, too, seeks such spaces. For it, too, the world outside is a scary place, teeming with secret murders, pedophilia, conspiracies, and organized evil. State assistance, even in the form of public health measures against a pandemic, amounts for them to a new kind of idol-worship — the Mark of the Beast. Demons are everywhere, preying on our souls and our bodily fluids. A similar obsession with safety, then, with being saved from confusion and pollution and sin, pervades American mentalities across the political spectrum.

Ideological utterances stand out against the background of deeper and apolitical sensibilities. There are those who see nature as fallen, though originally good, and in seeking safety they are simply looking for a means to overcome their fallen state. They want the assurance that, being among the elect, the correct, the children of light, they will ultimately be redeemed from the realm of darkness. For others, nature is a benevolent mother, the source of goodness and beauty, and evil springs from social causes, from particular social causes, against which goodness and purity must be secured. Everybody seems to believe that they can have the kernel without the husk, that the shell of evil and ugliness can be somehow surgically removed, leaving good wholly unattached to evil, as if the attachment of the kernel to the husk, of light to darkness, is without any intrinsic merit, as if reality can be distilled and clarified, no doubt by radical means, to an unalloyed marvelous essence.

Yet a different view of the compound nature of human existence is possible. The biblical and kabbalistic mind, for example, envisions things quite differently. The God of Genesis creates light out of darkness, but He never erases the primeval forces of *tohu* and *bohu* — "welter and waste," in Robert Alter's fine translation. Life, whatever else it is, is also horror and chaos. *Tohu* and *bohu* still live within us — "in the bowels of these elements," as Marlowe's Mephistoph-eles suggests. That is why to experience life fully amounts to being often unsafe, or, rather, to renouncing any definitive sense of security. It is, in John the Savage's words, "the right to grow old and ugly and impotent; the right to have syphilis and cancer; the right to have too little to eat; the right to be lousy; the right to live in constant apprehension of what may happen tomorrow; the right to catch typhoid; the right to be tortured by unspeakable pains of every kind." A dangerous struggle, a

mortal right, for sure, but a vital one, inseparable from poetry, freedom, and even virtue.

In ancient Judaism, the Israelites had to bring, once a year on Yom Kippur, a sacrifice to Azazel, a desert demon or deity. They tried to placate this evil spirit with the ritual bribe known as the scapegoat. That is, redemption was reached through sin itself, rather than by its negation. The Brazen Serpent likewise cured Israelites who had been bitten by snakes. The waters of the red heifer purified the impure, but also rendered the pure impure. Mixture and the interpenetration of opposites was a kind of ontological structure. Impurity could never be eliminated once and for all. This is a way of thinking in which life extends into death and death into life — in which good and evil are like twins, holding each other's heel in their mother's womb.

This "primitive" mentality entails some measure of dirt-avoidance, but it was the modern age, paradoxically, that saw a broadening of the idea of dirt, even though it relies on more objective and sophisticated means and standards: hygiene and a knowledge of pathogenic organisms. It was moderns who created the illusion of perfect cleanliness. The ancient rituals recognized the potency of disorder even as they endeavored to create order. Danger lay in marginal states, and therefore it was both "respected" and combatted, and certainly not ignored. The ancient Israelites knew of Azazel, and they knew how to deal with him. They strived to avoid him, but they did not consider destroying him. Admittedly, their world was in a high sense safe and orderly, since it was supernaturally protected against impurity and uncleanliness. It was not, however, as secured as ours. In a way, they needed the element of insecurity which the neighboring wilderness, Azazel's realm, embodied.

In *The Birth of Doubt*, his recent book about uncertainty in early rabbinical literature, Moshe Halbertal demonstrates

204

that the ancient rabbis responded to the sectarian dread of impurity by granting more room for uncertainty. The Dead Sea sect, in the cloister of the desert, had utterly refused to engage with uncertainty regarding matters of purity — in the case of carcasses, for instance, which in the canonical priestly doctrine put people at risk of becoming impure and contaminating others. The rabbis refused to entertain such a fanatical — and utterly unrealistic — standard of clarity, and instead they expanded the realm of uncertainty, the legitimacy of doubt, in matters of law. This suggests that "safe spaces," conceived as secluded areas where no one may be endangered by the outside and the unfamiliar, are in some measure akin to structures such as the Qumran communities, or modern-day rigorist yeshivas, or Catholic convents — more or less isolated communities geared toward avoiding all stumbling blocks and precluding all contact with polluting influences. For ideas, like carcasses, can defile us.

Such rites as the Brazen Serpent worship were performed as late as the eighteenth century in Western Europe — and until today among those Hopi tribes whose beliefs and customs Aby Warburg famously brought to light. Many French and European cities — Bordeaux, Metz, Provins, Tarascon, Barcelona — organized processions to honor a saint who had supposedly vanquished a throng of snakes or a dragon in the remote past. The grateful citizens would parade a dragon made of wood or cloth, as if to show that the former enemy had become a friend and a tutelary power. In some cases, the procession was the reenactment of the dragon's killing at the hands of a revered saint, or rather the ceremony through which evil was transformed into good. The apotropaic symbol of the dragon became ubiquitous in the twelfth century as a protector of cities. Likewise, some

prestigious families put themselves under the patronage of a fantastic creature — in the era of the Crusades, for example, a wyvern (a mythical winged dragon) in the case of the renowned Lusignans clan, who claimed that they were descendants of Mélusine, half-woman, half-serpent, a benevolent figure of French folklore. After she left their castle, the venerable dragon-fairy would still watch over them, as an evocative illumination from the *Très Riches Heures du Duc de Berry* makes clear. In this way the dragon, although a symbol of Satan and therefore of ultimate discomfort and danger, could become, in premodern mentalities, an image of protection. Some aspects of the modern age still operate according to this logic. There is something apotropaic about vaccination, for instance, since it exposes us to the very threats it is meant to fight — the germs themselves — rather than merely abolishing them. (I am not suggesting that modern medicine is no different from medieval magic.)

As the ethos of caution and safety gains ground, one has to visit places where it has not yet triumphed to understand how strange it is, how alienated from our mortal realities, how afraid of flesh and death it is. Here is a familiar example. There is always a moment when, for all their open-mindedness, Western tourists in, say, Mexico City, or Mumbai, have to choose anxiously between their petty germaphobia and a more generous hedonistic urge. When they are tempted by the fragrant and colorful appeal of the street food, it goes beyond a gastronomic encounter: the decision to taste or not to taste involves their very tolerance for hazard. Now consider some old-fashioned European place such as the Bar San Calisto in Rome's Trastevere, where one may drink *caffè corretto* and smoke the *sigaretto* while peacefully listening to the first chirping and mewing of the pigeons and seagulls, or to the old

customers cursing each other in Roman dialect: do not urban pleasures, and even the sense of memory, go hand in hand with such "unsafe" practices? Does not Bohumil Hrabal's soul seem to rise to the ceiling of Zlateho Tygra, the great café in Prague, entangled in heavy smoke rings and the crisp and even rancid scent of beer? In most cafes and restaurants in Paris and New York, by contrast, our intolerance for anything "unsafe" is starkly visible in the absence of smoke and the decreasing presence of alcohol, in the *belles salades*, even in the spacing of the tables. And their nice clean walls, on which all traces of previous meals and earlier merriment have been scrubbed away, make them look like places without a past. These places attest to our longing for the impeccable, which amounts to an overall rebuke of history. Has anything human ever been impeccable, which of course means sinless? And so we pursue a safer but more desiccated life, a life of suspicion and surveillance, a life organized more around costs than around benefits, in a present secured in the comfort of its increasingly polished horizon, relentlessly riveted by itself.

207

A.E. STALLINGS

Sahara Dust

The air is sharp with dust: it's hard to breathe.
The sky's scraped white with it, the light turns gold
And ominous. I cough and cough and cough.
It blows each year from Africa, a seethe
That Pollocks the parked cars with ochre, rust,
The powdered pigments for the nimbus on
The icon of a not-quite-sainted saint,
An "osios" perhaps: holy enough.

The air is edged with dust. The black-bird sings
The riffed cadenzas of all other springs.
One magpie clatters, black and white as rain,
Clearing the grey matter of the brain.
The trees pull thin air out of light. It's quaint,

We used to think, Sahara dust. On cue,
Each year, but more and more. Oxymoron:
The desert empties but it doesn't shrink.
Worn carpet shaken out against the sky!
If sometimes there are clouds half-lined in zinc,
And tinted with a putto-bottom pink,
So are the sickly seasons furbelowed,
Too-late romantic as Rachmaninoff.

Our children know this evening of dust,
The chalky sky, my iterative cough.
It's like the future to them, tired hit song
They never have not known, so hum along,
But still I can't get used to it. Can you?
Is being newly old what makes it new?—
The past so fresh—like wet paint—no—like dew.

Time, Signature

When I was small, my grandmother, who taught piano, told
me someday I would learn to "read" music; I was astonished!
What ogres, what emperors, what gingerbread, what coffins
of glass? Perched on five telephone wires, birds noted their
gibberish, like an unspooled Phaistos disk. When grown-ups
crescendo-ed overhead, when discords tensed for the felted
hammer, I went pianissimo, and hid, dampened, beneath the
black-lacquered forte, my fort. Silence was a box of rest, like
stale licorice. If only I had the clef to the cryptic grammar!
Every girl, bored, dreams fairytales. Arching its monobrow,
the supercilious fermata suspended disbelief. When, later,
I learned that the only thing written in music was music,
imagine my disappointment, my relief.

210

What Brings Bad Luck

Hat on the bed,
A peacock feather
Dragged indoors
From the blue-eyed weather,

Reflection smashed,
A baker's dozen,
Chain letter from
An estranged cousin,

The bumbershoot
Bloomed in the hall,
The ladder's lintel,
The owl's call,

The horseshoe's frown,
The salt knocked over
& not tossed across
The left shoulder,

A lone magpie,
A pre-glimpsed bride,
Friday next,
The bed's wrong side,

The sable cat
Bisecting your way,
A crack underfoot,
The Scottish play,

A gleaming penny
Not picked up,
New shoes set
On a tabletop,

Scissors left open
From sheer habit:
A month begun
Without "rabbit, rabbit,"

The grave (whose?) trodden,
The wish (hush!) spoken,
A run of good luck
Still unbroken.

Jump Rope Song

(with a nod to X.J. Kennedy)

The rope that makes of air a sphere,
Or else a grin from ear to ear,
Is something earth-bound feet must clear

When the parabola swings round.
Right before the snapping sound,
You have to float above the ground.

The trick is tempo, neither slow
Nor fast, and rhyming as you go,
And then forgetting what you know

(The end of every glad endeavor).
You count, until the numbers sever,
Since nobody can skip forever.

The Caryatid

Even though she has set down
The unwieldy entablature
And walked back into her life,

Her posture,
Her disheveled intricate coiffure,
Betray preoccupation.

Preparing dinner, she slices
The fluted celery stalk into drums,
The mushrooms into ionic capitals.

She is too old to be young anymore,
The moonlight petrifies.
She has left beauty behind, a ruined porch.

It leaves her lightheaded,
Being freed from history, that long mis-
Understanding.

PAUL BERMAN

Our Literature

On the gloomy days, when the American catastrophes are
too much to bear, I turn to my bookcases for solace and even
something like friendship, and the shelves throw a welcom-
ing arm over me. The bookcases are organized on the princi-
ple of no principle, and nowhere among them is there a
section dedicated strictly to the traumas and treasures of life
in our unhappy country. Still, scattered here and about are a
number of squat volumes in sumptuous black dust jackets, all
of the same height, devoted to flights of the American imagina-
tion — a sufficient number of those books, such that, if I ever
gathered them together, a proper bookcase devoted to them

alone would stand before me. These are volumes in the publishing series called the Library of America, which brings out the classics of American literature, Emerson and Mark Twain and little-known names like William Bartram, the ornithologist, and onward to Saul Bellow and beyond, perhaps too much beyond, in a uniform edition.

One of those volumes plops into my hand. The cover is maybe a little too sumptuous. A glossy ribbon of red, white, and blue traverses the middle, as if it were a military sash on a colonel's dress uniform. The publisher's logo at the bottom of the spine is the Stars and Stripes, configured to suggest an open book. When I open the actual book, still more stars and more stripes blink upwards from the endpapers and the flyleaves. It is the Fourth of July. A tiny bugle says hello every time a page turns. Patriotism at the Library of America does not suffer from timidity. But I do like the feel of those books on my fingers, their heft, the cloth binding, the texture of the paper, and the buttery black dust jackets.

It was Edmund Wilson who proposed the idea for those books, and his way of doing so figures in the lore of the series. He came up with the idea during the Second World War, which was perhaps not an ideal moment for founding a new literary institution. Nor was he in command of major finances, or any finances at all, though significant financing was going to be needed. Still, he talked up his idea, and he persisted in doing so into the 1950s. And only in the 1960s, at a vexing moment in his life, did signs of progress come his way. He was in trouble for non-payment of taxes. The IRS was threatening to jail him. And Arthur M. Schlesinger, Jr., who was a White House assistant to President John F. Kennedy, put in a word on his behalf.

Kennedy turned out to be an Edmund Wilson admirer. This was not an obvious thing to be, from a White House

standpoint. Wilson had lately published a book about the Civil War in which he described Lincoln as a tyrant and the United States as a sea slug. And just then, in 1963, he published a pamphlet, *The Cold War and the Income Tax*, in which he explained that, given how abhorrent was America's foreign policy, he was *right* not to have paid his income tax. But Kennedy was a lucid thinker. Apart from encouraging the tax authorities to show mercy, he decided to award Wilson a Medal of Freedom. The IRS objected. The president responded: "This is not an award for good conduct but for literary merit." In one of the sections of *The Cold War and the Income Tax*, Wilson sketched his concept for a publishing series of the American classics. And Kennedy wrote a letter endorsing the idea.

Wilson had competitors and enemies beyond the IRS, though. These included the academic literary scholars and their professional organization, the Modern Language Association, or MLA. The scholars and the MLA were promoting their own editions of American literary classics at the university presses. The MLA and the universities commanded a degree of political influence, and they stymied Wilson's project at every turn, even if he did have a letter from the president. Wilson needed to enlist the support of major foundations, and the MLA made sure to get in his way. Finally he wrote up his frustrations in an essay called "The Fruits of the MLA," which ran in two parts in the *New York Review of Books*. By then it was 1968, a year of insurrectionary riots, and Wilson, nothing loath, went about staging his own riot in the pages of the essay. He explained that some of the supreme classics of the American literary past had fallen out of print, which was a disgrace. He explained that still other classics had remained in print, but only in editions published by the university presses in conformity with the MLA's very exacting scholarly principles.

Wilson was endowed with a regal self-confidence, and he had come to feel that, if anyone could speak on behalf of America's literature across the centuries, he was that person. And, on behalf of American literature, he had no patience for the MLA and its scholarly principles. He observed that, under the MLA's supervision, teams of academic scholars had gotten hold of various writings by William Dean Howells, or Melville, or Mark Twain, and had pickled them in footnotes and pointless annotations, which rendered the books unreadable. The labor that had gone into amassing those scholarly annotations was, in Wilson's word, a "boondoggle." The book prices of the unreadable university editions, thanks to the boondoggle, rendered the books unaffordable, except to institutions.

And then, having paused (as his readers may imagine) to pour himself another martini, he threw in a few remarks on the nature of academic life more generally in America. He noted a preposterous quality: "the absurdity of our oppressive PhD system of which we would have been well rid if, at the time of the First World War, when we were renaming our hamburgers Salisbury Steak and our sauerkraut Liberty Cabbage, we had decided to scrap it as a German atrocity." He noted the consequences of this academic system for American literature: "The indiscriminate greed for this literary garbage on the part of the universities is a sign of the academic pedantry on which American Lit. has been stranded."

In other countries, he observed, publishers had figured out how to preserve and present their own national literatures in attractive formats. The model was the Bibliothèque da la Pléiade in France, which published a "library" or series of the leading French writers from across the centuries. The Pléiade volumes were leather-bound and handsomely designed, and,

to judge from the displays in the French bookstores, they were a popular success, too. Perhaps if Wilson had been in less of a rush to show the United States at a disadvantage, he might have noted that, in spite of every achievement, the Pléiade had a lore of its own, some of which might bring us to reflect, by way of contrast, on America's virtues. The Pléiade was not founded by one of the old-time French publishers, but, instead, by an immigrant to France who was Jacques Schiffrin, from Russia. Schiffrin got the project started in 1931 with a little help from André Gide, plus some investments from Peggy Guggenheim. Schiffrin was a crafty publisher, resourceful in his frugality. I know this because one day at the Strand second-hand bookstore in New York I bought an ancient copy of the original volume in his series, an edition of Baudelaire, only to discover that, when I went to read it, the decaying leather cover split apart and revealed a padding of old newspapers. This filled me with respect, once I had gotten over my indignation. Luxury leathers and gilt lettering (another feature of the series) were meant to be alluring. But the series was also meant to be accessible to a large public.

And, to be sure, with the moderate prices that penny-pinching made possible, the Pléiade right away became too big for Schiffrin to handle on his own. With Gide's help, he merged it into the much larger publishing house that was Gaston Gallimard's. Only, a difficulty arose. In 1940, under German rule, the Aryan code went into effect, and, because Schiffrin was not only Russian but Jewish, Gallimard dismissed him from the house and kept the Bibliothèque de la Pléiade for himself. Schiffrin and his family just barely succeeded in escaping to Morocco, and then, once again with Gide's help, to New York — a story that was told some years ago by Schiffrin's son, the late André Schiffrin, an eminent American publisher, in his

memoir *A Political Education*. But the German occupation came to an end, and Gaston Gallimard turned out to be content with how things had worked out. Jacques Schiffrin's keenest desire was to return to France and resume his old responsibilities and prestige at the Gallimard house as the publisher of the Bibliothèqe de la Pléiade. But Gaston Gallimard was not interested in sharing what by then he regarded as his, and he went on publishing the series by himself.

About the books themselves, though, Wilson was right. The Bibliothèque de la Pléiade was a beautiful series, all in all. A reader today may have to imagine some of the beauty, given that in our own era France's version of the MLA has achieved an influence over the Pléiade, and various editions in the series have come to resemble the American university editions that Wilson so vigorously detested. Svelte volumes from the early years have swollen into fat little things, bulging with hundreds of pages of arcane scholarly annotations, printed in type fonts so tiny as to resemble dust motes. Endnote numbers creep across the pages like insects. And the book prices have swollen in tandem with the annotations. In Wilson's time, however, the Pléiade volumes were designed to fit into a man's coat pocket or a lady's purse. They were books that a reader could carry to the locations where reading actually takes place, which is not typically the university library, but may be, instead, the garden bench, or the café table, or the subway, or, for people such as Wilson, who used to read while walking the streets, the busy sidewalk. And the texts were uncluttered with notes and footnotes. You could read those books without feeling that a miniature professor was hectoring you from the bottom of the page.

So he proposed an American series on the model of the early Pléiade. It was a project to bring into print and keep in

print first-rate editions of the principal and well-remembered American writers of long ago. And the project was to bring into print the not-so-well-remembered writers, too, if their works were of permanent value — the historical writings, for instance, of Francis Parkman, the author in the late nineteenth century of *France and England in North America*, about the European colonizers and the Indians. Parkman, in Wilson's estimation, was one of the American masters of historical literature, whose works had disappeared almost entirely from the bookstores. By presenting his argument for this sort of thing in the *New York Review*, and by launching his insults at the universities and their indiscriminate greed for academic garbage, and by pointing out academic boondoggles, he succeeded finally in attracting sympathetic attention from people with institutional power.

His co-conspirator in this enterprise was the publisher Jason Epstein, a generation younger than himself, who was a pioneer of paperback publishing in the United States, not to mention one of the founders of the *New York Review*. And Epstein began, at last, to make progress. He did this at the Ford Foundation, where President Kennedy's National Security Advisor, McGeorge Bundy, one of the colossally failed architects of the Vietnam War, had ended up in charge; and again at the National Endowment for the Humanities, during the period when Joseph Duffey (who died not long ago), was President Jimmy Carter's appointee. It was a tale of bureaucratic machinations and big guns of the Democratic Party, as recounted a few years ago by David Skinner in the NEH magazine, *Humanities*. The progress was less than rapid.

By the time the initial volumes made their way into the bookstores, it was 1982, and Wilson was ten years gone. And yet those first volumes turned out to be faithful to Wilson's

original concept in every way, except perhaps in their chunky size, which was not nearly as compact as the Pléiade editions. Also, it is hard to imagine how Wilson might have reacted to the Fourth of July bric-à-brac. But the basics were correct. The volumes were free of disfiguring footnotes and other scholarly intrusions. A small amount of useful information was tucked, instead, discreetly into the back pages, where it belongs. The initial set of books were by authors whose names would define the project for the general public: Whitman, Hawthorne, Melville, Harriet Beecher Stowe. One of the Hawthorne volumes was not up to standard. The editors chopped up Hawthorne's short-story collections and, in a professorial sneak-attack, rearranged the stories in a pedantic order of their own. The other volumes were superb. And, in homage to Wilson, the initial set was followed right away by two volumes of Parkman's history of colonial North America, even if Parkman's volumes were never going to be a commercial success.

The Library of America adhered to one more concept of Wilson's, which was fundamental to him, though it was not something that he went on about in *The Cold War and the Income Tax* or in the *New York Review of Books*. This was still another inspiration that he drew from the French — in this instance from Hippolyte Taine, the literary critic, who was a great passion of Wilson's. Taine, back in the 1860s, was the founder of modern literary theory — the founder, that is, of the idea that literature *ought* to have a theory, and science ought to be its basis. In Taine's view, the moral sciences and the physical sciences were ultimately the same, and the science of literature

ought to be comparable in some way to physiology or chemistry. He explained it in the introduction to his monumental *History of English Literature*: "No matter if the facts be physical or moral, they all have their causes; there is a cause for ambition, for courage, for truth, as there is for digestion, for muscular movement, for animal heat. Vice and virtue are products, like vitriol and sugar; and every complex phenomenon arises from other, more simple phenomena on which it hangs."

The simple phenomena that bore on the science of literature added up, in Taine's formula, to race, place, and time. This meant, respectively, the influence of ethnic or national traits on literature; the influence of geographical location; and the influence of historical events. It is true that, in elaborating these ideas, Taine arrived sometimes at dubious judgments. The Aryan races, he figured, were beautifully poetic, metaphysically gifted, and scientifically innovative, whereas the Semitic races were faultily poetic, metaphysically stunted, non-scientific, and fanatical — which, then again, perhaps proves Taine's thesis by showing that he, too, was a man of his race, place, and time.

The belief that he had come up with something scientific filled him, in any case, with confident energy. Taine was superbly well-read in one language after another, vivid in his descriptions, skilled in his summaries. And the science itself, such as it was, allowed him to conjure a living quality in the history of literature. He pictured a world populated by writers across the generations, neighbors and kinsmen of one another, engaged in the easy conversation of people who share a background and inhabit the same terrain, even if they do not inhabit the same century — writers who produce their individual works, and, at the same time, by entering into colloquy with one another across the ages, produce the cumulative thing that is a national literature.

Our Literature

Taine saw a triumphal quality in all this. It was the triumph of individual temperament, one writer after another, set against the landscape of national traits and the past; and, then again, a triumph of the national temperament. And he saw a heroic quality in his own enterprise, as the scientific historian of literature. He believed that, by revealing the material factors that enter into literature, and by revealing the literary traits that result, he had uncovered the mechanisms that would permit writers and critics in the future to confer a conscious shape on the evolution of their own national literatures. We could become, in his phrase from an essay in 1866, "masters of our destiny."

Wilson adored Taine even as a child. His father kept an English translation of the *History of English Literature* on his shelves at home in New Jersey, and those volumes appear to have been young Wilson's introduction to criticism and the history of literature. It was Taine whom Wilson read in the street, as a young man in New York. He wrote at length about Taine in his study of Marxism, *To the Finland Station*, which came out in 1940. But his principal effort to bring Taine to bear on questions of his own time was in a book that he published three years later, even if, on that next occasion, he did not invoke Taine overtly. This was *The Shock of Recognition: The Development of Literature in the United States Recorded by the Men Who Made It* — one of Wilson's most brilliant books, though one of his least known, and long and egregiously out of print.

The Shock of Recognition is a compendium of commentaries by leading American writers (plus one or two Europeans) in the nineteenth and early twentieth centuries on the work of other leading American writers, perhaps from their own epoch or from an earlier one. These are commentaries by

writers who have felt a shock of recognition upon reading one another — commentaries that amount to an ardent and even intimate conversation between one writer and the next. Wilson drew his title from Melville's essay, "Hawthorne and His Mosses," which expresses how excited Melville was to discover the profundities of Hawthorne. But there is also a commentary by Henry James on Hawthorne, and by T.S. Eliot on Henry James and Hawthorne both, and so forth, with each entry presented by an omniscient Wilson, who, like Taine, appears to be at home across the entire reach of literature everywhere.

The immediate purpose of the book was to make accessible a series of lively discussions, some of them not well-known. But the larger purpose was to demonstrate that an American literature does exist — a national literature in Taine's sense, consisting of conversation across the generations among writers whose social backgrounds and language and dwelling places and shared historical experiences lend coherence to their discussion. The notion that an American literature exists was a nationalist conceit in the decades immediately before the Civil War. Sometimes it was a battle-cry for worldwide democratic revolution, no less, as in Melville's essay on Hawthorne, or in Whitman's poetry. But even in those years the idea of a national literature seemed to be more of a slogan or an aspiration than a description of reality.

For wasn't American literature mostly a stunted and provincial branch of the fertile literature that was England's — even if a few blowhards were claiming otherwise? Wasn't the soil of American civilization too thin to produce a genuine literature — even if now and then a lonely genius wandered out of the forest and published a book? Wasn't America's truest talent a gift for inventing industrial gadgets, and not

for expanding the literary imagination? Those were Henry James's beliefs. But Wilson wanted to demonstrate that American writers did recognize one another, and they did so from one generation to the next, and they did not merely look to England and Europe. The American writers understood their project to be in some respect cumulative. And their conversation was itself a literary achievement — an imaginative reflection on the American imagination over the course of time. Here, in sum, was a consciousness that was also a self-consciousness — "the developing self-consciousness of the American genius," in Wilson's phrase.

He himself was a classic representative of the long American tradition, in its original and narrowly tribal version. Wilson was a Mather on his mother's side, descended collaterally from the Puritan divines, which meant that he came from the same Calvinist background that, half a century before he was born, which was in 1895, had produced all but a few of the writers from those earlier times whom we still read today. It was natural for him to think of the literature in its long history as an extended conversation within a relatively cozy world of families and schoolmates and neighbors, which is how things did use to be in nineteenth-century New England — with an additional branch in a New York that descended from the Dutch, and another branch in the white South. About the African-American branch he was willfully ignorant, which I suppose is likewise the tradition, though in Wilson's case the willfulness is hard to understand. He was a contributor to V. F. Calverton's *Modern Monthly* in the 1930s and friendly with Calverton himself, and he had to go out of his way not to draw something for *The Shock of Recognition* from Calverton's much-admired Modern Library compendium from 1929, *An Anthology of American Negro Literature*, a pioneering work.

And yet he did understand that, even in his own intimate circles, the old American coziness was giving way to something more capacious. The most talented of his own closest literary companions when he was young — his Princeton schoolmate F. Scott Fitzgerald and their Vassar contemporary Edna St. Vincent Millay — were Irish Catholics, which, ethno-religiously speaking, represented a bit of a novelty in American literature. The novel development suggested still more novelties to come. And they came. These were developments that might have given pause to Hippolyte Taine. Then again, Taine, too, understood that populations change, and national cultures adapt and advance. The great forward step for English literature, in Taine's interpretation, was achieved, after all, as a result of the Norman conquest of 1066, which allowed the French to civilize the Saxon barbarians. The non-WASP conquest of a previously WASP literature in the United States, then, the arrival not just of Irish Catholics but of everyone else as well, on top of the contributors to Calverton's anthology, who had been here all along — this did not have to be a bad thing.

But the old American tradition, the central trunk, did have to be rendered accessible to people who might not come by it in the simple way that Wilson did, amid the marvels of father's bookshelves, or bestowed upon him by a beloved English teacher at prep school. Here was an obvious purpose of *The Shock of Recognition*. It was to show writers and readers that a self-aware American tradition did exist, and to display its nature, and to allow everybody to enter into it. Or the purpose, more grandly, was to show Americans what was American civilization, from the standpoint of the writers whom he took to be the central personalities. He had given up Marxism only recently, but he retained something of the deep

idea that had animated him during his Marxist years, which was the ambition, Taine's and Marx's alike, to put knowledge to practical use and become "masters of our destiny," which in this instance meant becoming conscious of our own culture and capable of adapting it as we like.

Wilson came up with his proposal for an American Pléiade in the same period, and it should be obvious that in doing so he was extending what he had done in *The Shock of Recognition*. His compendium of American commentaries was 1,300 pages and came to an end in 1938. But the proposed new book series of American classics was going to be, in principle, endlessly elastic. In this respect, too, it was going to resemble the Bibliothèque de la Pléiade, whose own series has by now expanded to some eight hundred volumes, which is perhaps too many — a concession to the need for annual commercial successes of some kind, even if the Pléiade editors can reasonably explain that the French literary tradition is, in fact, enormous. (And the editors can explain that, because the French tradition has sometimes claimed to be a universal tradition, they have reason to publish writers from other languages, too, in French translation.) And so it has been with the Library of America, which has likewise expanded.

There are some three hundred volumes in the Library of America by now, which is more than sufficient in some ways, and less than sufficient in other ways. Among those hundreds of books are boxed sets of science fiction and sports writing, not to mention a volume of commentaries on *Peanuts*, the Charlie Brown cartoon, which, to be sure, is imaginative. And snobbism is yesterday's yesterday. And a good essay is

a good essay. Still, an extra couple of volumes of Whitman are crying out to be included. There is an original sin to overcome in Whitman's case, which was that, because he was such an outsider, nobody in his own time ever brought out the shelf-long Complete Works that were standard for the other great writers. But he is, after all, the national poet, and shouldn't his complete poetry, and not just *Leaves of Grass*, be easily available, and his literary criticism, and his political essays? The Library of America has brought out two volumes of Wilson himself, as is appropriate. And yet another four or five Wilson volumes are likewise crying out for inclusion: his study of the American Indians, his labor reporting, his essays on Canadian literature, his study of Marxism, his novels, his poetry, and his book about the literature of the Civil War, not to mention his private journals, which are marvelous. The original Pléiade ambition was, after all, to publish full editions of the major writers, and not just a couple of representative works, which meant Gide's journals and not just his novels and essays. But I do not mean to complain. The Library of America has just now brought out an unpublished novel of Richard Wright's, *The Man Who Lived Underground*, thereby rescuing Wright, not for the first time, from the unappreciative and censorious publishers of his own era, which is precisely the mission: to preserve and protect the American literature.

I wonder if something like the Library of America could ever be founded in an era like our own. Wilson's proposal ran into obstacles that were daunting enough, such that it was forty years before his project came to anything. But at least in those years America enjoyed a degree of self-confidence, culturally speaking, and the Democratic Party was not averse to occasional feats of policy innovation. It should be remembered that, in the Kennedy and Johnson era, the New

Frontier and the Great Society were not just programs for social reform at home and democracy promotion abroad, but were also, in a small degree, intended to shore up the national culture. Kennedy made a point of turning the White House into a center for the arts, and Johnson took the impresario instinct to another level by establishing the National Endowment for the Humanities and its sister, the National Endowment for the Arts, quite as if arts and letters were matters equal in dignity, if not in budget, to agriculture and transportation. The Library of America was one more of those new institutions, on a miniature scale. It was different only in that, after the NEH funding had gotten it launched, the winds of independent financing filled its modest sails, and onward it floated, propelled now and then by further gusts of NEH beneficence, and guided not at all by Washington, but, instead, by Wilson's colleague Epstein, and his own colleagues and successors. Those were cultural achievements of the Democratic Party, directly or indirectly.

Only, that was long ago. Today everybody understands that anyone who stood up to speak on behalf of the higher zones of the national imagination would get shouted down at once in the name of one or the other of populism's contemporary demands, which are the leftwing demand for identity representation and the rightwing demand for a dismantling of higher zones in general. And the Democratic Party could hardly be expected to rise above those debates. I wonder even if anybody in the upper ranks of the party has given thought to these matters. If the Democrats did stop to reflect, however, they might observe that America's political troubles right now appear to descend in some degree from a collapse in cultural understandings, which might suggest that, back in the day, John Kennedy and the Johnson administration were on to

something with their cultural promotions, and some kind of policy to shore up the culture and its literature would fit rather well with policies meant to shore up the highways and the climate.

But I never meant to go on about politics. How did I even get started? I began this reflection standing in front of my bookcases, fondling one book or another as they slip into my hands — here is *Emerson: Selected Journals 1820-1842*, and here is *Emerson: Selected Journals 1841-1877* — precisely in the hope of leaving politics and its miseries behind. I wanted a vacation from the politicians. I wanted to read about the Over-Soul! But there are no vacations. The times are to blame, of course. Or maybe the volumes are to blame, with their Fourth of July covers and the spangled logos. Or the Biden administration is to blame, with its repeated and all-too-thrilling echoings of Democratic Party grandeurs of long ago.

Where Have You Gone, Baby Face?

232 I watched too much Turner Classic Movies at an early age. It can be a burden: all my celebrity crushes have been dead for at least twenty years, and to this day I think that marcelled hair looks normal. But my obsession with films of the 1930s and 1940s can also instill another bias in a contemporary movie nut: I have no doubt that the depiction of women in Hollywood films has never been as good – that is, as rich, as varied, as focused, as human – as it was during the height of the studio system. The fortunes of women in real life may have gone up, but the fortunes of women in movies have gone down.

This is, admittedly, non-obvious: this has been a banner year

for movies by, for, and about women. There are more female writers and directors working now than at any point in the past century (more on this later). Modern movie women can pursue careers instead of relationships; they are allowed to talk about racism or raise kids out of wedlock. So what's missing? Hollywood, for one thing. Women's pictures in the new '10s and '20s are mostly produced outside the major studios, and their audience is limited to the kinds of people with a high tolerance for indie movies. At best, this can produce sharp, sincere character studies which would have been impossible a hundred years ago; at worst, there is a self-conscious, artsy unfunness to the whole endeavor: entertainment is for children and comics fans, but we're here to watch a miscarriage or a rape. A quick look at any top-ten grossing list of the past shows a market dominated by big-budget action movies and pre-existing intellectual property. Almost all of them have male leads, excepting the occasional action heroine or Disney princess. The blockbuster model is hardly only a woman's issue — I have it from reliable sources that men also like interiority and nuance in their motion pictures — but the marginalization of female roles is one of its more noticeable side effects.

The present situation makes it easy to write off the scarcity of women on the big screen as a necessary consequence of commercial, profit-driven Hollywood-style cinema. But this is not so. Molly Haskell first described the problem in 1975, in her classic study *From Reverence to Rape*: "Women, in the early and middle ages of film, dominated. It is only recently that men have come to monopolize the popularity polls, the credits, and the romantic spotlight ... back in the twenties and thirties, and to a lesser extent the forties, women were at the center." Haskell was writing in response to the New Hollywood movement — a brief, brilliant blip in movie history when

major studios let young European-inspired directors make movies about anything they wanted. Most often, they wanted to make movies about themselves, or their alter egos — at any rate, about men. I'm not knocking it. The artist-driven approach produced many great films, which also happened to be overwhelmingly male. Hollywood has changed since then, but the balance has not changed with it.

The ironic truth is that it was at the height of the studio system — the great American movie factory — when women ruled the screen. The really important thing to understand about the cinema landscape of the 1930s is how much bigger it was: major studios such as Paramount and MGM would start and finish a new movie every week. Before television and the internet and $15 tickets, people watched more movies. Not only that, but the movies they watched were more varied — and, frankly, much girlier. If modern Hollywood is selling a certain kind of escapism, rooted in the heroic fantasy that a single exceptional individual can save the world, depression-era studios specialized in aspirational elegance and glamour. The super-powered heroes and global stakes that are so universal in today's blockbusters were unheard of in the 1930s. Instead, the most popular films of the decade include weepy female-led melodramas, musicals (whether the Astaire/Rogers vehicles at RKO, the scrappy, down-to-earth stage door movies at Warner Brothers, or Lubitsch's pseudo-European operettas at Paramount), romantic comedies, and literary adaptations from *Little Women* to *The Wizard of Oz* and *Gone With The Wind.* Even the most swashbuckling boys' adventure films had major roles for their female co-stars – what would Errol Flynn have been without Olivia de Havilland?

Since the studios of the 1930s produced many times more movies than their modern equivalents, the range of

problems they manage to depict is correspondingly broader. While navigating a stricter set of taboos than their modern counterparts, studio-era filmmakers evinced a much wider curiosity about women's lives. A list of major dramas would touch on, among other subjects, mothers forced to relinquish their children to give them a better life (*Stella Dallas, Lady For A Day, That Certain Woman*), elderly couples separated by financial necessity (*Make Way For Tomorrow*), prostitutes with tuberculosis (*Camille*), womens' prisons (*Ladies They Talk About, Condemned Women, Ladies Of The Big House*), religious chicanery (*The Miracle Woman*), violent gangster ex-boyfriends (*Midnight Mary, The Purchase Price*), and romances between upper-class men and working-class women, whether as Cinderella story (*Alice Adams*) or tragedy (*Three Wise Girls, Forbidden*). By placing women at their center, these movies were able to analyze an entire society — they were what the Indian cinema of the same era called "social films."

These varied films share some common characteristics. More often than not, economic issues are front and center. This was the great depression: poverty was the background radiation of everyday life. Hard times produced a smart, scrappy, unsentimental breed of heroine. It is impossible to imagine a bimbo in a '30s movie; the type simply does not exist. If a woman uses her sex appeal, it is always with intention and purpose. The overwhelming emphasis of these films is what their leading ladies want and what they will do to get it. Consider *Gone With The Wind*, which is really much more about the 1930s than the 1860s. Scarlett O'Hara is the quintessential '30s heroine when she makes a dress out of old curtains to seduce Rhett, and when she brutally claws her way back into a life of luxury, and most especially when she swears that she will never go hungry again. Of course she is completely awful,

but she wants to survive, and Vivian Leigh's performance keeps us magnetized for almost four hours through the sheer force of that desire.

Even the most sensitive and brilliant of the women's pictures of our day can start to feel a bit anemic in comparison. Our heroines are more realistic, more enlightened, and even more profane than their '30s counterparts, but also weaker and less ambitious. We like movies to be authentic and personal — sometimes the word "raw" gets tossed around — and in our culture the easiest way to show authenticity is through vulnerability. Pain feels more real to us than grit or desire. As a result, there is a distinct prestige bias for female suffering. Just last year we have had *The Assistant* (sexual harassment), *Promising Young Woman* (rape), *Never Rarely Sometimes Always* (abortion), *Pieces Of A Woman* (stillbirth), and *Beanpole* (all of the above and then some). Interestingly, most of the critically acclaimed films that do not revolve around some formative sexual or obstetric trauma are period pieces. The closer these movies get to describing our real present-day experiences, the more likely they are to depict women whose bodily autonomy has been intimately violated.

The movies of the 1930s are not at all shy about female suffering, or even sexual violence; at least they were so before the infamous Motion Picture Production code was implemented in 1934. The difference is in how this suffering is depicted: in the old films the suffering is the start of a story rather than its subject. Studio-era filmmakers were less interested in the inner mechanics of trauma than in actions that their heroines took in response — victimization as an engine for agency. One of my favorite examples, *Blondie Johnson*, begins when the titular protagonist quits her job after being sexually harassed by her boss. After spending one

236

night on the street, her ailing mother promptly dies, because this is 1933 and the concept of laying it on too thick had not yet been invented. Blondie — played by the remarkable and somewhat eponymous Joan Blondell — decides to get rich whatever it takes. She starts running confidence games, dates a gangster, and gradually moves up the ranks. Soon enough, she has bumped off the boss and taken over his lucrative bootlegging operation. In the end, she gets to have her cake and eat it too: as a sop to the censors, she is arrested and convicted, but the boyfriend survives, and they tearfully promise to build a new life together — on the level. The whole thing is great fun. Like *Gone With The Wind*, it is a clear empowerment fantasy: Blondie gets her own back against a system that failed to protect her, and she does it without relying on men. Blondell specialized in this type of no-nonsense working-class dame, and she does a brilliant job of channeling Blondie's anger and cynicism as they gradually harden into steely self-sufficiency. We want to see her be ruthless, and we are happy for her when she no longer has to be.

Yet Blondie is still a good girl at heart. Things take a darker turn in the infamous *Baby Face*, also from 1933, starring Barbara Stanwyck. Our heroine, Lily Powers, is the daughter of a slimy speakeasy owner in Pittsburgh. She is regularly groped by her father's customers, and it is heavily implied that he is pimping her out to them, too. The movie really starts when Lily responds to an everyday instance of sexual harassment by pouring scalding hot coffee on the offender's lap. What's really remarkable is the casual way she does it — the same natural motion she would use to pour a drink, with just a hint of a sneer. "Oh, excuse me," she drawls. "My hand shakes so when I'm around you." Lily has only two friend in the world: a black waitress, Chico, and an elderly German cobbler.

Where Have You Gone, Baby Face?

He tells her to read Nietzsche (really — the camera zooms in on the book), from whom she takes away a new credo: "all life, no matter how we idealize it, is nothing more or nor less than exploitation." (Before the censorship board got to it, the rest of the cobbler's advice read as follows: "That's what I'm telling you. Exploit yourself. Go to some big city where you will find opportunities! Use men! Be strong! Defiant! Use men to get the things you want!")

When her father dies in a gruesome explosion, Lily takes the lesson to heart. She heads to the big city, and soon enough is sleeping her way to the top of a major New York bank. There is a clever bit where the camera slowly and salaciously pans up the building as she rises from the office boy to the manager to the bank's president. Stanwyck plays Lily with a combination of concentrated contempt and barely suppressed rage — at herself, at men, at the world. When an altercation between two of her lovers leads to a murder-suicide, she barely reacts. In the end, she settles down with the bank president's successor, a smart, rich playboy who has her number and loves her anyway. As in *Blondie Johnson*, there is a last-minute and somewhat dutiful gesture at redemption: about thirty seconds before the credits roll, she is given the chance to trade in her million-dollar jewel collection for a chance to start a new life with him. We can believe they go on to live a happy life together, but I don't think it matters either way. Lily Powers can save her husband or she can keep her loot. It is her choice.

Every time I watch *Baby Face*, I find myself thinking about how impossible it would be to make it today. It is not that Lily is a bad girl — we have those. It is how thoroughly she gets away with it. The film offers no judgement. It hides no guilt or embarrassment about its ambitious and amoral heroine. A more modern film might try and build up our sympathy with Lily

by giving her a moment of softness, hesitation, or weakness —
that *de rigueur* vulnerability. It might emphasize her trauma or
the injustice of the society that enabled it. *Baby Face* does not
bother. This is one of Stanwyck's most closed-off performances,
and it does nothing to weaken her electric and sympathetic
bond with the viewer. That's another thing about '30s movies:
sympathy is not earned by weakness, but by strength.

The same principle is at play in *Stella Dallas*, a very
different Stanwyck tour de force. Here, in 1937, she plays
a poor mill-worker's daughter, Stella Martin, who marries
Stephen Dallas, a gentleman currently down on his luck.
They have a daughter, Laurel, but gradually they drift apart as
Stella's vulgarity offends her husband's more refined sensibil-
ities. Stella is loud and garish and associates with race-track
gamblers, but she does love her daughter, and she is horrified
when her reputation gets in the way of a teenage Laurel
making her own high-society match. In the end, she decides
to protect Laurel by giving her up to be raised by Stephen and
his new equally well-bred second wife. The final shot of the
movie is of Stella standing alone in the rain, smiling wrench-
ingly as she looks through the window at Laurel's wedding. It
is a blatantly manipulative maternal tear-jerker, but it works.
Stella's pain has made her strong. Stanwyck's performance is
so powerful precisely because it is so contained. Filmmakers
of the 1930s (and 1940s and 1950s) understood that stoicism is
more brutally effective at wringing tears out of an audience
than any raw emotional breakdown or drawn-out screaming
childbirth. We weep for Stella because she refuses to weep
for herself.

239

The same principle — drawing audiences in through strength and self-sufficiency — is equally alive in '30s comedies. The sunnier counterparts to films such as *Blondie Johnson* and *Baby Face* are the glorious pre-code Warner Brothers musicals — movies such as *42nd Street, Footlight Parade,* and *Gold Diggers of 1933.* They explore many of the same themes — exploitation, sex, capital, Joan Blondell's legs — but with happy endings and tap dancing instead of gang violence. I can briefly summarize all of them: there is a stage musical production featuring a wide-eyed ingenue (Ruby Keeler) who pursues a romance with a juvenile man (Dick Powell) while surrounded by a rotating cast of wisecracking chorus girls (Joan Blondell, Una Merkel, Ginger Rogers, Aline McMahon). These were some of my favorite movies as a child. I was enthralled by the huge, trippy Busby Berkeley musical numbers; everyone was so snappy and smart and fast on their feet. I did not realize until much later that all of these women were fairly explicitly trading sex for money, although the title of *Gold Diggers* should really have been a tip-off.

The plot of that movie centers on four dancers thrown out of work when their show shuts down. They want the same thing as Lily Powers wants: to marry rich, and as quickly as possible. But what she sets out to get with cruelty and grim determination, they pursue with ingenuity and charm. Since this is the softer side of depression-era cinema, they even get to fall in love. Again, there is no judgement here: only a shared understanding that one does what one must do to get by. If you want to understand what the movie is really about, I recommend pulling up the opening number on YouTube. It involves Ginger Rogers and a line of backup dancers in bikinis made out of coins singing about how we're all so prosperous now that the depression is over. At the end of the song, the

men from the bank show up to repossess the sets. In an early scene, Blondell's character reminisces about her old Park Avenue penthouse while McMahon casually leans out the window to steal the neighbor's milk. If they do manage to marry into a life of wealth and security, it is really no more than they deserve. The whole thing is adult fun, and not in the R-rated sense. Rather, it's that these women are grown-ups: capable, self-possessed, resilient, and realistic, but not without a good sense of humor.

This kind of sexual license was impossible after 1934, when the Motion Picture Production Code introduced a strict set of standards for on-screen conduct — there was to be no profanity, miscegenation, glorification of crime, ridicule of the clergy. Licentious nudity was forbidden, as was the implication of cohabitation before marriage, and filmmakers were urged to be cautious about married couples sleeping in the same bed. The really remarkable thing, however, is that the people who came up with this list of rules were less afraid of sex than we are now. The lingering threat of sexual violence is more common than sex as a fulfilling, mutually pleasurable activity. Is there an on-screen couple today who are obviously enjoying themselves half as much as Nick and Nora Charles? After the code, all that sexual energy had to go somewhere, and so it was channeled into a new kind of comedy: the screwball.

The enormous success of Frank Capra's *It Happened One Night* almost single-handedly launched Columbia Pictures into the ranks of the major studios in 1934 while setting the tone for every screwball comedy that followed. More than any other genre, I think, screwball exemplifies the fluid, lunatic equality of the cinema of the 1930s. The man and the woman in a screwball comedy (and if we can write a cultural phenomenon as significant as the Marx brothers off as an exception,

there is always a man and a woman) live in their own private world. They start out embedded in some kind of a civilization — the upper classes, a house full of elderly encyclopedia writers, the mob, not that it really matters — whose rules and norms fall away as the couple is pushed together. Too much is happening to them too quickly for everyone else to keep up.

It Happened One Night opens with sheltered heiress Ellie Andrews (Claudette Colbert) jumping off her father's yacht in Miami, swimming to shore, and catching a greyhound bus to New York City, where she falls in with the unemployed newspaper reporter Peter Warne (Clark Gable). High society and newspapers are two of the most popular screwball settings — both of them come with a rigid hierarchy and a specific, impenetrable constellation of tacit and explicit values that practically invites a benign sort of blasphemy. Those codes of conduct matter because we can leave them behind to watch Peter and Ellie, alone, in the middle of nowhere, gleefully turning all of them upside-down.

One of the funniest scenes in the movie comes when a gaggle of private detectives hired by Ellie's father show up at a motel where the couple are staying under an assumed name. Peter and Ellie are having a very real fight when the cops burst in — but she instantly puts on an injured Southern housewife bit and he effortlessly plays along. This is the first time we see how intimately they understand each other, how comfortably they fall back into playing a game with the two of them against the world. This is how screwball works: all the anarchy and nonsense and plot contrivances are a scaffold for two people to develop a deep sympathetic attachment to one another. Think about the scene in *Holiday* with Katharine Hepburn and Cary Grant doing back-flips in the playroom of her family's mansion while the grown-ups congregate downstairs, or the

bit in *Trouble in Paradise* where Miriam Hopkins steals Herbert Marshall's pocket-watch while he makes off with her garter, or when Ellie leaves her aviator fiancée at the altar to hit the road with Peter and spend their honeymoon in another cheap motel. In the process of falling in love, they recognize each other and begin to recognize themselves, without the impositions of family or class or sex. Screwball love is never simple or unspoken. At its best it is a perpetual give-and-take, a partnership, the continual process of making each other a better, freer person.

In sum: women on the screen in the 1930s project strength. They are independent and smart and stoic and, yes, very sexy. But is this so much better than what we have now — and what does "better" mean? Is it more realistic? More feminist? I could not say. Trauma does not reliably make people stronger. Weakness is a central part of being human. Everyone experiences it, and the stories we tell should reflect it. On the other hand, sometimes we all like to see ourselves in a position of strength, with irreducible inner resources, and utterly without self-pity. And comedy is an admirable response to hardship — a sign of mastery. I miss the scrappy depression-era way of looking at the world. It is not the only way to go through life, but we could use a little more of it.

243

The question remains — what changed? There are a lot of things Hollywood studios took more seriously other than contemporary indie producers (starting and ending, of course, with profit). But female audiences were high on the list. Until the 1940s, when studios started conducting empirical research on audience composition, it was widely assumed that most

people who went to the movies were women. Even then, the attitude took a long time to die. In *Picture*, Lillian Ross's account in 1952 of the making of John Huston's *The Red Badge of Courage*, she describes an early meeting with Dore Schary, the head of production at MGM: "There was resistance, great resistance, to making 'The Red Badge of Courage.' In terms of cost and in other terms. The picture has no women. This picture has no love story. This picture has no single incident ... these are the elements that are considered important in determining success or failure at the box office." Imagine an era when not having any women was the first and most obvious predictor of a box office flop!

The industry focus on female audiences is even starker in fan magazines such as *Photoplay* and *Modern Screen*. A quick glance at the advertisements makes it clear who their readers were — the most popular products are cosmetics, laundry soaps, and outfits worn by the stars — "faithful copies of these smartly styled and moderately priced garments on display in the stores of representative merchants whose firm names are conveniently listed on page 115." These fan magazines helped to create another key element of classic Hollywood filmmaking: the star persona. Working closely with the studio's own publicity departments, fan magazines gave stars a continuous identity that they carried with them from picture to picture. (Today we would call it their "brand.") Greta Garbo was invariably alluring and otherworldly. Norma Shearer was poised and ladylike. Marlene Dietrich was sexy, exotic, and independent (though – as the magazine occasionally reminded its readers – she still loved nothing more than visiting her little daughter and husband back home in Germany). A spate of articles around Katherine Hepburn's screen debut in 1932 crafted the narrative that would, with remarkable

precision, define her career for the next six decades: a sophisticated thespian with patrician New England roots, but also something of a tomboy. One glowing review noted that she made her stage debut at age eight in a production of *Beauty and the Beast* – and she played the beast.

The magazines' female readers were encouraged to view female stars as aspirational figures. They identified with the character that the star created for herself much more than with their role in any particular film. In one fascinating letter published in the January, 1934 issue of *Photoplay*, a Miss A. M. Johnson describes her own cinematic education as an awkward young girl: "Watching the incomparable Shearer, she learned to have poise and self-assurance. Watching the breathtaking beauty of Marlene, the ethereal loveliness of Garbo, the lady-like Harding and the sweet sincerity of Hayes, she kept on learning. She isn't timid any longer, or lonely. She is popular now. She had, for the asking, the greatest teachers in the world." One of the reasons '30s stars always projected strength is because audiences in that era did not go to the movies to see reflections of their own weakness.

The stars were supposed to be like them, but better: more glamorous, more poised, more capable. The most successful of these actresses — Katherine Hepburn, Bette Davis, Barbara Stanwyck, Joan Crawford, Greta Garbo — had the power to shape the material they were given. Indeed, they shaped it simply by bringing their enormous individuality to bear. It is impossible to imagine any other human being making some of the acting choices that, say, Bette Davis does in *Jezebel*. The part is a rebellious Southern belle, but she plays it with a fragile, manic intensity, floridly and tragically, her eyes bugging out and her hands contorting into claws. (The rumor is that the role was her consolation prize from Warner's for not getting

Where Have You Gone, Baby Face?

cast as Scarlett O'Hara, and we should all take a moment to imagine what *that* movie would have been like). It is great and she is great and there is absolutely nobody like her — there has never been anybody like any of them. This is the genius of the star system.

Male stars did not attract nearly the same level of identification from their audience. As the film critic Dan Callahan has observed, "the limitation of so many of the screen men of the classic Hollywood period is their sense that men should not be acting at all." There were plenty of fine actors in classic Hollywood, but with a very few exceptions — James Cagney, Cary Grant — none of them had the all-consuming personalities of their female counterparts. The stoicism of '30s women becomes a kind of repression in the men, most of whom struggled with the belief that projecting someone else's emotions was just a little bit unmanly. All of that changed, of course, with Marlon Brando and Montgomery Clift and the Method. It created a new license for male vulnerability on screen — and it brought an end to the old kind of female star.

A lot of things happened at the same time in the late 1940s and early 1950s. In 1948, after a long legal battle, the studios' corporate owners were forced to sell off their theater chains, leaving their films without guaranteed buyers. Television was cutting into their market. Fewer movies were being made, and more of these were spectacles designed to compete with the small screen. The apparatus that had produced larger-than-life stars was collapsing, and audiences were gravitating towards a different kind of actor. For whatever reason, the women coming out of the Actor's Studio never caught on with film audiences. Method actresses such as Kim Stanley and Geraldine Page had thriving stage careers but could not make the transition to the silver screen. Clift's breakout performance in *Red*

River and Brando's in *On The Waterfront* are open, sensual, and sensitive — the kinds of parts that would have been reserved for women just a few years earlier. It is almost as if there was only so much emotion to go around: when the creative space available to men expanded, the room for women shrank.

Another popular explanation for Hollywood's shift in focus during these years is a decline in the number of female creators, but I have never given this theory much weight. It is true that there was a cadre of influential female writers in Hollywood in the 1930s — women such as Anita Loos, Lillian Hellman, Frances Marion, Mary McCall Jr., and Ruth Gordon. Mary Pickford went from being a major star to a major producer, first of her own films and later as one of the founders of United Artists. But women were never more than about fifteen to twenty percent of screenwriters over the course of the decade (exact numbers are hard to find because writers were so often uncredited) — in fact, there were about as many as there are today. That is still an improvement on subsequent decades, but a significant drop from the 1920s, when almost half of all screenwriters were women. The most powerful women in '30s Hollywood were those who started their career in the silent era. It was the rare exceptions, such as Dorothy Parker or Adela Rogers St. John, who broke into the business after it switched to sound (it helped that, like many sound-era screenwriters, they came from established literary careers). There was only one working female director — Dorothy Arzner — and female producers were always a small minority.

One of the great ironies of the studio era is that the rise of the talkies liberated women on screen while drastically limiting their creative role behind the scenes. On-screen women of the 1930s were more intelligent, more sophisticated, and generally more grown-up than they were in the 1920s, simply because

they could speak. The greatest silent film actors — men as well as women — excelled in their ability to play broad types. There is only so much one can do with just a face, even when one has a face as infinitely expressive as Lillian Gish. But in the '20s it was common for studios to buy scenarios from freelancers. There were some highly paid staff scenarists (with Frances Marion leading the pack), but far fewer than sound-era studios would employ in their writers' stables. Without dialogue, writing for the screen was less important and less prestigious, and thus, unsurprisingly, more female. The talkies brought a new crop of established writers to Los Angeles — journalists and playwrights, both largely male professions.

The surprising thing, then, is not that the women of '30s cinema were mostly written by men, but how little difference it seems to have made. I have never been able to tell whether a given movie from the 1930s was written by a man or a woman. They are equally likely to feature female protagonists and focus on women's issues. Arzner is a fine director, but I have not been able to identify a uniquely female subjectivity in her work — because female subjectivity was so much the norm in the Hollywood of her day.

248 Loos, one of the most important and prolific screen-writers of any gender, said this about the movies in a late-in-life interview: "None of us took them the least bit seriously." Hollywood in its earliest decades was full of people who treated their work with a mixture of perfectionism and contempt. They worked fourteen-hour days, spent years polishing scripts or invented new lenses just to get a particular effect, but they knew that the studios they worked for were glorified factories churning out a movie a week. Nobody involved in this system saw themselves as an artist — and if they did, they saw themselves as slumming it. Instead, they

were brilliant craftsmen. And the truth is that it doesn't take lived experience or any kind of special or arcane knowledge to write formidable female characters, just close observation and dedicated craftsmanship.

Here is an unexpected hope: perhaps the rise of the streaming giants will restore some of that factory mentality. Netflix has fifty-one movies on its slate for this year. There are more people making more movies in mainstream Hollywood than at any point in the past eighty years. And that means more stories — about strength and weakness, about men and women, about a million other things. It might not be the old studio system come again, but surely it is no less capable of exploring all the aspects of human personality, of delivering to the screen the fullness of human life.

MICHAEL KIMMAGE

American Inquisitions

Fyodor Dostoevsky published the first installment of *The Brothers Karamazov* in February, 1879. The novel was the culmination of a decade of ideological strife, during which Dostoevsky had noted a steady slide toward populism. Socialism, the passion of Dostoevsky's youth, was an enthusiasm still on the march. The author of *The Brothers Karamazov* was a devout Orthodox Christian and a conservative, a reactionary perhaps. He poured the expansive politics of his era into *The Brothers Karamazov* and especially into a phantasmagoric chapter — often read on its own — titled "The Grand Inquisitor." For the past one hundred and forty years, this text has been mined for

clues to modern politics. In the verdict of Lionel Trilling, "it can be said almost categorically that no other work of literature has made so strong an impression on the modern consciousness." Modern consciousness was never more receptive to "The Grand Inquisitor" than in the 1930s and 1940s, when Dostoevsky was typically read as a prophet of totalitarianism.

Dostoevsky had foreseen this interpretation. In a letter written while he was completing *The Brothers Karamazov*, he worried about a regime that would provide "one's daily bread, the Tower of Babel (i.e. the future reign of Socialism), and complete enslavement of freedom of conscience." Enter the Grand Inquisitor. In the novel he directs the Inquisition in sixteenth-century Spain, having co-opted Christian mercy and replaced it with a cynical recipe for social control. According to Dostoevsky's great biographer Joseph Frank, the Grand Inquisitor "has debased the authentic forms of miracles, mystery, and authority into magic, mystification, and tyranny." His church enjoys absolute power. It traffics in mystification and magic. It caters cunningly to people's spiritual needs and efficiently to their physical needs. For those who rebel against this domination masquerading as religion, there is the Inquisition. Thus did the Grand Inquisitor anticipate the techniques of the KGB, the Gestapo, and the political systems that those organs of oppression were meant to protect.

Dostoevsky's Grand Inquisitor is plausibly a proto-Bolshevik or a proto-fascist. Yet such readings can reduce this text to a kind of prophetic political journalism, to commentary *avant la lettre* on the cataclysmic 1930s. Read it again now, in the middle of our own tribulations. Detached from those long-ago debates, "The Grand Inquisitor" emerges as a timeless meditation on authoritarian attractions and on freedom's vulnerabilities. As the Grand Inquisitor declares, "man

251

prefers peace, and even death, to freedom of choice or the knowledge of good and evil... Nothing is more seductive for man than his freedom of conscience, but nothing is a greater cause of suffering." The dilemma of politics in this text is that freedom is a dilemma. Freedom of conscience causes pain, which is precisely the emotional resource on which the Grand Inquisitor draws: freedom's impositions are the secret of his power. The avowedly illiberal Dostoevsky was dramatizing a spiritual reality — freedom of conscience as a burden, a task, an impossible ideal — that is no less pervasive in free societies than in those regimes designated by the totalitarian label.

Perhaps "The Grand Inquisitor" is not just a discourse about them, the unfortunate totalitarians overseas. Perhaps it is also about us, citizens empowered by the Bill of Rights and basking in liberty. So considered, "The Grand Inquisitor" could be as illuminating about the United States, past and present, as it was supposed to be about Stalin's Soviet Union or Hitler's Germany. Without ever going to the extremes of sixteenth-century Spain, without an established church or a dictatorial government, the United States has never lacked for inquisitions. They have appeared, disappeared, and reappeared throughout American history, exquisite barometers of the national mood and the objective correlatives of political and cultural power. They are as often creations of society as of government. They cast their strange, lurid light on the seductions and the suppressions that emanate from freedom of conscience. And they are once again abroad in the land.

The birthplace of the American inquisition is Salem, Massachusetts. In 1692, several members of this provincial New England

community were put to death after a public investigation into witchcraft. Many outbreaks of alleged witchcraft had occurred in early modern Europe, and Salem was not at all unusual in the way it combined civil and theological authority, the supernatural and the legal, the magical and the scientific in order to save itself from witches. Nor were the guilty in the "Salem witch trial" quietly executed. They were given the role of exemplary perpetrators. The trial, the public exposure of their guilt, was the point. Only by seeing the forest into which the few had strayed could the many find their way to righteousness.

Historians disagree about the roots of what happened in Salem. It may have been material, a redistribution of property through the convenient discovery of witches. It may have been psychosexual, a letting go of forbidden energy under the pretense of witchcraft or amid a sprawling investigation into witchcraft. It may have been the anxiety of a religious elite convinced that the Massachusetts Bay Colony was not as homogeneous or as devout as it was supposed to be. The full inventory of motives for those tribunals may be lost to the vagaries and the hyperbole of the historical record. Whatever the actualities of the event, Salem's legacy in American history is not institutional or legal or political. It is symbolic.

With the creation of the United States, memories of Salem in 1692 began to acquire a gothic *frisson*. Witchcraft became the stuff of Hawthorne stories and then Halloween kitsch. The Salem witch trials were a ready metaphor for obscurantism, for of theocrats, of those who believed in witches, the zealotry of those who wish to destroy a human being accused of witchcraft. It was this bequest of the seventeenth century that was rejected in the language of the American eighteenth century, in the Declaration of Independence and the Constitution. Salem's murk was left behind in the clean lines of

253

Thomas Jefferson's University of Virginia, proof positive of a new republican order. Universities would deliver what they were meant to deliver — enlightenment. The United States was born in the age of reason, though reason was often more a proposition than a reality in the new country. Reason had at least been put on a pedestal.

Instead of medieval inquisitions, then, the United States would concentrate on delivering justice. Few societies are as enamored of law as is the United States: the approach to justice through law speaks to the *raison d'etre* of the American republic. The nineteenth-century figure who best captured this infatuation was Abraham Lincoln, a lawyer by trade. Moved as so many other northerners were by the passage of the Fugitive Slave Act in 1850 and by the moral upheavals of the subsequent decade, Lincoln's genius was to fight the Civil War with an eye to its legal outcome, which would be the guarantor of its moral outcome. His enduring achievements were the Emancipation Proclamation and the constitutional amendments that widened the scope of American citizenship. His literary-political style, like Jefferson's, was precise, careful, analytical. His mysticism never clouded his mind. "With malice toward none, with charity for all" — such phrases banish the inquisitorial spirit.

But beware the romance of Lincoln's oratory. In Lincoln's time and after, there was often malice toward many and charity for few. Lincoln and Jefferson did not get the last word, and the inquisitorial spirit turned out to be a regular feature of American modernity. In the twentieth century it bubbled up from the extremes of the political spectrum. The Left went first. In the hothouse world of radical politics, the Dostoevskian dramas playing themselves out in the Soviet Union had an American resonance. It began with left-wing

254

factionalism and culminated in the career of Joseph Stalin. (The Bolsheviks owed their name to factionalism, to their false claim to majority status and their mockery of their opponents as Mensheviks, the minority.) Stalin practiced the darkest arts of factionalism and, by logical extension, of inquisitions. Improvising rituals of investigation and confession, he had his enemies paraded before the Soviet public. Fewer than twenty people were put to death in Salem in 1692. Stalin had millions incarcerated and executed. The Massachusetts Bay Colony could not compete with the modern world in paranoia and dogmatic cruelty.

The American Communist Party slavishly followed Stalin and praised Stalinism. It justified the Moscow trials as it would the Molotov-Ribbentrop Pact of 1939. The American Communist Party also conducted a holy war against the Trotskyites, casting the demons out and subjecting those who wanted to stay on board to "party discipline." The American Communist Party did not have the instruments of repression available to Stalin, who ruled over a police state that could conduct inquisitions of the sort portrayed in 1940 in Arthur Koestler's epochal novel *Darkness at Noon*, a book that self-consciously retraces *The Brothers Karamazov*. Yet American communism endorsed the methods of the Soviet trials, which ensured that ideological and political enemies, having been publicly denounced, were airbrushed out of the historical photographs.

The reach of far-left sentiment — sometimes communist, sometimes not — was more cultural than political in the 1930s. It was an influence on educated people. The party and its fellow travelers were formidable enough to initiate a curious inquisition in the 1940s, just as an era of radical efflorescence was ending. In 1948, Whitaker Chambers, a former

communist, accused Alger Hiss, a former State Department employee, of having spied for the Soviet Union. As if by magic, Chambers got put on trial. In the courtroom and in the press, he was accused of mendacity, of pathology, of homosexuality. A witness for the prosecution, he was not convicted, of course; but his reputation was irreparably damaged. An avid Dostoevsky reader, Chambers identified with Nikolai Rubashov, the persecuted protagonist of Koestler's *Darkness at Noon*. At the same time, of course, Hiss was found guilty; he had been a spy, and Chambers, as would much later be shown definitively, had been telling the truth. For many of Hiss's supporters, the trial itself had been a witch hunt. This tendency to see inquisitions in politically inconvenient investigations was an omen of political polarization to come.

The archetypal twentieth-century inquisition arose from the ashes of the Hiss case. One politician who profited from the case was Richard Nixon, Chambers' friend and defender. Eisenhower chose him as his Vice President in 1952 in part because of Nixon's barbed anti-communism. Another politician observing the Hiss case closely was Senator Joseph McCarthy of Wisconsin, who possessed most of the Grand Inquisitor's cynicism and only some of his cunning. McCarthy was less moved by the Cold War and by the facts of communism, American or otherwise, than by the political opportunities that he saw in anti-communism. Ideology as such was not really McCarthy's forte — not to the degree that personal ambition was. He was skilled in the relentless application of power, updating the practice of inquisition for the age of mass media. He wrapped the techniques of character assassination in the garb of legal and senatorial procedure. McCarthy was and remains the virtuoso inquisitor of American history.

McCarthy founded his harassment on fear and guilt and gullibility. The Cold War's unclear borders and its reliance on espionage raised punishing questions of friend and foe. McCarthy presumed enmity and, having presumed it, he found enemies. Where there was no actual subversion, it was invented — by projecting the Cold War's mood back onto the 1930s, when an affiliation with communism could mean so many things. McCarthy compounded the guilt of his victims by prodding them to "name names." An inquisition inquires: it must ask or, better yet, interrogate. But interrogation can take place in different ways, in different spirits; not all questions that take the form of asking for the truth actually want the truth. Even when it inquires, an inquisition is not the same thing as an inquiry. A person publicly interrogated is made culpable by the sheer fact of having been interrogated. Though McCarthy's fans enjoyed the television show that the Senator put before them, they also took his words at face value. McCarthy's fictions left their mark on reality.

For McCarthy, generating fear was indispensable. It was not he who fired people. He was holed up in the Senate. He let the fear ripple out across the country, from the State Department to Hollywood. Guilt by association ran rampant. Treason committed by communists, which did occur in the 1930s and 1940s, was not the only crime about which investigations were launched. Certain books were declared treasonous; some were removed from the libraries of American embassies. Works of art by those implicated in the Red Decade could be treasonous too, and for McCarthy and his supporters there was no way a person, once accused, could be exonerated. Naming names did not expiate anybody. To the contrary: it transformed public into private guilt, while guilt by association made fear ubiquitous, a virus for which there was no vaccine. People got fired

mostly because their employers were afraid. As often happens, the institutions buckled.

The Salem witch trials and McCarthyism met in 1953 in Arthur Miller's play, *The Crucible*. Miller's parable challenged the modernity of McCarthyism. In the year of our Lord 1953, the salience of 1692 was supposed to be shocking. So too was the religiosity of the Puritan colony, which was not impossibly distant from Eisenhower's America. The Puritans' fanaticism foreshadowed McCarthyism. It was the all too familiar precedent, the resurrected template. *The Crucible* attributed a power-hungry, manipulative darkness to the divines of seventeenth-century Salem, whose purpose (in the play) was transparently McCarthy's purpose — to deceive, to destroy, to terrify, to ruin, to control. Less grandly, Miller developed a political analogy in *The Crucible*. Like McCarthyism, Puritan justice was conservative in Miller's eyes and as such it was dour, rigid, intolerant, and hierarchical.

Miller was himself a political progressive. McCarthy's war on progressives allowed Miller to adorn the play's hero, John Proctor, with the attributes of a liberal — as Miller understood these attributes. Porter is a handsome "farmer in his middle thirties," one who "had a biting way with hypocrites... even-tempered, and not easily led." Proctor's Enlightenment courage, his Voltaire-inflected liberalism, inspires sympathy. A moderate churchgoer, he struggles with his having committed adultery. He cannot stop the trial from running its course. He is put to death, but he will not name names and he rises up at the play's end and condemns the hypocrisy that is closing in on him. He asserts his freedom of conscience, which is his honor — "Because it is my name!" Proctor's freedom is to not go along with injustice and, by not going along, to speak the truth. He robs an illiberal hypocrisy of its ultimate victory.

Like John Proctor in *The Crucible*, Bill Clinton felt persecuted in his second term as president. Clinton was yet another reader of Arthur Koestler, and he, too, likened his interrogation at the hands of Kenneth Starr to scenes from *Darkness at Noon*. There were severe limitations to the analogy, of course. In its obsessive, self-righteous cadences, in its prurient interest in private matters, the Starr report certainly belongs to the literature of inquisitions, but it is hard to see the "trial of Bill Clinton" as a bona fide inquisition. Inquisitions are group phenomena. They are rituals of strength and weakness. They intentionally cross the lines of guilt and innocence, since doing so enhances their scope and spreads their message. Clinton, a sitting president, was guilty of a sexual liaison with an intern and of lying about it. He was too compromised and unique for his troubles to reach the level of an inquisition. He also stayed in office and did not fall very far from grace among his supporters. When Hillary Clinton ran for president in 2016, memories of the Clinton-Lewinsky affair resurfaced without becoming a major stumbling block for Democratic voters.

The contemporary cycle of American inquisitions began after Clinton's presidency. It was something new in the annals of inquisition, and not because people had changed. What had changed in our time was technology, and with it the public sphere. Social media mirrored a confluence of novelties. Opinions could be generated in new ways, and reputations and personal histories were publicly available in new ways. Whereas in the past a letter to the editor would have to be accepted for publication, making the press the key arbiter of the public domain, social media eliminated oversight. This gave opinions the speed of lightning, liberating disclosures

259

and emotions that in the past were mostly confined to private conversation or to the proverbial grapevine. There was no time for introspection or a second look. The public sphere was accelerated and democratized as it had never been before.

The public sphere's democratization had its bright side. The capacity of the powerful to suppress awkward or awful information about themselves diminished abruptly. Individuals and groups acquired access to a public sphere — mediated though it was by corporations — that could not be controlled. This assisted in the exposure of crimes sometimes in the form of information and testimony, sometimes through photographs and sometimes, as the technology got better, through video. It was not until the second decade of our century that we began to understand just how manipulable the public sphere had become. In the twenty-first century's first decade, social media could be the hoped-for vehicle of democratic progress, holding the high and mighty to account. What obtained for the United States obtained even more dramatically outside of the United States. Authoritarianism had met its nemesis in social media. Was that not the lesson of Tahrir Square in 2011 and of the Maidan in 2014?

But democracy also met its nemesis in social media, and not only because authoritarian governments — in Russia, China, and elsewhere — had learned to use them for their own ends. The dark side of the public sphere's democratization lay in its canonization of aggression. Expressing aggression was suddenly effortless and seemingly cost-free for the many who expressed it. Social-media aggression alternates between the random and the targeted, the light-hearted and the deadly, but it is anything but a trivial aspect of American political culture. In 2014, feminist critics of misogynist video games were not just argued against on social media. They were

subjected to odious attacks made in the most brutal language, and to threats of violence that may or may not have been purely rhetorical. This aggression was a grotesque comedy for its advocates and a terrifying ordeal of intimidation for its victims — video-game posturing intended to silence voices and thus to dominate the public sphere. But ugly as it was, unprecedented as it was, the acts of aggression did not backfire. There was no mass revulsion against them. They went largely unchecked.

"Gamergate" prefigured the miserable election of 2016, during which several long-term trends converged. One was the collision between politics and social media, without which Trump could not have become president. He channeled the natural bellicosity of social media, its aura of unreality, its malicious humor, its absence of restraint, its invitations to violence. Another development was a metastasizing faction-alism, for which Trump *and* his critics were at fault, a zero-sum attitude toward politics that promoted an abyss between the political parties, between Left and Right, between the signifiers of political friendship and the telltale attributes of a political foe. The election of 2016, its rough texture followed by its revolutionary outcome, ushered in a new inquisitorial age. Enmities encourage inquisitions.

The record of recent inquisitions reveals an interesting asymmetry. Trump's victory in 2016 gave him immense political power. He never accepted the separation of powers and constantly encroached on the independence of the judiciary. With some limits, he had the power of the state behind him. The Democratic Party did not disappear under Trump: it regained the House of Representatives in the mid-term elections and mounted two impeachment trials. "The resistance" found compensation for four years of exile

261

from political power in the awesome cultural power linked in one way or another to progressive sentiment. Under Trump, the consequential inquisitions on the Right relied on state power, while the consequential inquisitions on the Left relied on cultural power. It has been an era rich in progressive inquisitions.

The story of Marie Yovanovich is a useful example. As Ambassador to Ukraine, she found herself in the middle of Trump administration schemes to find or to fabricate damaging material on Hunter Biden, Joe Biden's son, who has some business connections to Ukraine. Ambassador Yovanovich did not comply. Phony accusations of her political bias circulated in the press. Social media piled on. The ambassador was recalled from Kyiv as a response to baseless accusations. The Trump administration never lifted a finger to clear her reputation for the obvious reason that it was the Trump administration that was besmirching her reputation. As inquisitions go, it could have been worse, and given the factionalism of American politics Ambassador Yovanovich's persecution by Trump made her an overnight hero on the other side of the political spectrum. Had Trump won a second term, government-led inquisitions would have come fast and thick.

The practice of twenty-first century inquisitions has found a congenial home on the Right. A perceived transgression and at times a real transgression is the starting point. Social media cacophonously cries out for justice. The pressure mounts and an institution is asked to take action — usually by firing someone. Suffice it to say that these procedures have little to do with a courtroom trial. They have no prior rules; they do not require anything remotely resembling due process; the accused is not necessarily given his or her chance to mount a defense. An example here is Will Wilkinson, a vice-president

at the Niskanen Center who sent out a crude tweet in January 2021 and was fired after a burst of right-wing anger on social media and in the press. The anger entailed a misreading of Wilkinson's tweet. His poor taste was misconstrued as an incitement to violence. The misreading is a predictable, almost a necessary ingredient of such frenzies. The perplexities of evidence are irrelevant to the inquisitorial mind.

The same inquisitorial technique is familiar on the Left as well. Its popularity owes something to the Left's special agony in the Trump years, when a viciously coarse and anti-progressive man was in the White House while the majority of the country's elite cultural institutions were becoming more overtly progressive. Those institutions found solace for the loss of political power in the exercise of social and cultural power. They took after those who deviated too egregiously from progressive etiquette. Whether the offense was real or perceived was often beside the point, as were in many cases the intentions of the offender. Motive is the concern of trials. Criminal law revolves around intent. Inquisitions, by contrast, presume motive and intent, and look only for confirmation and satisfaction. Again, due process, which used to be a pillar of the liberal worldview, was nowhere to be found. The effect of these inquisitions has been a climate of fear, a growing conformity of speech and behavior, a resigned acceptance of a bullying authority.

The most extraordinary inquisition conducted by progressives in the Trump era was of Trump himself. Owing to the Trump campaign's bizarre ties to the Russian government, and to Trump's egregious comments about the excellence of Vladimir Putin, and of course to the fact that Trump was Trump and guilty by definition in the eyes of his enemies, he was found guilty of being a Russian asset. This indeed may

have been the case, but the evidence — even after the exhaustive Mueller investigation, after countless books on the topic, after round after round of first-rate investigative journalism — is still not there. In the inversion of a courtroom trial on which inquisitions rely, Trump was guilty from the outset. A thousand data points were gathered into a narrative repeated for months by journalists and experts on CNN, MSNBC, and other platforms. Social media added to the ministrations of this exuberant jury. Trump's nods to Salem and to his being enmeshed in a latter-day witch hunt were not altogether wild. His baroque hypocrisy was that he was energetically engaged in witch hunts of his own.

For those convinced that Trump was a Russian spy, evidence could easily be subordinated to optics. Senator McCarthy had operated on a similar principle, exploiting a populist suspicion of the diplomats in striped pants, the fancy kind of people likely to join a treasonous conspiracy. Trump made matters worse by himself employing the inquisitor's tactics — against government employees such as Ambassador Yovanovich and against whichever celebrity or athlete or journalist or politician (Republican or Democrat) annoyed him. Much of his campaign against Hillary Clinton ran on guilt by association: she was a Clinton, a globalist, a feminist, a liberal, and *therefore* not to be trusted with the presidency. Or, better yet, she was all of these things and should therefore be locked up. Eager to scorch the political earth, Trump could be seen as deserving an inquisition. Live by inquisition, die by inquisition.

While an inquisitorial spirit was proliferating on the Left and the Right, many of the people who fell within its sights were not household names. Beginning in earnest in 2016, progressive institutions proved receptive to inquisitions also

of lesser-known and low-profile personnel. These institutions were sensitive to the verdict of social-media campaigns, less interested in individual cases and more alert to the perception of wrongdoing than to the complexities and obscurities of lived reality. They displayed little patience, critical thinking, fairness, and courage. It is typical of inquisitions that those who instigate them are at ease with the fear they unleash. Fear is their tool. The fear of a potential misstep that many now feel at progressive institutions preemptively internalizes the inquisitor's tactics.

A striking case study is Smith College in Northampton, Massachusetts, a hundred miles or so from Salem. In 2018, a black student at Smith off on her own and eating lunch was approached by a janitor and a campus police officer. She was asked what she was doing, as reported in a detailed *New York Times* article. The student later went on Facebook to describe her upset. News articles projected the student's side of the story — that she had been discriminated against — though the college looked into the incident and found out that the student was eating in an empty dorm. By approaching her, the unarmed officer and janitor had been following protocol. There was no evidence that they were motivated by prejudice. The incident was most likely a misunderstanding on the student's part.

Knowing what it knew, the college administration stayed silent when photographs, names, and email addresses of the Smith employees involved in the incident were made public. Accusations of guilt touched an employee not at work at the time. Death threats, whispering campaigns, and public humiliation followed, while the college did little to defend its employee, offering no proof of his guilt but implying it because the student had perceived malign intent in their actions. Their punishment, of course, was not execution. It

265

was not getting fired outright, although one employee was eventually furloughed and had trouble finding another job because the accusations of racism were so well known in the Northampton community; her reputation has been destroyed. The punishment was the repetition of untruths by those in positions of authority and the requirement that the employees undergo anti-racism and intersectionality training.

The willful misreading and misinterpretation on display at Smith College bore the imprint of an inquisition. Beyond the fear shadowing the accused, beyond the social media moralizing and the stigmatization at will, this story of inquisition speaks to the enormous power of these public abuses. The handful of poorly paid employees who fell into the inquisition's net were not a threat to the college or the community. They sought out no controversy. The power and suffering brought down on them was the power to control the narrative, which is that Smith College is a valiantly progressive institution awash in a sea of structural racism and doing its best to right the age-old wrongs of American society. The employees' humiliation was necessary in the scheme of things. They had gotten in the way of a popular and righteous narrative, of a tempest of virtue.

Freedom of conscience is not protected by the Constitution. It is not equivalent to religious freedom or to freedom of speech. Religious freedom intersects with freedom of conscience in the phrase "conscientious objector," someone who for religious reasons cannot fight in a war. This status accords civic space and moral prestige to conscience. It is generous in its assumption that people are not uniform, that their conscience might

indicate something rare about them and something inviolable. A majority enlists. A small minority conscientiously objects. Freedom of speech is similar. It is by definition the freedom to lie and to offend and to criticize, the freedom to explore life in all its heterodox constructions. No established church in religion, no government restrictions on speech (with some qualifications) — more than anything these constitutional rights are protections. American citizens cannot be forced to attend any one church. They cannot be told by the government what a newspaper can publish or what a scholar can write. These are their rights.

Though it can be violated, freedom of conscience cannot be legally protected. It is a loose set of principles or ideas. One is the freedom to choose, which is impossible without the freedom to err. When choice becomes crime — murder, theft, rape — freedom of conscience is abrogated. Short of crime, though, freedom of conscience deserves a wide latitude. Even when choice tips over into crime, freedom of conscience is not erased forever. It is implicit in the criminal's recovery and in the possibility of moral transformation: one might still recognize a crime, feel remorse for it, and try to change one's ways. Freedom of conscience is also individual. The state does not set its terms. No church can guarantee it. To survive it must be respected as something that everyone seeks or finds to the same degree. Freedom of conscience enables moral lives that are autonomous, that allow people — making mistakes — to choose the good as they see it and the good that is not imposed, not homogeneous, not obvious, the good that is idiosyncratic and non-conforming, the good that is always a work in progress.

Dostoevsky's Grand Inquisitor focuses with ferocity on freedom of conscience. He relieves the people over whom he

267

rules of their freedom, knowing that freedom of conscience carries with it ordeals of reflection and responsibility: choosing the good comes naturally to no one, and is at best a fleeting triumph over one's internal limitations. Having freed his subjects of freedom, the Grand Inquisitor rewards them with moral uniformity: his church apportions dogmas, happily adjudicating all aspects of behavior and winning for itself immense power along the way. In this the Grand Inquisitor sees a version of happiness: obedience, authority, a narrative handed down from above, so that people can calmly go about their business. They are safe now. His inquisitions deliver them from the temptation of choice and from the onerous inner life in which conscience either flourishes or fails. By burning people alive, his inquisitions regulate conscience — not the consciences of the dehumanized victims but the consciences of the weak and fascinated onlookers.

If freedom of conscience cannot be legislated, how can it be defended? Its importance must first be acknowledged. Inquisitions translate people into cardboard enemies. They script them, they reduce them and diminish them and fill in all the blanks, meeting the psychological needs of their audience. Hence the never-ending political utility of inquisitions: they satisfy large numbers of people. They are populist theater. As long as our current factionalism reigns, we will be stuck with inquisitions. When you have raised the cost of expressing an unpopular opinion, when you lead individuals to censor themselves, when dissent (either for or against power) can result in the loss of one's livelihood and social acceptance, then you have violated the freedom of conscience. Conversely, honoring another person's freedom of conscience constrains the extra-legal machinery of ascribing guilt, of shunning. It argues for a light touch, for not going all in and for being

especially vigilant about the points at which public shaming and the will to power converge. Freedom of conscience elevates the ideal of a merciful public sphere, an uphill battle in our unforgiving public sphere, addled as it is by the social-media furies and by incentivized sensationalism. *Morte tua vita mia* is the moral code of the internet.

The recent travails of Smith College illustrate the menace of a moral landscape without freedom of conscience. To the college administration, the employees accused of harassing a student were so unfree in conscience as to be almost without agency. Since they were regarded as unfree, as pillars of structural racism until proven otherwise, their actions and their intentions had no bearing on their destiny. Guilty or not in practice, they deserved their public shaming in theory. The college administration also felt justified in tolerating a public inquisition because it was certain of its own enlightened attitudes. The Grand Inquisitor would have approved. He is not, in his own view, a man who causes harm. "We shall triumph," the Grand Inquisitor says in *The Brothers Karamazov*, "and shall be Caesars, and then we shall plan the universal happiness of man." His hold on power is so firm because his policing of public morality leads to happiness. And what is a bit of collateral damage in the vast enterprise of bettering humanity?

Precisely because freedom of conscience is not a right and cannot be a right, it is precarious. ("They have brought their burden to us and laid it humbly at our feet," the Grand Inquisitor proudly declares.) No ACLU can be endowed in the name of this pre-political virtue. Its preservation — or its evisceration — will come from the culture, the climate of opinion, the spirit of laws, and from the education that art and philosophy confer. Repressive societies have amassed the richest litera-

ture of conscience. They make heroes and martyrs: while they exact a cruel price, and sometimes the ultimate price, from those who say no, they transform Václav Havel and Nelson Mandela and Sophie Scholl and Aleksandr Solzhenitsyn and Liu Xiaobo into great historical figures, whose hands may have been tied but whose conscience was free. But less repressive societies, and even some open societies, too readily congratulate themselves in these matters. They may not make martyrs, but they sometimes forget the labyrinthine lessons of moral freedom, thus unlearning the balancing acts of a culture that can thwart inquisitions big and small, of a culture that refuses to speak the final word about the guilt or the misdeeds of other people, even of criminals. The scales of justice can easily be melted down and repurposed as the crucibles of endless recrimination. Let us fight inquisition with inquiry. Even if there will always be witch hunts, there will never be witches.

PEG BOYERS

Staple Lady

Next time her skull is sliced open,
she must have a mind limber as rubber,
bending to the pain. Under the bright lights
of the icy theater she will melt, allowing the saw's buzz
to fade into the sound of the surgeon entering
her interior, surveying the field of tumors for the bad one.

When he finds it, there will be no escaping
his blade. She will hear him hack through her anesthetic fog
and scrape at her numb meninges wall, vanquishing
the invader. Perhaps she is only dreaming,
she thinks: when she awakens she will be
at home, puzzled but refreshed

from this deeply troubled sleep. But then
she feels the bone door closed and stapled
shut, cancelling her delusion. Later she is told
that the enemy is gone but his colluders, claiming
innocence, remain. A new vigil begins as she watches
and waits for them to regroup, organize and grow.

She confesses that she loves her staples. Furtively,
she caresses them throughout the day. They are her secret
cranial adornment. Under her hair, in all their metallic glamor,
they are hers alone to enjoy. Daily, she attends to them holding
closed her incision, tenderly washing and polishing
them so they shine like a zipper, ready for the grab.

Meanwhile, inside, the humors rise and fall like the tide, sway
to the east with the wind, hold fast against
the western torment brewing. Above, the wise sagittal
sinus keeps things churning, as the heart pumps
furiously below and the mind—her determined mind—keeps
flexible but centered on the task of healing and staying healed.

Gingerly, she peers through her two
still functioning eyes, the skull's port-hole access
to the sea, and beyond, to the healing world
for whom she will endure still more incursions, stay
supple and ready, if only
in the end she can stay a while.

To the god who does not exist she prays—*teach me to ride
the storm safely, past the fatal depths, to the receding shore.*

272

For the *Afterlife*

She wanted a crypt like the temple of Dendur,
an enormous monolith unshakeable as their marriage.

He favored the granite sarcophagus gaily
decorated with Victorian swirls and oak leaf cornices.

She wanted poplars tall and straight—leafy and shameless
as Italian trees of summer, if sadly deciduous.

He preferred cypresses, their constancy through the seasons:
shrubs—yew or arbovite—modest, low to the ground.

She fancied a stone table with seats for friends to come dine
al fresco. He said a few high-back benches would do.

She said as long as they're comfortable, without Hallmark
card prayers or one-size-fits-all labels like "Father" and "Mother."

When they settled on the white granite love seat carved
from a single block, its elegantly supportive back to the forest,

they were told it was impossible to order now
that the factories making them in China and India were closed.

Everything in the world was closed. Yet they strolled,
faces masked, every day, in these grounds, secure

in their solitude, among the decorated dead,
the veterans from Gettysburg, the Somme, Normandy
 and Saigon

and all the wars against measles, flu, whooping cough
 and plague,
whole families wiped out by one contagion or another resting

now in the rolling hills and burial mounds, under
marble markers by now mostly effaced, amid medals
 and flags stabbed

into the earth to celebrate their valor, here among the
 ancient oaks
and stalwart pines, clustered in stately groves joined

each to each by pebbled paths and avenues—daily they walked,
stopped and even sat, feeling strangely welcome and
 terribly alive.

274

Invalid Afternoons

1.
Precocious in her dotage, she teeters like a top unravelling,
now spinning, now faltering, now lunging across
living room carpets, over

William Morris tendrils and Bokara medallions, past
the leather sofa and beyond,
arriving at the south window.

She stoops over the hope chest with her watering can,
drenching the amaryllis, dotting orchids and jade with ice,
then pruning the cactus blossoms.

One by one, she pulls off their delicate,
erotic red heads, leaving
the sheath for the next flower to occupy, and the next.

She is not dying, she reminds herself, though today she feels
a sort of emotional anemia come over her, a thinning
inside, a rising-up of white corpuscles over red.

There is shame, she thinks, in yielding
to this voluptuous ennui, shame
in failing to school the mind past boredom, past

the exquisite temptation of absolute emptiness.
Didn't her mother tell her a commonplace—
that she had no inner resources?

To be complacently bored, she preached, is to be
an ill-bred donkey: Solo los burros se aburren,
the refrain of her childhood. Her mother's go-to line.

She plays it now, over and over, and almost laughs
to think somehow it has to do with her
after a lifetime of ardor and infatuation.

2.
In her nostalgia she thinks of snow and snow days,
of lazy afternoons with children demanding snow
men and snow balls and snow angels

and excursions to the park along the majestic snow-laden
Avenue of Pines, the ancient trees hanging over
the picture-perfect American families,

the snow-packed branches
now protecting, now threatening.
Now gone.

Today the March winds cut through a snowless city, a barren
light over it all, exposing late-winter detritus, impending
decline, the house silent, as she detects in her lungs

a breeze, imagines a multitude of voyages, remembers
landscapes, a lake—near frozen—a boat, a shoreline, the sound
of waves breaking inside her chest, an impediment, a voice—

something from deep inside the rim, something
unreachable, the waters rolling towards her, rolling,
her briny cough a harbinger

of who knows what
in her future, something illegible, distilled,
a promise in the unfathomable sea of self, of selves.

3.
But life is good, she thinks today, as she hears
the irrepressible cardinal, newly arrived,
beseeching his mate, sees

the neighbor's calico alert, though the bird is out of reach—
Stubbornly, he waits for some sudden splendor to fall
into his lap, his tail twitching.

The bird is immoderate
in his casual exultances. She loves him
immoderately, loves the world

immoderately for all its violence and decadence. Even
its boredom is lovable. She wants
never to leave it. Never.

4.
Under the yews the tulips push through the loam. Life
insisting its way back again. Ötzi, the frozen mummy found
in the Alps, had thirty varieties of pollen in his stomach,
some ibex meat and two chunks of wild goat.

There was evidence of arthritis and over fifty wounds, all
treated with Copper Age acupuncture, tattoo-style,
 from head to toe.
When they chipped him out of the glacier he was smiling
his Neolithic smile: what fleeting happiness
before the avalanche felled and swallowed him?

CELESTE MARCUS

Nine Little Girls

I

Some years ago, deep into a confounding research assign-
ment for which I had been combing through the website of
the South Dakota legislature, I stumbled upon the recorded
testimony of a woman describing in detail her own rape and
torture, and the tortures of her sisters by the same hands. In her
account the acts, which allegedly took place in the 1960s and
1970s, continued for several years and had begun when they
were all children some fifty years earlier. The discovery of that
testimony was a thing that happened to me, an event in my life,
in the way realizing for the first time that my parents will grow
old and die was an event in my life. The sound of her voice,

the stories she told, gripped me, and attached me to a group of people I had never met, to a story that, before that evening, had nothing at all to do with me and my world.

We are surrounded, of course, by reports of atrocities of various kinds, and the mass of them often has the unfortunate effect of inuring us to many hells. But on that day I encountered a human voice and, despite our cultural preoccupation with trauma, which should have readied me to understand what I heard, I did not know how to think about what the woman's voice was saying. In a confrontation not with data points, but with a personal account of extreme cruelty, I was without adequate resources. I recognized the problem of my human unpreparedness.

The horrors needed to be studied and reflected upon over time. There were implications that I needed to work out, and understandings that I needed to develop. Framings that had seemed sturdy and fundamental now felt flimsy. I experienced the testimony of those abused women as new knowledge, which ruptured trusted conceptions of justice and duty. It was not obvious to me that justice was possible here, or that this evil could be punished. My strongest sensation was of having been inducted into a darker acquaintance with the world.

The story stayed with me. What follows is not an attempt at investigative journalism or historical scholarship. I wish only to share what I discovered, in order to give an account of how I tried to find a mental and social context for certain acts, and to offer some reflections about how to think about them. Much of the grisly information relayed here is in the public domain. It turns out that there is a lot that we do not know, and do not comprehend, about the public domain.

Geraldine Charbonneau believes that the scars from her abortion must have been there since just before her seventeenth birthday, though for most of the intervening decades she couldn't remember the procedure that left them, or the rape that she says necessitated it. Like all eight of her sisters (Louise, Francine, Mary, Barbara, Joann, and three others who wish to remain anonymous), and like most victims of childhood sexual assault, she claims that she repressed memories of the abuse that she sustained while a child and a teenager. Louise, Geraldine's older sister, alleges that she was in third grade when she became the first of her family to be abused by the priests and nuns at St. Paul's Mission School (now called Marty Indian School), a Catholic school in Marty, South Dakota. The nine sisters were born and raised in Olga, North Dakota into a tribe of the Anishinaabe people known by the federal government as the Turtle Mountain Band of Chippewa Indians, to a strong-willed matriarch, the mother of seventeen children. They were among those Native toddlers whose parents had willingly sent them to Native boarding school in order to secure an education that could supply the skills necessary to thrive in this country. Others across the country were ordered from their homes by government officials, still others were allegedly forcibly taken from their families.

Both Charbonneau parents died without ever hearing their daughters' stories. Like other children at similar boarding schools across the country, the nine sisters say they were warned not to tell anyone about the abuse they alleged took place there. When the nuns at St. Paul's discovered that Geraldine was pregnant, they warned her that if she revealed her condition to her parents, all three of them would burn in eternal hell. In a clandestine operation in the school's infirmary, Geraldine recalls, her fetus was aborted and forced

Nine Little Girls

into the incinerator in the basement. "They always kept a fire burning in the incinerator room," she said. " I know now that's where they put the unborn child. They burned it."

Since the inception of the Native American boarding school movement, the goal of these institutions has been the deracination of young Native Americans and their assimilation into American life. The schools were considered a potential solution for the "Indian Problem" beginning in the 1870s. They were conceived as a progressive alternative to the reservation policy, which had long been the favored policy in America. In 1869 the *New York Times* declared that "the only possible method [with which to keep Indians from hindering American growth] would seem to be to rigidly confine Indians to certain specific localities, until by their good conduct or progress in civilization they can be allowed perfect freedom." Two and a half decades later, in an article entitled "Senator Dawes Talks to the Cambridge Indian Rights Association" the *Times* reported favorably about Dawes' support for the reservation policy: " [The Indian] is losing the last acre of his heritage. He can no longer retreat from the advance of civilization. We must either support him in idleness or else devise some way to make him a part of us and absorb him into our body politic. As we cannot exterminate him, we must make something of him."

Colonel Richard Henry Pratt, the pioneer of the Native American boarding school movement, and the founder of Carlisle, the first off-reservation boarding school, delivered a speech in 1892 entitled "Kill the Indian, Save the Man." In it he conceded that the only good Indian is a dead one, a nod to General Philip Sheridan's infamous evaluation, but he urged the country to commit bloodless — that is to say, cultural — genocide. If granted entry into what he and most other whites

of the period considered an indisputably superior way of life, Pratt assured his audience, the Indians would abandon their traditions willingly. This, he thought, was a far more humane and effective method than Jefferson's reservation strategy, by which Natives were sequestered on patches of land "held apart from all association with the best of our civilization." Pratt was proposing to erase them with kindness, or at least tolerance.

Many Natives agreed with him about the reservations, and about the hope of assimilation. There were Indian teachers and parents who supported Pratts' schools, and who clung to the chimera of a "white man's chance." Pratt's promise was made at the start of a great wave of immigration that would alter the American sense of belonging and identity. He conjured a future in which it was possible for a Native to become an American in a pre-multicultural context. It was, in essence, a melting-pot argument for America's indigenous population. What is most unnerving about Pratt's famous oration is its jumble of progressivism and racism. The speech champions the liberal truth that there is something essential and irreducible in all people that transcends their particularity. Pratt espoused a jarringly humanist argument. It was also a universalist argument, rather like the French view of citizenship since the Enlightenment: erase your difference, lose your traditions, and you will be welcomed as members of the general society.

This mottledness in Pratt's objectives, the mixture of good and evil, of benign and malign intentions, is characteristic of much of the Native American experience. It is a messy story, peopled with unlikely alliances and incongruous endings, and whereas the larger moral picture may be clear, and the historical verdict about American prejudice unequivocal, the story

283

closer to the ground is clouded with complexities. There are plainly abhorrent actors whom some Natives defend. For decades after the rumored abuses that took place at Native American boarding schools had become semi-notorious within many Indian tribes, there were Native subcultures in which Carlisle was revered.

The first compulsory education clause affecting Native Americans appears in 1858 in a treaty between the United States and the Pawnees. Such clauses would appear in ten other treaties before the end of the treaty period in 1871. In 1891, federal legislation was passed which extended compulsory school attendance to all Indians regardless of tribe. In 1893, for a single year, it was legal for government officials to withhold "rations or the furnishings of subsistence either in money or in kind to the head of any Indian family" for failure to send Indian children between the ages of eight and twenty-one to school the previous year (this legislation and its revocation the following year can be found in chapter 7 of the US Code title 25). Nonetheless, there are cases of children being forcibly separated from their families well into the twentieth century. Consider the case of Dennis Seely, who was removed from his home and sent to the Tekakwitha Indian Mission in Sisseton, South Dakota in 1946 (further horrifying details of the Seely case, which have been made public, are of a piece with those of the nine sisters). In 1929 much of the authority to enforce Native school attendance was given to the states. The Meriam Report, commissioned by the Department of the Interior and published in 1928, focused on reservation and boarding school poverty. All 847 pages of the report, detailing a truly appalling episode in our nation's history, are easily accessible online. Regarding the Native American boarding schools, it reads in part:

For several years the general policy of the Indian Service has been directed away from the boarding school for Indian children and toward public schools and Indian day schools.... It is, however, still the fact that the boarding school, either reservation or non-reservation, is the dominant characteristic of the school system maintained by the national government for its Indian wards.

The survey staff finds itself obliged to say frankly and unequivocally that the provisions for the care of the Indian children in boarding schools are grossly inadequate.

The outstanding deficiency is in the diet furnished the Indian children, many of whom are below normal health. The diet is deficient in quantity, quality, and variety.......

The boarding schools are frankly supported in part by the labor of the students. Those above the fourth grade ordinarily work for half a day and go to school for half a day.... The question may very properly be raised as to whether much of the work of Indian children in boarding schools would not be prohibited in many states by the child labor laws.

Just ten years after Carlisle's founding, 10,500 of the roughly 36,000 Native student population went to Native boarding schools shaped by Pratt's social-evolutionary philosophy. A web of these schools spread across the country over the course of the next century.

Allegations about the mistreatment of Native students at these establishments are as old as the schools themselves.

Nine Little Girls

Children were allegedly forced to eat lye soap for speaking their native tongue, whipped for running away, and beaten simply for holding one another's hands. Some died from malnourishment. Disease due to overcrowding was rampant. Richard Monette, professor of law at UW-Madison, former president of the Native American Bar Association, and a graduate of a boarding school in North Dakota (and former chairman of the Turtle Mountain Tribe), put it this way: "Native America knows all too well the reality of the [Native] boarding schools, where recent generations learned the fine art of standing in line single-file for hours without moving a hair, as a lesson in discipline; where our best and brightest earned graduation certificates for homemaking and masonry; where the sharp rules of immaculate living were instilled through blistered hands and knees on the floor with scouring toothbrushes; where mouths were scrubbed with lye and chlorine solution for uttering Native words."

Still, as always, the history is complicated. Not all student experiences at Native boarding schools are alike. Some former students recall their time at these schools fondly. For many it provided an education and an opportunity to develop inter-tribal Native identities, since schools often mixed students from different tribes. Michelle Dauphinais Echols, the Charbonneau sisters' cousin and lawyer, is one such alumna. Like her cousins, she attended St. Paul's. Even after spending the better part of the past decade pursuing justice on the nine sisters' behalf, she describes the years she spent at the school happily. It was with her help, patience, and example that I was able to explore this episode.

What follows are the accounts that the nine sisters have given about their time at St. Paul's in the 1960s and 1970s. These stories have been edited for brevity and clarity.

On the first Monday of every school year all of us would undergo the same initiation ritual: Straight off the bus we'd be organized into one long line and then stripped naked. Once we reached the front of the line, nuns would pour DDT powder, a poisonous insecticide, over our heads and bare bodies [for delousing]. We were told this was because we were dirty Indians and had to be debugged. If we tried to wash the powder off, we'd be forced back in line and the process would simply be repeated. Every single year, the first Friday evening at the end of that first week the entire school would assemble, and they would screen films of Jews in concentration camps lined up towards the gas chambers. The next morning all of us would be led into group showers where we would finally be permitted to wash off that powder. After washing each child would stand naked in front of the nuns waiting for us just outside the bathroom in order to inspect our bodies. They would bend us over and touch us before finally permitting us to collect our clothes and redress. From that very first week, that fear of being put into the gas chamber was instilled and remained throughout our time at St. Paul's.

There were all kinds of horrors awaiting us after that initial trial. Some of us suffered permanent frostbite, some still bear physical scars from the beatings administered by the nuns and priests. Some of us were beaten so badly we had to be hospitalized for up to ten days. Some

287

of us were sodomized. Some have scars from births and abortions from being raped by our caretakers. Once, on an outing to a lake, one of the boys went into the water and started to drown and we were all screaming asking them to help him but the priests and nuns just ignored us and he died. No one took care of us. We had no mother or father figures. There were no toys. We made friends quickly. We had to — friendship was a form of protection. We always had our cliques. We had to have our cliques to look out for one another, or we would have been severely beaten on a daily basis. The staff hated us. They made us know they hated us in no uncertain terms. They gave us no affection. We wouldn't have known what a hug was or how to have a bond with anybody if it hadn't been for the summers back home with our mother. We were the lucky ones because we got to go home. There were students there who couldn't afford the trip back, and they had to stay at that place the whole year round.

School was 700 miles away from our hometown. There was no way to connect with family. They made sure of that. Even our aunt and uncle, who lived on the grounds because they worked at the school, never got to see us. From the moment you got there it was total isolation at Marty. They enforced it by beatings, strappings, shaving heads, by saying "You'll go to hell. Your parents will die and they'll go to hell." If one of us was at one table and we saw our sisters at another we didn't dare say hello, just made eye contact. No talking at all. Sometimes when they fed us that mush we'd put it in our hands and go wash them at the sink, and that was the only time we'd be able to

lean against a friend or touch their shoulders. If you were caught touching you got the worst beating of your life.

There was always the lurking of a priest or of this one man, the groundskeeper, who worked there and who also molested us. It was like they had different signals that they gave each other. Like for instance, the man who molested Louise would hold her to a chair by the front of her clothes and use his finger on her. And sometimes a few of his fingers. And then he would leave her there and we would see him making a motion with his hand to one of the priests and he would come over and do what he wanted with her. Was the hand motion a sign that she was ready for intercourse? We couldn't be sure. But we remember definitely the secret looks they gave each other, and the snide remarks they'd make about young girls becoming women. Geraldine says her sexual abuse started when she was eight. Father George began to try and touch her and kiss her. Father George kissed her several times which made other children tease her and say that Father George was in love with her. Father Francis was in the room when Father George kissed her. He laughed and accused Father George of saving Geraldine all for himself.

Father Francis was clever. He tricked Barbara into trusting him. The way he did it was, he knew that our aunt and uncle lived on the grounds and that we couldn't go see them on our own, and we were so desperate for some connection with family. Father Francis would say 'Come with me, I'll take you to visit your uncle.' And she missed our mom and dad so much so she'd go with him.

Nine Little Girls

And then after he'd gained her trust he would take her to the church basement and force her to fondle him and perform oral sex. Once there was a coffin in the church basement, maybe they were preparing the body for burial in there, and he lifted her up and showed her, there was a dead woman in it and he put her in that coffin next to the corpse and said if Barbara ever told anyone he'd lock her up in there. So we learned to keep quiet.

The groundskeeper who abused Louise had a big ring of keys with him all the time. When we were in the little girls dorm, so we must have been about fourth graders, we would say to each other "did you hear some keys? Some keys clinking in the night?" Because we used to hear them jingle. And on the nights that we heard them jingle, we'd see a priest in the dorm at night. We learned to pull the blankets up over our heads and hold our breath so he wouldn't pick our bed to climb into. Once Louise went to the bathroom in the middle of the night and came back and found a man in her bed. This man with the keys was letting them in through the tunnels that run under the school, for the pipes, you know. The tunnels are still there now. They run underground connecting every building in the school — the rectory, the church, and the dorms. That's how the priests got in.

The nuns were in on it, too. They let the priests do what they wanted, and they abused us too. They used to pull our blouses down, making believe that they thought we'd hidden something in our bras, but knowing full well we hadn't. They just wanted to humiliate us. It was a team effort. We were handed around like used clothing,

and nobody cared. Even the missionaries who worked at the school were in on it. There was no one to turn to and we knew it. We were told that we would be hurt if we told anybody, that they would kill our parents and our parents would go to hell. We certainly couldn't turn to our parents so we buried it so deep inside that there was no way it would ever surface.

For many years none of the sisters spoke of their alleged abuse to each other or to anybody else. This is not uncommon. According to CHILDUSA, if child victims of sexual assault disclose at all, they do so during adulthood. The median age of disclosure is 48, the average age is 52. Of those who do disclose, only 6% to 15% contact authorities, while most others confide only in friends. That is why many state statutes of limitations for cases of childhood sexual assault, if they exist at all (some states have no SOL and permit plaintiffs to come forward at any time), provide timeframes for plaintiffs to bring their case after memories are likely to have resurfaced, rather than immediately after the incident occurred.

Geraldine Charbonneau was alarmed when asked by her gynecologists, who recognized the scarring, if she had gotten an abortion early in life. She had buried the memory of the procedure since it had happened. It was not until a family gathering in 2009 that one of the sisters, Louise, told the others that she had been abused at St. Paul's and asked if they had been too. Barbara Kay Charbonneau recalled that "We all cried but nothing was said. It was so traumatic, so incomprehensible. But the memories came back one right after the other…. It was like Pandora's Box was opened."

The sisters had been approached in 2006 by other alumni who were members of a class action suit seeking recompense for abuses sustained by students at boarding schools such as St. Paul's. Between 2003 and 2010, over a dozen alumni of South Dakota's Catholic boarding schools filed civil lawsuits against the federal government, the Catholic Diocese of Sioux Falls, and various religious orders operating the schools. The following descriptions of abuse are from the Complaint for *Zephier, et al. v United States of America* (2003):

a. Plaintiff, Sherwyn Zephier, attended Boarding School at St. Paul's at Marty, South Dakota, in the Yankton Reservation, where he was beaten and witnessed nuns regularly commit sexual assaults on boys;

b. Plaintiff, Adele Zephier, attended Boarding School at St. Paul's at Marty where she was sexually abused by a priest, who would put his hands under her dress and fondle and penetrate her. She was also physically abused by the nuns, one of whom would pick her up by her hair, shake her, and lock her in a closet for hours.

c. Plaintiff, Roderica Rouse, also attended St. Paul's at Marty Boarding School, and was physically beaten and sexually abused by a priest in the same manner as Adele Zephier.

d. Plaintiff, Lloyd B. One Star, attended the St. Francis Board School in South Dakota, on the Rosebud reservation. He was physically beaten and sexually abused from the age of 6 to age 10 by multiple priests and nuns, which included oral sex and sodomy. He was threatened physically by the priests if he told about the abuse. He was

beaten and tortured continuously for a week, including head slappings and paddlings, for telling his father about the abuse.

e. Plaintiff, Edna Little Elk, attended the St. Francis Boarding School on the Rosebud reservation in the period 1921-24. She was locked in an attic for days because she did not speak English. She was beaten and stripped by both nuns and priests. She witnessed her cousin, Zona Iron Shell, beaten to death in front of her. She also witnessed other girls being sexually fondled by priests.

f. Plaintiff, Christine Medicine Horn, attended the St. Pauls Boarding School at Marty. Because she did not speak English, she was thrown down a three-story laundry chute. She was also stuffed in a trash can and locked in an incinerator for not speaking English. She was forced to strip to her underwear, when she was whipped with a leather strap.

g. Plaintiff, Lois L. Long, attended the Holy Rosary Boarding School in the Pine Ridge Reservation. Because she was left-handed, her educator accused her of Satanism and attempted to "cure" her by tying her left hand which caused permanent physical injuries. She was repeatedly stripped and beaten by nuns. During baths, the nuns would fondle her and attempt to "wash the devil out" of her.

After memories of their alleged abuse resurfaced, the sisters joined *Bernie v Blue Cloud Abbey*, a class action suit that was a consolidation of eighteen cases. In 2010, days before the

293

case was scheduled to go to trial, the South Dakota Statute of Limitations (SOL) for childhood sexual assault (SDCL 26-10-25) was amended to bar claims against entity defendants after plaintiffs reach the age of 40. (Recall that the average of disclosure for cases of childhood sexual assault is 52 and the median age is 48.)

The amended SOL was drafted and introduced by Steven Smith, a lawyer for the Congregation of the Priests of the Sacred Heart, the religious order that operates St. Joseph's Indian school. At the time the bill was drafted, Smith was the lawyer for the defendants in about a dozen pending cases of abuse alleged to have occurred at St. Joseph's Indian School. The judge applied the new statute of limitations retroactively, and dismissed the case. About the amended SOL and the judge's decision to retroactively apply it just days before the suit went to trial, Joelle Casteix, western regional director of Survivors Network of Those Abused by Priests, observed to WOMENSENEWS: "you bet the South Dakota legislation was designed to keep Native American lawsuits out of the courts. The Church has a hard time defending itself because it has the proof. It keeps a paper trail on sexual-abuse complaints." And indeed during discovery for the case letters surfaced in which, for example, Abbot Thomas Hillebrand wrote to a victim and former student, in November 2008, "[Denis Quinkert] does know that he was going through a crisis in his vocation and a deep struggle with his own sexuality. And he is deeply sorry for the hurt that he caused you.... The favor that I want to ask is that you do not mention that incident outside of the sacrament of Confession. It causes a lot of damages to his character and sets off all sorts of alarms in the official Church."

Every year since 2010, the Charbonneau sisters and their families return to South Dakota to lobby for a change in

legislation that would allow them to bring their case to trial. In 2015 Michelle Dauphinais Echols drafted an amendment to the South Dakota SOL which would permit the sisters to reopen their claim and allow other survivors to bring forward their claims as well. The bill failed. After conversations with opponents of her original amendment, Dauphinais Echols drafted a new proposal which, if passed, would create a two-to-three year loophole in the 2010 Statute of Limitations, during which time plaintiffs would be permitted to bring their case to court. This bill failed as well. In 2018 Dauphinais Echols created the advocacy group 9littlegirls, dedicated to bringing awareness to child sexual abuse and to pursuing justice and healing. Every year she and her cousins, with bipartisan support from South Dakota representatives, present the bill to the legislature, and every year it is defeated.

II

A person raped can never be unraped. They will have those scars inside themselves until they die. The sisters' pain is the silent, festering pain of overlooked people. It is not exquisite, glamorous, articulate, or redemptive. Nobody marches to denounce it. They suffer in obscurity, and the obscurity, the indifference of their surroundings to their story, compounds the suffering. They live with their understanding of all that was done to them and all that has not been done for them.

We have been taught that the knowledge of tragedy can transform societies. There are victims, such as Raphael Lemkin, coiner of the term "genocide," who are able to salvage dignity from their personal tragedies by forcing others to be transformed by their experiences and the knowledge they managed to harvest from them. Lemkin, whose mother, father, and forty-seven other relatives were killed in Treblinka in 1943,

dedicated most of his life to this effort. But there is nothing about victimhood that confers a capacity to do such work. The general truth is that tragic circumstances do not make ordinary people into extraordinary people. And people with the internal resources to bring tragedy eloquently and affectingly to our attention are rarer than tragedy itself. There were the slaves and there was Frederick Douglass. It is not the responsibility of a victim to know how to make use of her pain or give it lasting voice. Pain grants no wisdom, only the need for it.

No consolation will come to the nine sisters, but their stories should be known anyway. There are practical reasons for this, and I will list and explain them, but first I must say that the primary effect of their story is to explode our faith in happy endings. By telling their story or arguing for reform we can fulfill the duties of ethical beings and that is some comfort, but the sisters are themselves beyond the reach of solace. For them, the horror is irreversible. It is essential that we grasp this about all victims of atrocity — we must understand the aftermath in which they are condemned to live.

The South Dakota legislature will not give these sisters their day in court, and even if they did, the law still would have little capacity to enforce justice in their case. The scars will stay, they are indelible. The cultural genocide will not be undone, despite the astonishing power of Native cultures to sustain and to flourish. In 1975 St. Paul's School, like many of these institutions, was transferred from the church to tribal control and became Marty Indian School. There is no one left even to punish. The alleged rapists and sadists are long dead: their mortality, and popular indifference, protected them. There should be monuments in the streets in South Dakota commemorating the horrors that were done there. High school students throughout this country should know the

disgraceful history of these boarding schools. But if all this were to happen, by some social miracle, still justice would not be done. The wounded will remain the wounded.

And we do not have the luxury of saying that we tell these stories to stop evils like them from happening again. Our cultural obsession with utility, our impulse to respond always with practical steps, misleads us. This *will* happen again. Such horrors will be repeated. We know too much about human nature to believe only in human goodness, and in the efficacy of historical lessons. One of the essential characteristics of humankind is that it contains evil. There will always be evil people, and many of them will escape punishment, and there will always be an overwhelming majority of disinterested onlookers, a mass of unmoved movers, who will facilitate that evasion.

In this story the onlookers play a particularly disturbing part. After all, as people like to say, the story is complicated. Not all the students were brutalized. Many enjoyed their time at the Native boarding schools. Should the alleged tragedies of some overshadow the normalcy of others? Many Native survivors with the strength to seek justice are asked this question. Why soil the reputation of whole groups and whole institutions by making them known only for their crimes? Aren't they much more than the darkness they harbor? These are questions that have been asked also about the rapes and abuses that were perpetrated against other students at different sorts of schools in America. The question is basically an invitation to lie or to look away, and in so doing to damage the victims and distort the history still further. In the protracted wrestling with these issues in many Catholic dioceses in America, the path of truth was eventually chosen. If children in Boston deserve truth and protection, so

297

do children in South Dakota. Perhaps we feel awkward about intruding upon the privacy of another community, but all ethical criticism and action is a kind of intrusion.

Most victims will not be rescued, and their aftermath will stretch on, and those who could have saved them, or ameliorated their conditions, but did not, will not be absolved of complicity. Yet we must be careful not to tell these stories in order to absolve ourselves. The act of telling the story redeems no one — not us, not the victims. The tales may increase the ethical sensitivities of the hearers — or they may be treated only as stories, a passing disturbance of our minds with a beginning and an end, a structure designed to abrogate shock. As an incentive to change, narrativity's power may be exaggerated. These stories must be inducted into our national collective memory, alongside every other significant episode in our national history, the magnificent and the repugnant, for another reason: because America should know what America is.

There is a pop-therapeutic axiom that talking through pain or anxiety will diminish its power. Americans believe in the salvific power of speech. One long heart-to-heart and the world is already a better place. *Let's talk it out.* That platitude is actually a sugary dilution of The Talking Cure, which has an interesting origin. It was first conceived by Bertha Pappenheim and inducted into our lexicon by Freud, who included hers as the first of six case studies in *Studies on Hysteria*. But it is worth noting that Pappenheim did not talk through her pain in the way that contemporary mental health advocates seem to think she did. She found, in consultation with her doctor, Josef Breuer, that her somatic disorders — headaches, partial paralyses, loss of sensation — would begin to weaken if she could recall aloud to him the repressed traumas and emotions related to the initial manifestations of each symptom. This

process has little to do with *let's talk it out*, with the theory that assumes that there is something inherently healing for a survivor about telling others their stories. Pappenheim wanted Breuer to fix the symptoms of a wound that itself could not be fixed. She wanted respite, not consolation or redemption. And respite was the most that the discursive therapeutic setting could offer her.

Talking it out is not always healing. It certainly has not been so for the Charbonneaus. Recalling their childhood, which they had for years done their best to forget, is excruciating for them. Silence is a natural reaction to the experience of horror, and a dignified one. Within the Native American community, the sisters are among many who have withdrawn into silence. Children of the survivors of the Native boarding schools were told by their parents not to go looking for clues about what happened in those places. Often this silence is an expression of shame, which many of these descendants say colored their childhoods, and was bequeathed to them. The shame makes the heavy memory heavier.

Some say it is fatal. The sisters who survive her believe that Louise Charbonneau, who died suddenly in 2020, just three weeks before she and her sisters planned to return to the South Dakota Legislature once again, could not bear to retell her story. They say that the looming burden, the annual pilgrimage back in time, hastened her death. During testimony for the proposed amendment, Geraldine told the legislators: "I feel the Creator took her home so she didn't have to come here again, so she didn't have to be raped all over again by your 'no' vote." Is it *ever* a victim's responsibility to relive her trauma?

In cases of atrocity, it is essential that the onlookers, and not just the victims, bear the burden of remembering. For over two centuries, since Carlisle's founding, these stories have

Nine Little Girls

remained outside our national collective memory. It is a moral imperative that this willed amnesia be cured — not just among the tribes, and not just in South Dakota and North Dakota, and all the other states in which the boarding schools stood. These atrocities deserve to be incorporated into the shared past of the country, out of respect for the humanity that was desecrated and as an impediment to future desecrations. I say impediment advisedly. Collective memory, and even historical knowledge, certainly cannot preclude the recurrence of injustice. One of the saddest and most erroneous claims of the post-Holocaust sensitivity to atrocity is its confidence that the remembrance of past evil will prevent future evil. Survivors and victims bet a lot on the power of memory to dissuade people from violent action. But by now we ought to know better. "Never Again" did not prevent Bosnia, or Rwanda, or Syria. The destruction of the concentration camps built for Jews in Europe did not prevent the construction of the concentration camps built for Uighurs in Xinjiang today.

Evils must be remembered by people to whom they did not happen. We must remember other people's histories. It is reasonable to wonder whether people can remember things that they have not experienced. Doesn't that defy the nature of individual memory? But we do so all the time. We call this ubiquitous and mysterious phenomenon collective memory. Descendants of slaves never experienced slavery, and yet they are right to say that they remember it. The children of Holocaust survivors never experienced the Holocaust, and yet they are right to say that they remember it. It is possible to achieve great proximity to the experiences of other people.

In order to remember what did not happen to you, you have to immerse yourself so completely in the knowledge of the past that an inner intimacy with it is achieved and it takes

on the sensation of personal acquaintance. The instrument of this intimacy, of this acquaintance, is the imagination — not the imagination of fantasy but the imagination of fact. Every year on Passover every Jew is enjoined to conceive of herself "as if she herself had left Egypt" two thousand years before her birth. That "as if" is the ancient rabbinical euphemism for the imagination. Even remembering episodes of one's own group's history is a creative exercise which requires an imaginative leap. The imagination is an ethical instrument. It has to be such: if the only evils one could conceive, abhor, and fight are those one has experienced oneself, then fortunate people would be useless against injustice. Which, for this reason, they often are.

The women of Olga, North Dakota are not like anyone I have ever known. Their personal histories are quite alien to me. We are children of different Americas, and I have no natural understanding, based on my own life history, of how these Ojibwe women lived and what they endured and how they interpreted it, though it may be easier for me to incorporate their stories into my collective memory because my own tradition supplied a training course in the importance of such strenuous empathy. (I have thought many times while researching the story of the Charbonneaus that the Jewish tradition's emphasis on memory was essential preparation for this work.) But despite the differences between us, the distance in space and in background, the emphatic otherness, these women have haunted me, have been with me, since that night three years ago.

In the space of an evening, I went from knowing almost nothing about these stories to becoming familiar with myriad specific details, and then to imagining minutes and hours that occurred decades ago in strange places where I have

301

never been. By becoming aware of them, and by extension of all the men and women like the nine sisters whose lives were permanently mutilated by similar ordeals, these stories became in some sense also mine. I say this humbly. Again, I am not like them, and I have not suffered anything like what they have suffered. But it would be wrong to turn away from them for that reason, to invoke "alterity" and try to forget what I have learned. Difference should not be an excuse for indifference. If one does the work of study and imagination, the arduous and respectful work, then the gulf can be adequately traversed — certainly enough to impose moral and social and political responsibilities. Strangely, solemnly, in ways totally unlike the victims and their communities, I remember. They are a part of me. Now they are a part of you.

LEON WIESELTIER

"The Wise, Too, Shed Tears"

I

How close to the world can one be? How far from the world should one be? Those questions represent two mentalities, two doctrines — the aspiration to nearness, the suspicion of nearness; engagement as a form of strength, engagement as a form of weakness; the hunger for reality, the horror of reality; the nobility of belonging, the nobility of alienation. We begin with the world and we end with it, and we spend our mortal interval ascertaining what to do about the relation, and how to get it right. There are some who draw close because they seek pleasure, or because they seek pain; there are some who fear pain, or fear pleasure, and pull away. Charity, and moral action,

demands proximity, but proximity also narrows and deceives and corrupts — and immoral action requires it, too. Beauty enchants, and absorbs, and overwhelms, but it is not obvious that the dissolution of the self is its highest fulfillment, or that sublimity is our best level. And love — does anything imperil the heart more? Love, the commonplace miracle, is the cradle of anxiety; its fragility casts a shadow over the very happiness that it confers. The truly happy man, it would seem, is the man who lives only in the present and alone, which is to say, the man who is without a father or a mother, a son or a daughter, a lover or a spouse or a friend, which is to say, almost no man, really. A man with a memory is hardly alone. Even solitariness is a kind of social relation, which may be refined into solitude. The world comes with terms.

One of the greatest satisfactions in the history of philosophy is the inconsistency, even the hypocrisy, of the Stoics. For as long as I have studied them, I have quarreled with them. Like the late Tolstoy, they get into your head. The Stoics were meticulous students of human breakability and raised it into a subject for philosophy. Nobody in the West ever pondered more rigorously the actualities of pain. The integrity of their ideal — tranquility of mind achieved by the stilling of strong feelings — is incontrovertible. Who lives *too* serenely? And incontrovertible, too, is their portrait of the assault of the world upon the soul, and of the soul's consequent dispersal by stimulations and attachments. Experience is the enemy of composure; poise must be wrested from circumstance; we are taught by being troubled. When I encounter equanimity, then, I feel envy. And yet I have always believed that the price of Stoic equanimity may be too high. The virtue that it recommends is achieved by an ordeal of paring down and stripping away and pulling back that looks to me like a process of dehumaniza-

tion. What is the self-sufficient self, if not the self that exaggerates its own resources? Where is the line between self-sufficiency and self-satisfaction? This is why the inconsistencies of the Stoics delight me, why I even gloat in their failures. And this is why the literature of Stoicism — and of Pyrrhonism and Epicureanism — is riddled, when read closely, with exceptions to the lofty rule of wise retirement.

Stilpo was a philosopher in Megara in the late fourth and early third centuries B.C.E. and the teacher of Zeno, the Cypriot thinker who founded Stoicism. Seneca relates that "Stilpo's homeland fell to invaders; his children were lost, his wife was lost, and he alone survived the destruction of his people. Yet he emerged happy; and when Demetrius, who was called Poliorcetes, or City-Sacker, asked him whether he lost anything, he replied: 'All my goods are with me.'" Seneca extols him for thinking that "nothing is good which can be taken away." He "conquered even his enemy's conquest. 'I have lost nothing', he said. How amazing is this man, who escaped fire, sword, and devastation, not only without injury but even without loss!" *Nothing is good that can be taken away*: was this man a saint of indifference or a monster of indifference? There are other testimonies, other ancient exempla, equally stirring or shocking, in praise of imperturbability. The father of this tradition of virtuous passivity was Pyrrho, who began as a painter and founded the school known as Skepticism (which is not to be confused with skepticism). He outfitted indifference with an epistemology. In the company of his teacher Anaxarchus, he travelled to India with Alexander the Great, where no doubt he encountered Eastern varieties of philosophical quietism. It is said that Anaxarchus once fell into a ditch and Pyrrho walked right past him, without any offer of assistance, as evidence of his immunity to attachment.

Diogenes Laertius relates that when Pyrrho was attacked by a dog and recoiled in fright, he apologized for his panic, pleading that "it was difficult entirely to strip away human nature," which was otherwise his goal. According to Diogenes, Pyrrho's principled obliviousness was perfect: "avoiding nothing, taking no precautions, facing everything as it came, whether wagons, cliffs, or dogs."

The problem with Pyrrho's extraordinary consistency is not only that it was fanatical, and like all fanaticism intellectually facile. It was also a little fraudulent: Diogenes further reports that "he was kept safe, as Antigonus of Carystus says, by the friends who accompanied him." A detachment of attached people to protect his detachment. How could they stand him? Places, everybody! Pyrrho needs to be alone! A reputation for holiness is the best protection. The conclusion that must be drawn from Pyrrho's amusing arrangement is that the values of *apatheia*, or freedom from strong feeling, and of *ataraxia*, or tranquillity of mind, the magnificent ideals of the ancient proponents of withdrawal and placidity, are not magnificent after all; or if they are magnificent, they are not practicable; or if they are practicable, they are premised on the worldly involvements of others, on a surrounding population of perturbables. The sight of equanimity should inspire not only envy, then, but also doubt. Seneca produced his elevating letters to Lucilius in the same years in which he stooped to the lowest court politics in Rome, with catastrophic results. Was he a hypocrite, or merely a human?

There were thinkers who codified the inconsistencies of the wise man and conceptually extenuated his philosophically embarrassing needs. In his life of Zeno, Diogenes offers a brief analysis on the ways in which objects and qualities may be classified as indifferent. "Of indifferent things they say

that some are preferred, others rejected. The preferred have value, whereas the rejected lack value." The delicious notion of preferred indifferents is the backdoor through which the commitments of existence re-enter the Stoic life. "Of the preferred things, some are preferred for their own sake, others for the sake of something else, and still others both for their own sake and for the sake of something else." It is hard not to smile at this casuistry of humaneness. There is something affecting about its intellectually tortured way of rehabilitating imperfection and vindicating the unlikelihood of a complete escape from the human muddle.

The preferred indifferents include other people. Whereas Epictetus warns that the good supersedes all ties of kinship, and Cicero argues against Camus that parricide is justifiable because the son of a tyrant may "prefer the well-being of his fatherland over that of his father," and Seneca cites approvingly the case of a good man who murdered his own sons, there is in Stoic writings a kind of creeping reconnection of the sage to others, a restoration of the human bonds that have just been deplored, a recognition of the intrinsic value of certain social relationships. Having been demoted as impediments to the development of the rational and virtuous individual — Philo of Alexandria, in one of his least Jewish moments, declares that a man who takes a wife and has children "has passed from freedom to slavery" — there is ample discussion of the merits of marriage, on the assumption that, in the words of scripture, it is not good for man to be alone. The proper qualities for a spouse are deliberated upon, and fertility is not primary among them. Arius Didymus, also of Alexandria, who was Augustus' teacher, stated that the sage should marry and have children because "these things follow from the nature of a rational animal designed for community and

307

mutual affection." It would appear that we have left behind the war on worry.

So detachment is not all, and disruptions of serenity are admitted. The sociable Stoic: is he a contradiction, or one of culture's great tributes to complexity? In the literature of friendship, certainly, the Stoics are among the founders. Friends are highly preferred indifferents; they are even instances of the good. Many eloquent passages could be cited. Seneca writes to Lucilius with passion about this passion, thereby doubling the sin. "The wise person loves his friends very deeply," he says, explicitly joining wisdom to emotion. He calls the Stoic sage an "artist at friend-making" and proclaims "the grandeur of friendship." He is offended by friendship that is based on expedience or utility. "What brings [the wise man] to friendship is not his own expediency but a natural instinct." Seneca's description of the motive for friendship is not only rational, it is almost romantic: "Why make a friend? To have someone I can die for, someone I can accompany into exile, someone whose life I can save, even by laying down my own." The world has its hooks in this man. Not for him a callous walk past that ditch. And more: "One could even say that love is a friendship gone mad." (One could also say that friendship is a love gone sane.) "Friendship is choice-worthy in itself," Seneca explains, "and if friendship is choice-worthy in itself, then it is possible for one who is self-sufficient to pursue it." A splendid result. In my tradition this sort of category-splitting, of dialectical rigging, is known, not altogether favorably, as *pilpul* — but this is *pilpul* against the impoverishment of life, pagan *pilpul*, beautiful *pilpul*. One of the purposes of *pilpul* was anyway to make life more livable.

The self-sufficient individual with needs and with bonds: this is not an anchorite dream, and it harbors no longing

308

for the desert. Do such individuals exist? The truth is that the streets may be full of them, in differing degrees of inner strength and outer connection; not sages, exactly, but men and women surprised by events and beset by hardships and summoning the reason and the solidarity that is necessary to endure them, fighting off fear and struggling with dread, ordering feelings or choosing a dignified way not to order them, reckoning with the limitations of their wills, ruefully noticing transience, answering to some conception of the good life; not Stoics, exactly, but neither thoughtless nor helpless, and not without the capabilities of self-possession, and of understanding, and of courage. Here is Seneca's characterization of the Stoic at home: "He is self-sufficient, and yet takes a wife; self-sufficient, and yet raises children; self-sufficient, and yet would not live at all if it meant living without other people."

The ataraxic hearth? At this point the reasonableness of the picture becomes irksome, and the initial radicalism of the recommended discipline begins to seem implausible. Can the Stoic have it all? Is no significant renunciation necessary? If nothing is good that can be taken away, how can family and friendship be good? For they will be taken away from me as surely as I will be taken away from them. The original objection against the dependency of human affections, the warning against caring, is still valid: it is indubitably an invitation to pain. Good morning, heartache, sit down. Loss is the end of the story of every bond, and also the condition of its urgency. Eternal life, were it possible, would be no guarantee of eternal love, because eternity is the enemy of love. In our enthrallment to our vision of the good life, have we forgotten what we know about the lived life? There are not many things we can confidently foretell about the future, but it is safe to

prophesy that it holds bitterness. It holds bitterness because it holds loss. Loves and friendships provide the specifications of our eventual bereavements.

This is morbid, but every effort to prepare for mortality is morbid. For this reason, one of the central exertions of Stoic spirituality is the attempt to separate bitterness from loss — to preempt sorrow with reflection. "The wise person," Seneca writes, "is not afflicted by the loss of children or of friends, because he endures their death in the same spirit as he awaits his own. He does not fear the one any more than he grieves over the other." For "all anxiety and worry is dishonorable." Dishonorable! I scan those words and I grant the rationality in them. It may be that one day I will be able to regard the prospect of my own death with equanimity, not only so as to die freely, as the philosophers say, but also so as to find the words and the glances that will ease the sorrow of my mourners. But the death of my family and the death of my friends? I cannot do this. I will not do this. I will mourn. It is the failure to mourn that is dishonorable: a treason, a misrepresentation. The abrogation of grief by reason looks to me like the violation of a duty, and like an imperialism of reason. My tears will flow as a sort of somatic entailment, a physical proof, of my interrupted attachment. Perhaps I am soft, or insufficiently logical; or it may be that I hold a different view.

I was rudely thrown into these matters when, in the space of a week, two of my most preferred indifferents, two of my most cherished friends, died.

II

I met Adam Zagajewski in Paris three decades or so ago and it was love at first sight, or at least at first sound. Since that lucky day our conversation was constant, in every medium, until last

spring, when he selfishly died. We were introduced by Tzvetan
Todorov, a mutual friend, a sterling man with a soft, hopeful
voice and curly silver hair, a radical who became a liberal, a
Maoist who became a humanist, a rarity. Tzvetan and Adam
and the American poet C.K., or Charlie, Williams were a circle
of fellowship and cultivation in Paris, all of them expatriates,
all of them serious but none of them earnest, offering ideas the
way people used to offer cigarettes, sharing new work, merrily
mocking cant, scouring the world for things to admire. They
did me the honor of allowing me in, and Joseph Frank too,
Dostoevsky's sweet and bearish and masterly biographer:
Charlie once joked that Joe and I were corresponding members
of the little academy.

Adam was the first person I ever met who disliked Paris:
except for Tzvetan and Charlie and a few others, almost all
of them gone now, Adam was lonely there, and his poems
were not read. It was in Paris that we began our history of
walks — of the reveries of unsolitary walkers, in Paris and in
Krakow and in Amsterdam and in Chicago and in New York.
We wandered aimlessly, talking and laughing and reciting
— "poems from poems, songs/ from songs, paintings from
paintings,/ always this friendly/ impregnation..." There was
usually a museum on our itineraries. Once we had three whole
hours together at the Rijksmuseum, which under each other's
influence became an afternoon of shared trances. I recall how
we stood before Vermeer's milkmaid, transfixed in a unitary
focus upon the gentle pour of milk from her pitcher to
her bowl, which is the heroic action of the picture, the spill
leaving the red clay above in a delicate spout-shaped triangle
and becoming a sure white line, a gentle vertical crux, as it
falls into the red clay below. We agreed that this small passage
was nothing less than a portrait of time. This most humble

of scenes broached this least humble of subjects. We watched the liquid flow but not move, and we agreed that the painter had found a retort to Heraclitus' river. Then we walked on, in a happy aesthetic daze, and trained ourselves on the stupendous facture in *The Jewish Bride* (now properly re-named *Isaac and Rebecca*), perhaps the greatest parcel of painted canvas in the world. In unison we were utterly bored by the notion that what Rembrandt had accomplished was an exciting anticipation of abstraction. For us the excitement lay in the fact that the glittering mess of pigments before our eyes was a representation. At Adam's request, I recited a few verses of the story of Isaac and Rebecca in Hebrew, for the music of it, a story that is noteworthy because the furtive sex that it depicts is not forbidden; it is secret, but it is not illicit. The secret is that the lovers are husband and wife. A wholesome scandal, we chuckled, and strolled to the next gallery. (Years later Adam wrote to me: "The Rijksmuseum: I remember exactly those beautiful moments in front of the masterpieces. Very elitist.")

The walks I treasured the most were in Krakow, because Adam lived there. I came once to give a lecture in memory of Czeslaw Milosz at the Jewish Cultural Center, which was run by a kind soul named Joachim Russek, a "righteous Gentile" if ever there was one. It was located in Kazimierz, the old Jewish district that is home to a large and venerable population of ghosts. One afternoon I was drawn by the window of an antiques shop on Josefa Street, which had been the main thoroughfare of the neighborhood, but I fled the shop immediately when I realized whose salons those elegant objects had once adorned. I was especially glad to have Adam's company, because my trip was a disquieting one: a few days after my lecture I was to cross the border at Przemysl into Ukraine and visit my parents' hometowns, in the region of

312

Galicia that is soaked with my family's blood. I needed a friend.

The subject of my lecture was Jewish messianism, which I had been studying for a long time and arriving at unconventional conclusions, and Adam was in attendance. After the lecture we set out across the city and he wanted to know more about a distinction that I had made between the messianic predicament of the Jews and the messianic predicament of the Christians. For the Jews, I said, the problem is that the redeemer does not arrive and the world stays the same; but for the Christians, the problem is that the redeemer did arrive and the world stays the same. They each have theological traditions of adjusting to the eschatological flaws in their respective situations. I suggested that I preferred what the Jews do not yet know to what the Christians already know. Who wants to wake up the morning after redemption? The coffee will still have to be made. The internet will be ablaze with the advent, but injustice will still abound and banality will still threaten everything. Adam wondered whether this was not similar to a dilemma that we had been discussing for years, which we called "after ecstasy." It was a dilemma broached by mysticism and by eros and by music — by Mahler especially, for Adam. How can Mahler's Ninth Symphony, that monument to the limitlessness of yearning, end? How dare it end? And in what spirit does one breathe when it is over? Can memory adequately contain ecstasy? Or does the quest for ecstasy doom us to a grim alternative between frustration and repetition, with its deadening consequences, the way the search for love can come to ruin in chastity or promiscuity? By now we were in the *rynek*, the city's grand square. The hour was late and it was deserted; the open market, where I had been dismayed, but not surprised, to discover tiny wooden figures of Jews with a beard and a penny attached to them, was gone, and the cafes

were closed. "Do you want to visit the ermine tomorrow?" Adam cheerfully asked.

I wanted to visit the ermine. In a small museum that houses the various collections of the aristocratic Czartoryski family, there hangs a strange and important picture by Leonardo called *The Lady with the Ermine*. The weasel-like creature held closely by the noble lady is an allegory for certain virtues, and the painting had many adventures during the world wars. But it was not the main event for the morning. There was something else that Adam wanted to show me, an object that for him was the secular equivalent of a religious relic. We walked over to the Collegium Maius, which is the museum of the Jagellonian University, where we visited a stuffy green room in the middle of which stood, in bright wood on a bright wooden floor, one of Chopin's pianos. He used it on a concert tour of Scotland in 1847, and he inscribed his name inside it. If Adam had a god, it was Chopin. He always pronounced the name with reverence. He found the cosmos in Chopin's pieces. He had highly developed views about the interpreters; I never squandered an opportunity to listen to any interpretation with him; I learned so much. Ekphrasis is the ancient literary technique of making poetry out of painting, by describing in verse a particular work of visual art. Adam was an ekphrastic poet — I especially adore his poem about Morandi — but the inspiring art was usually music. *Ut musica poesis.* When he died, at a wretched loss for how to grieve for him, I began to listen to Chopin, and Schubert, and Scarlatti, over and over again, with a ritual intensity, and Bach ("*das Wolhtemperierte*," he exclaimed in an email, "it's the whole world"), and Chopin again, and all the Edwin Fischer I could find, until I began to feel not only that I was listening for him, that I would be his ears the way we had together been each other's eyes, but

also that I was consoling the composers for his loss. The poor bereft geniuses, they will never be heard by him again.

We left the holy piano for a leisurely walk in the Planty Gardens, one of the largest parks in Krakow, which traces the contours of the medieval walls of the old city. Here, too, I was haunted: I have a photograph of my parents in the Planty Gardens in 1945, immediately after their liberation. My father briskly wears a Polish officer's uniform and my mother, an elegant woman even when shattered, appears in a smart dark coat with a hat tilted stylishly above her graciously smiling face. They had been in hell only months before. Now they were living under fictitious names, my father masquerading as a military man, because it was dangerous for Jews to become known to their Russian liberators; and when someone recognized my father on a reviewing stand and threatened to inform on him, they jumped a train and left the curse that was Poland. I told Adam the story, and our conversation turned to an early poem in which he compared Celan's "Deathfugue" to Bach's *St. Matthew Passion*, until finally we arrived at our next destination, which was Boguslawskiego Street. Milosz had lived and died in an apartment in number 6, and Adam had arranged for us to visit it.

He gave me a great gift. That huge man, that giant redwood of a man, that man of infinite and indestructible spirit, that writer before whom tyrants eventually fell, that poet who wrote imperishably about the burning of the Warsaw Ghetto from the other side of the ghetto wall — he had been both our friend. Adam was his spiritual son. I earned Czeslaw's friendship in 1981 with a piece in *The New Republic*, of blessed memory, in which I was harshly critical of certain American intellectuals who were advising the American government to do nothing about General Jaruzelski's crackdown on

Solidarity, and our friendship lasted until he was too weak to pick up a pen. His flat was as small as he was large. His slippers were still in place, and some of his books still stood next to his nondescript desk; and on a wall in the living room was a painting by his old friend Josef Czapski, who survived the Katyn massacre to become a profound painter, a profound writer, and by all accounts a saint. (The last gift I received from Adam, only a few months before he died, was a handsome monograph on Czapski's art, to which he contributed one of the finest essays he ever wrote.) From the apartment we found our way to the Basilica of St. Michael the Archangel, specifically to its crypt, one of Poland's pantheons, where Czeslaw is buried. Adam asked a stranger to take a photograph of us standing next to the heavy marble sarcophagus. On our faces is an unmistakable look of gratitude.

"Now again in Krakow, trying to encourage my soul to emerge from its hiding place." "The London Derek Walcott evening was very moving, but of course a soccer match would draw a hundred thousand more people." "The other day I heard the first Violin Concerto by Shostakovitch by the Krakow Philharmonic. And then you remember how he waited for the NKVD by the elevator." "I'm writing again (I attach a recent elegy for Charlie) and I keep my anger alive, the anger at our stupid nationalistic government. Instead of Lenin and Stalin we now have Mary, Jesus, and Pilsudski." "I know that not everyone is keen on spiritual life. I noticed it some time ago and I can still barely believe it." "My voice is gone and my higher mind too. Do you ever have weeks when your higher mind disappears? But what a joy when it returns." And there were the inscriptions: "to my younger brother, able to combine wit and metaphysics (what's better than that?)..."; "to my brother in the seeking business..." Every word I ever had

from Adam, in his letters and in his books, no matter how sad or dour, was fortifying. As in his poems, so in his emails: he had an uncanny way of mingling the lyrical with the mordant, the magically dreamed with the keenly observed, the fanciful with the true, the elegiac with the risible. It was all done without raising his voice, even in his courageous anti-communist essays of the late 1960s and early 1970s. He spoke slowly, as if to leave time for his meaning to reach you before his irony. He loved mystery but he hated obscurity. His work carried the patrimony of European humanism into an allegedly post-humanist era. He was crazy about Billie Holiday. He was a great boon for the seeking business.

III

I met Larry McMurtry in 1989, at the public meeting of solidarity and protest that PEN tardily organized in New York in support of Salman Rushdie, who had recently gone into hiding to escape the *fatwa* against his novel and his life. I say tardily, because in the immediate aftermath of the Iranian outrage against freedom and literature many of the literary titans of the city were scared into silence, flattering themselves that sleeper agents were coming for them too, as if the Supreme Leader of the Islamic Republic had strong feelings about, say, *Billy Bathgate*. Rushdie's publisher was also running for cover. But finally the event did take place, in an empty storefront not far from PEN's offices at Broadway and Prince. The space filled quickly; people spilled out into the street. The cramped and rushed scene suited the emergency, which was real. The speakers included Sontag, who was president of PEN at the time, Mailer, Doctorow, Diana Trilling, Said, Talese (who bizarrely chose to honor the moment by reciting the Lord's Prayer, which was sort of what had gotten us into this mess),

317

"The Wise, Too, Shed Tears"

McMurtry, and myself. When it was over, Larry came over to me and said: "You're in Washington and I'm in Washington. Come to the bookshop next week."

The bookshop was Booked Up, one of four antiquarian bookstores that Larry owned around the country. He was not only a writer, he was also a "bookman"; he was narcotically addicted to books, high and low, old and new, he loved unpacking them and shelving them and pricing them and reading them and writing them, all in great numbers. His personal library in Archer City, Texas held more than thirty thousand volumes, and was a *personal* library, that is, the books on those floor-to-ceiling shelves were, in their genres and their subjects, expressions only of what most interested him. A library is not a bookstore. A true library excludes things, because nobody can care about everything. Nobody should care about everything. Larry had the entirety of the bibliographical map in his head, but he lived most fully in certain precincts of it. In Georgetown, Booked Up occupied both corners of Wisconsin and 31ˢᵗ Street. There were treasures there. The ones that moved me most were original copies of *Mont-St. Michel and Chartres* and *The Education of Henry Adams*, privately printed in the first years of the twentieth century by their increasingly incandescent author, in a large format bound in blue cloth, legendary books, and both of them signed by their author, the greatest writer who ever lived in the capital. The signatures themselves told the story of Adams' last years: the first in a confident hand, the second in a hand that shook with the results of a stroke. I recall that each of them was priced in five figures, though I never believed that Larry, or his shrewd and charming partner Marcia Carter, would sell them.

For me, they glowed in the dark. So did other volumes,

some of which I was able to afford by the kindness of the house: the 1669 edition of Thomas Browne, complete with portrait and quincunx and urns, and the jewel-like first edition of *The Black Riders and Other Lines* by Stephen Crane, published in Boston in 1895, a book the size of your hand, its verses printed all in capital letters, its cover decadently illustrated by a black vine creeping across the cream-colored boards. Over the years Larry generously sent me books that reminded him of my obsessions, usually as they came out of the boxes which libraries and collectors had shipped to him. The most spectacular offering of all was Eliezer ben Yehuda's vast dictionary, in eight huge volumes, of the "modern and ancient" Hebrew language, which he began to publish in 1910, complete with its "Great Introduction." I was a little delirious when I saw the spines. This was the epic work of erudition and fanaticism that re-established — no, established, since no Jew ever spoke Hebrew before Ben Yehuda the way an entire Jewish society spoke Hebrew after Ben Yehuda — the language of the Jewish people. "I figure if you can't use this, you'll know someone who needs it," Larry's letter said. "Me in my role as the Last Bookman." He went on to lament the decline of the trade in his time. "It's come down to me, Peter Howard, and Bill Resse. When this generation wastes...."

Anyway, we agreed to meet at Booked Up in Georgetown the following week. He was waiting for me at the bottom of the rickety metal staircase that ran up the side of the building to the second-floor entrance. He was holding a key. "This is for you," he said and placed it in my hand. "You might need a place to write. I write on the second floor. Your desk is on the third." He was like that. The place became my lair, especially when Larry was in town. He worked and slept in a tiny room just off Philosophy and Theology, with a small writing table and

a monk's bed. The clacking of his old typewriter downstairs rattled me, but not because of the noise. It was the reproving sound of his preternatural productivity. As I sat above him pondering the shape of an essay, or more often, losing myself in another book that I found on another shelf, the typed pages were piling high on his desk below — novel after novel, *Some Can Whistle*, tap tap tap, *The Evening Star*, tap tap tap, *The Streets of Laredo*, tap tap tap, *Duane's Depressed,* tap tap tap. He had so many stories in him. More, he relished the company of his characters. To paraphrase the screenplay for which he accepted an Oscar in jeans, he didn't know how to quit them. Sometimes we unpacked boxes together — I remember a long night excavating all of Huntington Cairns' library, a humanist's candy store. Like anyone who appreciates the erotics of browsing, I was helpless there. One night I went up to the roof for some air, only to find a wooden structure that contained the contents of the Phoenix, a renowned and recently shuttered poetry bookshop in Greenwich Village. It was there that I discovered, in many copies, *The Platonic Blow* by W.H. Auden, published in 1965 (without the poet's permission, I later learned) by The Fuck You Press, a work with which I was not familiar. A man's education never ends.

When Larry was invited to a fancy dinner in Georgetown or at the White House, he would return to Booked Up to write a hilarious account of what he had seen and heard — and in the morning I would find those anthropological reports from the field faxed to my office at my magazine. (Those were the days of glossy paper and fading ink, and I did not have the sense to copy them.) He was the most perspicacious fly on the wall who ever lived. If Larry was taciturn, it was usually because he was taking notes. About people, he missed nothing, as his novels show. He had Balzac's appetite for types

and temperaments. In the years when he was president of PEN — a cultural comedy of the first order, though he was diligent in his duties and they brought him east more often — Larry regaled me, usually at a French restaurant up the street over his favorite Montrachet, with his impressions of the solemnities of Manhattan. (Some of this delightful material appears in *Literary Life: A Second Memoir*.) These were followed by the inanities of Hollywood. The business of Washington rarely figured in our conversations; politics interested him only as another spectacle of human idiosyncrasy. We also pondered the devastating emotional effects of a heart operation that he underwent a few years after we became friends. He never completely escaped its shadow.

Yet our many meals together were also something else, for me: a long course in the American West. Larry was supremely a man of his place. He was a scholar of it; his text was the land and its vicissitudes, its people and their scars, which he knew with as much authority as any scholar I have ever known has ever known anything. I admired Larry for his immersion: it is good not only to come from somewhere, but to know well from where one comes. In the tradition of writers who are universal but not cosmopolitan, Larry's corner of the earth sufficed to fascinate him forever. This is evident in his books: they are full of detail but they are not made of research, as so many American novels are. (Richly imagined, those novels are usually called.) Gore Vidal once said, about his novel *Lincoln*, that he would read the historians in the evening and write the chapter in the morning. Not Larry; he came fully and naturally prepared. The history, the geography, the mythologies, the facts: he commanded them all. About his subjects he was sovereign. This freed him for imaginative play and social criticism. He once wrote a little book called *Walter Benjamin*

at the Dairy Queen in which he pretty much sided with the Dairy Queen.

At one of our dinners we were talking about Native Americans, and he was introducing me to the tribes of the Southwest and telling me what to read for further instruction, when he came to the tale of an American scout, I think it was Kit Carson, who had a famous fight with an Indian chief. According to legend, they met in the middle of a creek and fought *mano a mano* until the American hero vanquished his opponent in a fine spirit of manifest destiny. "Well, the truth isn't that," Larry said. "The truth is that Carson waited for the Indian to show up and shot him in the back." Manifest destiny, indeed. And then Larry added: "Which is exactly what he should have done." I was startled, of course. But I learned some things about my friend from his laconic and unsentimental remark. There was nothing triumphalist about his defense of Carson's ambush. Larry was a man without prejudice, and his down-to-the-ground Americanism was utterly devoid of the ugliness that mars American identity in his parts of the country. He merely understood that the world, and the West, is harsh, and he liked that the American scout knew the score. Larry once showed me an old photograph of the women in his family in Archer County a few generations back – I think it is reproduced in one of his books — because he wanted me to see the toll that life on that unforgiving territory had taken on their faces and their bodies. He had little patience with unreality and much patience with reality.

Larry admired many people but he idealized nobody. He was the sworn foe of Liberty Valance-ism: he never printed the legend. Instead, in his writing and in his demeanor, he was a remorseless demythologizer. He often brought to mind a precious sentence from Hawthorne: "Let us thank God for

having given us such ancestors; and let each successive genera-
tion thank him, not less fervently, for being one step further
from them in the march of ages." His critical essays about
Texas irritated many of his readers because he insisted that
the beating heart of the state is to be found in its cities. In his
"lecture" to me on Buffalo Bill and the transformation of the
old West into entertainment, he concluded that "the old West"
existed only for twenty years or so, but I heard no disenchant-
ment in his voice. He was pre-disenchanted, which is what
made *The Last Picture Show* a great film and *Lonesome Dove* a
great book.

Archer City is a two-hour drive northwest from Dallas.
It is a small town with a small population, the county seat, a
place for roads to meet, with no feeling of a future. Jesse James
hid out there. When I used to visit, it looked exactly as Peter
Bogdanovich had filmed it. The movie house was a poetical
ruin, as if it had been built to be best enjoyed in memory
and most truly seen in a rearview mirror. The hospital that
appears in the film became the Lonesome Dove Inn, where I
enjoyed the blandishments of the Terms of Endearment suite.
Larry had transformed four large buildings in the center of
town into four large bookshops. Book Town, it came to be
called. (Some years ago, as his health began to fail, he threw
a big party and auctioned off three shops and three hundred
thousand books.) The main store was down the street from
the courthouse. The rarest holdings were there, and some
literary memorabilia. From a comfortable chair in a corner
in the front room Larry would greet visitors — bibliophiles
and book dealers and locals looking for old books about
Texas and writers from all over the country who heard that
it was very cool. There was almost nothing to do at night in
Archer City. At the American Legion hall I learned the Texas

two-step and was regaled by the inebriated reminiscences of a toothless old oilman named Green. When Larry had guests, however, he provided for their nights: he kept the bookshops unlocked. So when sleep failed, as it often did, I would leave my bed for the deserted streets, where the only activity was the changing light at the crossroads, and ramble in the entirety of our literary civilization until dawn. Sleeplessness was never sweeter. My only responsibility was to turn the lights off. On my walk home my head swam with the rewards of serendipity, with the unexpected phrases and images and names and ideas that I encountered in the nocturnal sanctuary that my friend had created for people like us, but mainly I thought: I love this man, who keeps the lights on.

IV

Seneca's ninth letter to Lucilius treats the loss of a friend. It begins by clarifying that his hostility to emotionalism does not require the elimination of emotion. "Our position differs from theirs in that our wise person conquers all adversities, but still feels them; but theirs does not even feel them." The sage is stringent, not grotesque. Yet even this concession to human frailty is limited: whereas the sage acknowledges feeling, because feelings are natural and the Stoic aspires to live in accordance with nature, Seneca advises Lucilius that his ideal should nonetheless be "the invulnerable mind." This insistence upon invulnerability must have originated in an exceptional vulnerability. Only someone who feels deeply would be so alarmed by depth of feeling.

Yet the antidote to tender-heartedness cannot be hard-heartedness. Seneca compares the loss of a friend to the loss of a limb — it is an amputation. But the comparison is surprisingly unsympathetic: it is designed to minimize the

injury, not to magnify it. "There are times when he is satisfied with just part of himself. He will be as happy with his body diminished as he was with it whole." Surely there will be other times too, when he will be unsatisfied with his mutilation, but the philosopher continues in the same toughening spirit: "He is self-sufficient, not in that he wants to be without a friend, but that he is able to — by which I mean that he bears the loss with equanimity." It is certainly the case that the maimed man has no choice: he will use his good eye or his remaining hand. (If you have ever seen a three-legged dog enjoying an afternoon in the park, you have seen this equanimity, and you have been touched by its unreflectiveness.) But do not approach the maimed man with solace, the Stoic counsels. It would be a philosophical error. In this account, the death of a friend is not an occasion for consolation, because reason will have obviated the need.

The philosopher goes further, into the farther reaches of detachment where Stoicism becomes obnoxious. No consolation for the loss of a friend will be required, Seneca adds, because the sage turns out to have picked up a certain emotional efficiency. "In truth he will never be without a friend, for it rests with him how quickly he gets a replacement. Just as Phidias, if he should lose one of his statues, would immediately make another, so this artist at friend-making will substitute another in place of the one who is lost." All he has to do is swipe right! In passages such as this one, the consolatory tradition of the Stoics, to which Seneca also contributed, begins to look a little phony. The death of a friend is quite obviously not the death of friendship. When my friend dies, I do not miss friendship, I miss my friend. All of Phidias' statues may have been alike, but no two individuals are the same. And even Phidias might have noted that his reproductions were

not perfect, and that there are no exact equivalences in human affairs. It should not take a sage to recognize that there are no "replacements." The uniqueness of what has disappeared, its gorgeous specificity, is precisely the source of the pain. And the avoidance of the pain, the tranquility of mind that is the increasingly desperate master of these proceedings, has been accomplished by means of a shallow notion of human commensurability.

As James McMurtry, of Archer City and Austin, likes to sing, "I don't want another drink, I only want that last one again." *There* is the problem of sorrow. The general awareness of our mortality may be of limited value in summoning the courage to confront individual mortalities. Human finitude is universal, but Adam Zagajewski and Larry McMurtry were particular. No one like them will ever live again. Of course we do not expect our friends to live forever, but such "stoicism" is useless when the wounding day arrives, because we cared too much before to care less, or not at all, now. There is no profit in the attempt of the philosopher of indifference to defend the heart with definitions. One more text, then, this one from Epictetus, which I offer in praise of all the actually existing people whose specificities refute it: "In the case of everything attractive or useful, or that you are fond of, remember to say just what sort of thing it is, beginning with the least little things. If you are fond of a jug, say, 'I am fond of a jug!' For when it is broken you will not be upset. If you kiss your child or your wife, say that you are kissing a human being; for when it dies you will not be upset." It! But not even two jugs are identical, if they were made by human hands, and if you think they are identical then you have no eye for jugs. The collapse of such discernment should not be dignified as wisdom. The differences between people are what draw them to each other.

If there is such a thing as species-love, it is not the highest love, or the most strenuous love, or the love that gets one through the night.

"Anyone who complains that a person has died is complaining that that person was human," Seneca snaps. He takes mourners for fools. Their dejection is an intellectual misunderstanding. "Nothing is more foolish than seeking a reputation for sorrow and giving one's approval to tears." Are tears in need of approval? The disapproval of them seems so haughty, so cold. Whereas "the wise, too, shed tears," this is only because "one can be tranquil and composed even in the midst of tears." Seneca does not say how. But is there really nothing worse than a lapse of composure? Surely rationalists, or especially rationalists, may break down, and have their outlook tested by the tremendous unreason of experience. Were Mill's tears bad for him, or for philosophy? Reason will not gain followers by attempting to recruit them where it does not belong. There will be time enough for argument when the tears dry. Like other thinkers in other traditions, Seneca warns against the excesses of grief, but his warning is hollow because he derides grief. He believes it is chiefly a social performance: "The show of grief demands more of us than grief itself requires. Without a spectator, grief comes to an end." Yet the opposite is more often the case: it is when the others leave, when the spectators and the consolers are gone, that the quiet ravages of sorrow begin.

And then one learns, in desolation, not about the limits of sorrow but about the limits of solace. If consolation is difficult, it may be because consolation is impossible. When a person dies the world changes, once and for all, for those with whom, closely or distantly, he lived. The world is the people with whom one goes through the world. The emotional efficiency

327

of the philosophical Stoics, which bears a resemblance to the emotional efficiency of the unphilosophical Americans, scants the finality of what has occurred. Religions seek the same evasion with their fantasies of resurrection, but resurrections and replacements are equally outlandish responses to the circumstance in which (as the Talmud says) something has been lost which shall not be found again. Too much grieving is hardly our problem. We can anyway count on the world for distractions from it. But respites may be the most we can hope for. There is nothing temporary about mourning; it is an essential view of an essential characteristic of human life. Since ephemerality is permanent, so is sorrow. We may set it aside, we may diversify it with lighter emotions that are warranted by lighter incidents, but it is never wrong. Sorrow befits the sage. Anyone who has ever loved may speak in praise of inconsolability.

329

CONTRIBUTORS

ELLIOT ACKERMAN is a writer and former Marine and the author most recently, with Admiral James Stavridis, of *2034, A Novel of the Next World War.*

DURS GRÜNBEIN is a German poet and essayist. His most recent book of poems is *Porcelain: Poem on the Downfall of My City.* This essay was translated by Karen Leeder.

THOMAS CHATTERTON WILLIAMS is the author most recently of *Self Portrait in Black and White: Unlearning Race.*

ANITA SHAPIRA is an Israeli historian. She is the author, among other books, of *Ben Gurion: Father of Modern Israel* and *Israel: A History.*

ADAM ZAGAJEWSKI, who died in Krakow in April 2021, was a Polish poet and essayist. His most recent book of poetry in English is *Asymmetry.* The poems in this issue were translated by Clare Cavanagh.

SALLY SATEL is a visiting professor of psychiatry at Columbia University's Irving Medical Center.

R.B. KITAJ, the American painter, died in 2007. His autobiography, *Confessions of an Old Jewish Painter*, was posthumously published in 2017.

MATTHEW STEPHENSON is the Eli Goldston Professor of Law at Harvard Law School.

HELEN VENDLER is the author, among many other books, of *Wallace Stevens: Words Chosen Out of Desire.*

DAVID HAZIZA is a French writer and the author of a translation and commentary on the Song of Songs.

A.E. STALLINGS is an American poet and translator living in Athens.

PAUL BERMAN is the author of numerous books, including *The Flight of the Intellectuals.*

CLARA COLLIER is a writer based in California.

MICHAEL KIMMAGE is a professor of history at the Catholic University of America and the author most recently of *The Abandonment of the West: The History of an Idea in American Foreign Policy.*

PEG BOYERS is a poet and the executive editor of *Salmagundi.*

CELESTE MARCUS is the managing editor of *Liberties.*

LEON WIESELTIER is the editor of *Liberties.*

Liberties — A Journal of Culture and Politics is available by annual subscription and by individual purchase from bookstores and online booksellers.

Annual subscriptions, which offer a discount from the individual cover price, can be ordered from libertiesjournal.com. Gift subscriptions are also available.

In addition to the regular subscription discount price, special discounts are available for: active military; faculty, students, and education administrators; government employees; and, those working in the not-for-profit sector at libertiesjournal.com.

Liberties — A Journal of Culture and Politics is distributed to booksellers in the United States by Publishers Group West; in Canada by Publishers Group Canada; and, internationally by Ingram Publisher Services International.

Liberties, a Journal of Culture and Politics, is published quarterly in Fall, Winter, Spring, and Summer by Liberties Journal Foundation.

ISBN 978-1-7357187-3-6
ISSN 2692-3904

Copyright 2021 by Liberties Journal Foundation

Printed in Canada.

The insignia that appears throughout *Liberties* is derived from details in Botticelli's drawings for Dante's *Divine Comedy*, which were executed between 1480 and 1495.